2003

FOULPERFECTION

The MIT Press Cambridge, Massachusetts London, England

MIKE KELLEY

FOUL PERFECTION

essays and criticism

EDITED BY JOHN C. WELCHMAN

This book was set in Frutiger by Graphic Composition, Inc. and was printed and bound in the United States of America.

Library of Congress Cataloging-in-Publication Data

Kelley, Mike, 1954–

 Foul perfection : essays and criticism / Mike Kelley ; edited by John C. Welchman.

 p. cm.

 Includes bibliographical references and index.

 ISBN 0-262-11270-1 (hc. : alk. paper) — ISBN 0-262-61178-3 (pbk. : alk. paper)

 1. Kelley, Mike, 1954– —Written works. 2. Kelley, Mike, 1954– —Aesthetics. 3. Art criticism. I. Welchman, John C. II. Title.

N6537.K423 A35 2003

700'.92—dc21

2002029391

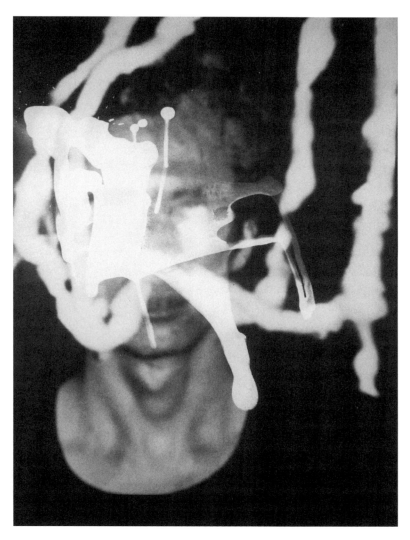

Mike Kelley, *Ectoplasm Photograph* (1979). Black and white photograph altered with bleach. 30 × 23 ins. Collection of the artist.

CONTENTS

SECTION II

PREFACE

This series of books comes as a surprise to me. I was shocked to discover just how much paper I have covered with ink. In my youth I aspired to become a novelist, until I realized I was no good at writing fiction and wisely, I believe, chose to pursue my interests in the visual arts instead. I came to writing through the back door, so to speak—first by writing short statements about my artworks, which developed into "performance art" monologues and, finally, into essays. The essays were not labors of love, rather they were a response to my dissatisfaction with the way my work was being written about critically.

I decided I had to write about my own work if my concerns were to be properly conveyed. Also, I was not pleased with how contemporary art history was being constructed, so I felt it was my duty to raise my voice in protest and write my own version—whenever I could. In a sense, then, much of my writing was reactive. It never truly seemed that the decision to write was my own. If it weren't for the urging of my friend John Welchman, this book would not exist.

Special thanks to Patrick Painter for his generous support for the provision of illustrations. Sadly, though, many of the images that originally accompanied these essays couldn't be presented here.

John and I would also like to thank the following for their assistance in preparing this volume, or for kindly agreeing to allow images of their artworks to be reproduced here: David Askevold, Cody Choi, Darcy Huebler, John Miller, Sharon Avery-Fahlström, Plaster Foundation, Sebastian, Sixth Street Studios, Survival Research Laboratories, Eleanor Antin, John Waters; Emi Fontana, Glenn Bray, Nancy Youdelman, Mimmo Rotella, Catherine Sullivan, Rita Gonzalez, Julia Dagostino, Farhad Sharmini, Tim Martin, Metro Pictures, Alexander and Bonin, Regen Projects, the Paul Thek Foundation. Thanks also to the journals, publishers, or institutions that commissioned and/or published first or subsequent versions of these writings: Artforum, Grand Street, Parkett, Texte zur Kunst, More & Less, Spectacle, PAJ: A Journal of Performance and Art, C31; Sonsbeek, Arnhem; Steirischer Herbst, Graz; Castello di Rivara, Turin; Deitch Projects, New York; Galerie Hauser & Wirth, Zurich; Cantz Verlag, Ostfildern, and Gesellschaft für Aktuelle Kunst, Bremen; Confederation Centre Art Gallery and Museum, Charlottetown, Prince Edward Island; Palais des Beaux-Arts, Brussels; Magasin, Centre National d'Art Contemporain, Grenoble; JRP Editions, Geneva; and Les presses du réel, Dijon.

Mike Kelley, Los Angeles, 2001

INTRODUCTION

This is the first of three projected volumes assembling for the first time a diverse selection of Mike Kelley's writings in the numerous genres, idioms, and styles he has taken on (or invented) during the last quarter of a century. Kelley's generic range is quite remarkable: it includes "creative" and critical essays for art and alternative journals, essays for exhibition catalogues, artist "statements," scripts for sound sculptures, libretti, dialogues (real and imagined), performance scripts, manifestos, numerous interviews (as both interviewer and interviewee), polemics, panel presentations, screening introductions, radio broadcasts, public lectures, CD liner notes, invented case histories, and poster texts.

 The variety of subjects and issues about which he has written, noted, and talked is equally broad, ranging from commentaries on and additions to his own work and that of teachers, friends, colleagues, and heroes, to meditations on contemporary music, science fiction, and popular culture. He has produced important reflections on the nature of caricature and contemporary dialogues with it; on ideas and effects of the uncanny; and on UFOs, gender-bending, pop psychology, adolescence, repressed memory syndrome, and architecture. Among other issues, his interviews discuss the Detroit underground in the late 1960s, conceptual art, feminism, sexuality, rock music, formalism, the relation between New York and Los Angeles, politics, and the pathetic. And writing itself.

 I have organized this profusion of vehicles and themes in a manner that I hope is both useful and accessible, but that also acknowledges some of the play, irony, and overlap that abound in Kelley's work, whether written, performed, videoed, drawn, or installed.

 The present volume surveys two of the leading aspects of Kelley's writing, collecting his major critical texts on art, cinema, and the wider culture; and his essays, mostly commissioned for exhibition catalogues, on the artists (or art groups) David Askevold, Öyvind Fahlström, Douglas Huebler, John Miller, Survival Research Laboratories, and Paul Thek.

 Volume II will concentrate on pieces that were integral to Kelley's own art practices from the mid-1970s to 2002, including his most influential statements and "manifestos"; texts from photo-editions and posters; a sequence of humorous pseudo-psychological interpretations and quasi-fictions; introductions to videos; and writings on architecture and Ufology. A projected third volume

will collect, edit, and annotate a selection of scripts for the celebrated series of performances Kelley wrote, directed, and performed or co-performed in the concentrated burst of activity between 1976 and the mid-1980s that established his reputation as one of the most innovative contemporary artists working on the West Coast.

Even three volumes will accommodate only part of Kelley's writings. There is no space for his signature essays, liner notes, and panel discussions of contemporary music, or the large and exciting body of interviews, recorded conversations, and broadcasts. While not really known as a writer by many in the art world (in large part because of the multiple geographic and media locations of this work), considering volume alone Kelley takes his place alongside the theory-oriented abstractionists of the historical avant-garde (Wassily Kandinsky, Piet Mondrian, Kazimir Malevich) as one of the most productive artist-writers of the twentieth century—ironic company, perhaps, for an artist engaged in projects in the conceptual vernacular who is "staunchly against the whole idea of nonrepresentational art."[1]

This volume begins with "Urban Gothic" (1985), written just a couple of years before Kelley virtually abandoned live performance. With its distinct aural qualities ("spoken word rather than written text")[2] and persona-driven incantations, the piece bears explicit traces of the styles and methodologies Kelley used to develop his performative work, reminding us that from the start his writing took on experimental folds and complexities that matched the material and thematic overlays of the performances, drawings, and installations. But while the style and form of Kelley's critical writing modulated after 1985 into a combination of first-person critical opinion, contextual observation, and historical and thematic revisionism, what he once termed the "library work"[3] that underwrites almost all of his projects in different media remains a constant resource—"It's just like doing a research paper," he once remarked.[4] Indeed, Kelley's commitment to research, compilation, and citation—what we can term his archival impulse—and its reassemblage, dismantling, or explosion comes as close as anything to a center for his intergeneric activities; and the notion of "poetic" concentration, or condensation, emerges as the key figure of this continuity in "idea generation."[5]

So while it was never abrupt, the shift from speaking, singing, chanting, or ranting—first improvised, then based on a performance script—to writing texts for publication demanded new forms of attention and reference, as well as a turn in Kelley's orientation to research. Owing partly to teaching duties in the graduate Fine Arts program at Art Center College of Design, Pasadena,[6]

he was conscious, in particular, of a move in the mid- and later 1980s from what had been a habitual involvement with historical and avant-garde literature to reading in art history and criticism and cultural theory. "I never read literature anymore," he said in conversation with Heinz-Norbert Jocks in 1999, "I read almost only critical theory and history books."[7] The result was a self-conscious attempt to write "straight text[s]" in a manner that was neither "subjective [n]or artsy."[8]

Kelley's formative influences in literature included the Beats, especially William Burroughs, early twentieth-century avant-gardists like Tristan Tzara, Raymond Roussel, Alfred Jarry, Gertrude Stein, Raoul Hausmann, and the futurists Filippo Tommaso Marinetti and Luigi Russolo. He read Novalis and Lautréamont, Nathaniel Hawthorne and Herman Melville, William Beckford and Matthew Lewis, Vladimir Nabokov, Günter Grass, Jean Genet, Witold Gombrowicz, and Thomas Bernhard, as well as practitioners of the new novel and their associates, such as Thomas Pynchon and Samuel Beckett. Among his own generation, Kelley was a supporter of the literary circle that grew up around Beyond Baroque in Venice, California, where Dennis Cooper, Bob Flanagan, Benjamin Weissman, Amy Gerstler, Tim Martin, and others made regular appearances. Early on, his reading also included the psychological studies of R. D. Laing and Wilhelm Reich; and, in politics and social criticism, the Yippie manifestos of Abbie Hoffman and John Sinclair. He was also interested in fossilized systems of thought, like the theology of Thomas Aquinas, and pseudo- or out-of-date scientific constructions, including Jarry's Pataphysics or the writings of Lucretius.[9] With the exception of the "eccentrics" of the genre—H. P. Lovecraft, P. K. Dick, J. G. Ballard—he generally disliked science fiction, however, because its exoticist aspirations were so often at odds with its "normative intentions."[10] Kelley learned many lessons from these genres—appropriation, collage composition, humor and irreverence, anti-institutionality, the diagnosis of repression, system construction (and parody)—all of which passed by one means or another into his art practice and the composition of his writings.

With all this reading behind him, and a confessedly "bookish" side to his early development, it is hardly surprising that one of Kelley's dreams as a youth was to become a novelist, something he admits was frustrated by a self-professed lack of literary talent: "I couldn't write," he said in a recent interview (and underlines in the preface to this volume).[11] As a student at the California Institute of the Arts from 1976 to 1978, he later confessed that an important motivation for his move to writing was provided by his alienation from—and ignorance of—prevailing theoretical

discourses in the conceptualist milieu that dominated the school at this time. "I really developed my writing skills," Kelley noted, to combat the way his work was received. "I didn't want to. I'm not a natural writer. I did it on purpose and it was not a pleasant task."[12]

A key aspect of Kelley's thought about the theory and practice of writing can be found in his negotiation with the modernist notion of collage and, in particular, with the aesthetics of fracture and structure associated with the new novel and postwar experimental fiction (that of Pynchon, Burroughs, Genet, among others), as well as with postmodern media practice. Kelley is careful to separate the writing techniques he developed for performance from either Joycean stream of consciousness or pure montage and cut-up. "It's actually not cut-up," he commented, "it's very much organized . . . like improvisational music . . . I always had a more compositional approach to writing."[13] Always aware, then, of the limitations of fracturing strategies, Kelley points out that the aesthetic of disassembling "ultimately fails as a strategy of resistance because it emulates the sped up and ecstatic effects of the media itself."[14] Kelley's views on "disruption" exemplify the complex adjudication he sought, for while he admits to the use of "disruption . . . in a Brechtian sense," which promotes "a return back to the real," he opposes the solicitation of more radical forms (as in the work of Burroughs), desiring instead to arrange transitions between "a string of associations." By simulating "natural flow," Kelley would thereby produce an "almost ambient feel."[15]

In a panel discussion on the occasion of his collaborative exhibition with Paul McCarthy at the Vienna Secession in 1998 (*Sod and Sodie Sock Comp O.S.O.*), Kelley offers the notion of fracture and collage perhaps his most sustained consideration, focusing on the idea of appropriated or appositional criticism. The artists' selection of texts by Georges Bataille, Wilhelm Reich, and Clement Greenberg "in lieu of a catalogue" can be considered as one of the many "layers of reference" Kelley identifies in the installation itself. Like that work, the chosen texts can be read historically, formally, poetically, or in any combination. The act of assembling them, and the particular intensities with which they might be consumed (or ignored) by viewers, read with or against each other, and with or against the work and its own contexts and references, reinforce Kelley's own sense of postmodern relativity, his refusal to think about texts or objects in terms of their "content or their truth value," but rather as complex entities with their own structures and histories, blind spots and illuminations, relevance and detours. Working across and against fashion and revivalism, using these texts "for their poetic value" but also as a rationale for the materials in the exhibition,

Kelley notes both his distrust of the truth-giving or denotative function of writing, and that he has become more interested in his later career in the "historicist" situation of texts, which, he suggests, has come to "supersede my interest in the formal aspects of . . . writing." With the provocative notion of "socialized visual communication," Kelley attempts to draw the work, its forms, its audiences, its conceptual and historical references, and the writings it occasions, designates, or appropriates, into a multilayered compositional totality based on an open logic of association, consumption, and repressive return.[16]

Another step in the move from performance/script to essay or manifesto arrived with Kelley's development of his signature black-and-white word-image combo pieces (always referred to by the artist as paintings), which originated around 1978 as a part of his performance apparatus but emerged a few years later as independent works. They pair uninflected outline figures painted in black acrylic with box or sidebar text in a profuse range of calligraphic styles that stand out against the relative homogeneity of other postmodern mergers of image and text, in the work, say, of Jenny Holzer, Barbara Kruger, or Joseph Kosuth.[17] In these works, language acts as a destabilizing agent that intervenes across what Kelley described as "culturally standard" images, complicating their "legibility."[18] The image-text combinations themselves are "illustrations"—flow charts of meaning clusters—that establish their prominence in the artist's work following the diminishment of the object and a new interest in manners of speaking and address. As, most notably, with the photo-texts of Kruger, important relations are staged between the captions, slogans, clichés, put-downs, and jokes Kelley inscribes on his illustrational paintings and the thematic concerns of his longer writings.[19] I suggest elsewhere that Kelley's turn to statements and essays and the delivery of sonic components to his artworks (in the *Dialogue* series, for example) may have been a kind of compensation for the "de-scripting" of his images, apparent in the late 1980s as he turned to more consolidated presentational structures and the ironic tactility of craft materials.[20]

But as with other elements in Kelley's work, there are several origination narratives that underwrite his decision more than twenty years ago to render his own accounts of his art and ideas. "I was so unhappy when I was younger with what critics wrote about my work," he noted in conversation with Isabelle Graw, that "I was forced into a position of writing about it myself."[21] A primary motive in the shift to criticism, then, was to defeat what he viewed as the Chinese whisper of falsely imputed intentions, passed as assumptions and misrepresentations from review to

review at the outset of his career. In a real sense, Kelley's battle against psuedo-reportage and vicarious intentionalism anticipated more general conditions of criticism achieved only in the 1990s: "Only recently," he suggested in 1998, "has criticism been seen as itself like art, or fictive in some sense, or constructed, representing the writer's point of view."[22]

While focused on the idea of condensation, the styles and textures of Kelley's writings are typically profuse. One response to the wide net of research he feels obliged to cast is the compilation of "a lot of notes very fast—you know, ba-ba-bum-bum-bum-bum."[23] Many of his texts start out with strings of concepts and quotations assembled with speed and rhythmic compression. Often departing from these concentrated clusters, the spectrum of Kelley's styles ranges from an expository mode ("trying to explain to people what I'm up to in a very clear way") mostly reserved for catalogue essay commissions, through the explicit corruption of this clarity using parodic forms of pseudo-exposition and "high flights of fancy,"[24] to the penning of "wild manifestos,"[25] like "Goin' Home, Goin' Home" (to appear in volume II).

Each mark on this gradient of types is set against the notion of "standard" introduced above: exposition is normally organized against standard interpretation (critical consensus or received opinion); pseudo-exposition utilizes, but then derails, the standard formats established for critical and artistic writing; while wilder moments of Kelley's writing (more evident in volume II) merge document and fiction, common sense and reverie in fusillades of ironic moralism or parodic social zeal. Several commentators on his writings have been perplexed by the range and overlaps between these textual types. One designated the more experimental texts "great perverse objects" because of the difficulty they purportedly create for "art critics or theoreticians": "On the one hand," notes Jean-Philippe Antoine, "you take the place of the critics, and forbid them to do their job, you become your own critical theorist. But on the other hand, if one reads the texts, one perceives something else going on."[26]

In all its idioms, even the most straightforward, Kelley's writing is laced with humor and irony, which arise from the many gaps and dissonances he builds into his willfully faulty structures. In the image-text combos, for example, with their in-image titles and commentaries, the text might mimic the work, or operate "as another figure in a visual proposition" (Isabelle Graw), offering another layer of meanings that mediate, often unstably, between "jokes," "red herrings," and real "issues" (Kelley).[27] The compounding of textuality with, or as a supplement to, the visual image is

a part of Kelley's plea for scrutiny, the kind of close but open reading that punctures the social veneer and probes underneath his rearrangements of mass culture.[28] There is, then, both a literal and a figurative side to Kelley's central ironic/comedic strategy of playing with "figures of speech."[29] Humor in Kelley's work is also a function of his wider view of art as "a byproduct of repression." "Part of the humor in my work," he notes, "is about making that obvious."[30] In his writings, repression is identified with histories and reputations passed over or suppressed by the critical status quo; and Kelley's revisionism often crackles with irony as he reengages with what he views as omissions or misinterpretations in the historical record. Finally, humor and irony are necessarily caught up in another conceptual focus of Kelley's work and aesthetic as a whole, his proposition that art is crucially connected to ritual, and that one measure of its power and success is founded on what he terms "a kind of structural analysis of the poetics of ritual."[31]

For Kelley writing can be considered as just another among many possible media (drawing, performance, video, photography, etc.), an idea underlined by Paul McCarthy in 1998 when he noted that "I think Mike and I view all mediums as equal—we use whatever medium is appropriate to the idea";[32] and by Kelley himself when he remarked during a radio interview in 1994 that art has a "syntax . . . [that's] like a written piece of language."[33] Thus, while Kelley is attracted to the literary conditions, writerliness, or poetics of writing, these apparently medium-specific qualities are also associated with other artistic attributes—in a kind of transverse exemplification of the metaphoricity that defines them. In the case of Freud—"I like Freud's writing simply as literature, because it is so metaphorical"—Kelley likens this aspect to "a sculptural way of talking about the construction of the personality which could be connected to Freud's own interest in antiquities—those things which are dug up out of the earth as evidence of the past."[34] This suggestive formula offers another of the striking conjunctions between form, trope, material, and historical meaning that characterize the most convincing of Kelley's works.

There are other filaments of consistency in Kelley's intermedia practice that connect his writings to his visual art. The most immediate arises from his long-standing interest in the relation between an artwork and that primary field of texted intervention provided by the title: "I've always," Kelley noted, "been very careful about titles." Typically, Kelley's titles offer a deliberated field of reference for the image or installation, sometimes acting to counteract the tendency to psychologize a work, as with *Zen Garden,* whose "peaceful, contemplative title" is intended to divert

the viewer's projective reading of "the animals hiding under the blanket."[35] Kelley rarely refuses to designate his works, or calls them "Untitled," except in those instances when he wants "to point to [the] fiction of material self-reference."[36] Another intermedia consistency can be found in his commitment to implied narratives and associational flows that arise from the spaces between compressed images and texts; while a third emerges in his repeated "conflation of various genres to produce . . . absurd or surprising effects," which he likens to the genre confusions of Burroughs and the idiosyncrasies of Lovecraft.[37] And all relate to an overriding suggestion by the artist: that media and materials are subordinate to ideas: "I use various media because they seem appropriate to the idea that I want to work with. And I don't have a real investment in any kind of particular materials. I've never really loved materials [or] had [a] . . . super-fetishistic relationship" to them.[38] For Kelley, the artistic process "almost always" originates with ideas, and the activity of "thinking first" is decisive.[39]

Kelley has often expressed his resistance to forms of art that trade too overtly with the biographies of their makers, while at the same time aspects of his personal history and development have clearly played an important part in all phases of his career, though with renewed emphasis in the last decade: "From the late '80s on there was a general tendency for critics to psychologize my work, and that was something that surprised me. . . . As a response . . . I felt I had to bring myself into [the work] or make myself part of the subject of the work, in order to problematize that psychological reading. I had to make it difficult . . . by giving a lot of false information."[40] The dichotomy between structure and information and personal history is even more vigorously present in the progression of Kelley's writing, and can be seen, almost nakedly, in the difference on this question posed between the two sections of the present volume. While seldom lacking in opinion, color, and personal style, the essays and comment pieces in the first section address themes and issues within which Kelley's presence is largely remaindered as composition or critique. The essays in the second section, on the other hand, with the exceptions of the shortest piece of all, on Marcel Broodthaers, the piece on Paul Thek, and the discussion of Survival Research Laboratories, discuss a selection of male artists who are (or were) friends or mentors of Kelley (Miller, Askevold, Huebler) and who shared aspects of his personal and professional history. Even the essay on Fahlström, whom Kelley met only once, in his student days in Michigan, closes with an epilogue recalling the awkward circumstances of their encounter.

Such proximity to his subject matter, supplied as it is with an intensity of seeing, sharing, reading, and exchange, offers one of the more compelling aspects of his writing—but at the same time, of course, presents an obstacle for the more critically "objective" Kelley (and his readers) to negotiate. But the strand of personal and professional knowledge woven through the catalogue essays joins with another dimension of subjective investment visible across the volume: the intermittently irascible, cavalier, or cranky voice that drives these writings forward. Kelley has always been candid about the disadvantages, repressions, and dissatisfactions of his youth, even suggesting—half seriously—that his recourse to art was simply a "more productive way than just being a drug-addict or a criminal or a juvenile delinquent or all the other ways that you can vent your dissatisfaction." Emerging from a personality that was once "naturally miserable . . . mean-spirited and angry,"[41] Kelley's style and opinions are characteristically frayed by occasional misanthropy or art-world cynicism whose boldness makes for a convincingly strident and partisan criticism all but absent through the 1990s, except in those unappetizing vestiges of right vs. left polemic. Reading the pages that follow, we rarely have the sense that Kelley indulges in what he once termed "the Zen effect," the lazy leveling of meaning into a kind of value-free equilibrium in which the reader or viewer is invited merely to "float."[42]

While success in the art world obviously complicates his outsider ethos, and blunts some of his more rebarbative remarks, it cannot be denied that Kelley has defended his positions on aesthetics, popular culture, contemporary music, and the art world at large with conviction and rhetorical tenacity. Most of the present volume is comprised of writings that propose a thoroughgoing critical revisionism predicated on a set of principles and arguments that recur in subtly different formulations. Kelley is concerned with figures or themes that don't quite fit, or that trespass across paradigms deemed separate or sacred by sanctioned critical interests. His revisionism can be thematic, as in the essays on caricature and the uncanny; or monographic, as in the essays in section II that question the ageist assumptions underwriting the partial omission of Huebler's confounding exercises in "planned futility" from the conceptualist avant-garde; Fahlström's relative neglect by the partisans of pop; Thek's anomalous location between minimalism and critical figuration; or what Kelley views as an undue lack of engagement with Miller's art and writing in the precincts of New York postmodernism.[43]

Along with his disavowal of traditional writerly excellence and his intermittently cantankerous style, Kelley's refusal to accept canonical histories of contemporary art is one of several

measures of his "badness" as a writer. But being bad is not simply a concession Kelley ironically grants himself; it is—as Yvonne Rainer noted in another context—a symptom of the difference between normative conventions and assumptions and the *artistic* inflection of a discourse, whether filmmaking, writing, or whatever. Kelley's flirtation, then, with what he described as "*allowed* bad writing"[44] reaches for the strategic permissibility of a "bad style," the relative dysfunction and opacity of which challenge the operating systems that occasion it—whether criticism, commentary, or theory.

Most of Kelley's essays are unpublished, or first appeared in alternative rather than mainstream journals (only two, "Foul Perfection: Thoughts on Caricature" and the essay on Survival Research Laboratories, came out in leading art magazines—*Artforum* and *Parkett,* respectively), or were commissioned for catalogues accompanying exhibitions which, with the sole exception of the brief piece on the Korean-American artist Cody Choi, took place outside the U.S.—in Arnhem (*The Uncanny*), Turin (Thek), Zurich (Broodthaers), Brussels (Huebler), Bremen and Cologne (Fahlström), Charlottetown, Prince Edward Island, Canada (Askevold), and Grenoble, France (Miller). Both anthologies of Miller's collected writings (Kelley's introduction to the second is reprinted here) were published by presses located overseas, the first in France, the second in Germany.

As a prophet in the wilderness of his own national culture, it is hardly surprising that Kelley's views on the U.S. critical establishment are often skeptical, even polemic. "Art magazines," he remarked in the mid-1990s, " are special interest magazines like any other . . . they are trade magazines. Increasingly there has been no attempt to hide that. Whereas art criticism . . . used to adopt a tone of criticality . . . putting things in some kind of historical perspective . . . [using] social critique . . . it's increasingly obvious that it's some kind of fluff or advertising for artists or trends or movements or galleries."[45] Kelley is especially disappointed by the kind of criticism that does nothing more than describe, acting, in effect, as a kind of bookmark for prospective buyers.

Kelley once remarked that he was made up of "various histories": "I have a painting history, a black and white history, a performance history, a sculpture history and a stuffed animal history."[46] With the appearance of this volume—and others on the horizon—it seems clear not only that his history as a writer should be added to the list, but that it functions as a kind of super-medium (sound, talk, slogan, inscription, metaphor, critique, script, poetry, assemblage, history, polemic) binding all the others together. "I can raise my voice in protest," Kelley once remarked, "but I'm not the one who writes the history."[47] Well, not so fast—now you're not the *only* one.

NOTES

1 Mark Breitenberg, "Freak Culture: An Interview with Mike Kelley," *Art + Text,* no. 68 (February-April 2000), p. 61.

2 Mike Kelley, interview by Robert Sentinery, "Mike Kelley: Form and Disfunction," *Zone* 1, no. 2 (1994), p. 15.

3 Ibid.

4 Mike Kelley, interview by Gerry Fialka, "Genesis of a Music," KPFK Pacifica, May 19, 1994 [aired June 1994], transcript, p. 3.

5 Mike Kelley, interview by Heinz-Norbert Jocks, part 1, transcript, p. 1. Kelley was interviewed several times by Jocks. Earlier discussions were published in German in *Kunstforum International* in May-July 1995 and December 1997–March 1998, but the most recent interviews, cited here from the artist's transcript, were conducted in August and September 1999 and are forthcoming in *Dialog: Kunst, Literatur, Mike Kelley,* ed. Heinz-Norbert Jocks (Cologne: DuMont, 2001).

6 Kelley, interview by Fialka, p. 3.

7 Kelley, interview by Jocks, part 1, p. 1.

8 Mike Kelley, interview by Jean-Philippe Antoine, *Cahiers du Musée National d'Art Moderne,* no. 73 (Fall 2000), p. 110.

9 Kelley, interview by Jocks, pp. 2–3.

10 Kelley, interview by Antoine, p. 117.

11 Ibid., p. 110.

12 Mike Kelley, interview by Robert Storr, "An Interview with Mike Kelley," *Art in America* (June 1994), p. 90.

13 Kelley, interview by Antoine, p. 107.

14 Mike Kelley in "An Endless Script: A Conversation with Tony Oursler," in Deborah Rothschild, *Tony Oursler INTROJECTION: Mid Career Survey 1976–1999* (Williamstown, Mass.: Williams College Museum of Art, 1999), p. 51.

15 Kelley, interview by Antoine, p. 107.

16 Mike Kelley in conversation with Paul McCarthy, Martin Prinzhorn, and Diedrich Diedrichsen, on the occasion of *Sod and Sodie Sock Comp O.S.O.* (an exhibition with McCarthy), Vienna Secession, September 23, 1998, transcript, pp. 2, 6, 7.

17 "Look/Write/Act: Word/Image," the second section of my survey essay ("The Mike Kelleys") for *Mike Kelley* (London: Phaidon, 1999, pp. 52–56), develops this analysis of Kelley's image-text combos.

18 Kelley, interview by Sentinery, p. 15.

19 For analysis of the imaging of text and its relation to other writing types in Kruger, Holzer, and others, see my *Invisible Colors: A Visual History of Titles* (New Haven: Yale University Press, 1997), pp. 339–48.

20 Welchman, "The Mike Kelleys," p. 56.

21 "Isabelle Graw in Conversation with Mike Kelley," in *Mike Kelley* (London: Phaidon, 1999), p. 8.

22 Mike Kelley, conversation with the author, February 2001.

23 Kelley, interview by Jocks, p. 3.

24 Ibid.

25 Isabelle Graw, "Isabelle Graw in Conversation with Mike Kelley," p. 8.

26 Kelley, interview by Antoine, p. 109.

27 "Isabelle Graw in Conversation with Mike Kelley," pp. 8–9.

28 Ibid., p. 9.

29 Kelley, interview by Sentinery, p. 15.

30 Kelley, interview by Jocks, p. 12.

31 Kelley, interview by Antoine, p. 119.

32 Paul McCarthy, conversation with Mike Kelley, Martin Prinzhorn, and Diedrich Diedrichsen, p. 3.

33 Kelley, interview by Fialka, p. 3.

34 Kelley, in conversation with Paul McCarthy, Martin Prinzhorn, and Diedrich Diedrichsen, p. 5.

35 Mike Kelley, interview by John Miller (March 21, 1991), in *Mike Kelley* (New York: Art Resources Transfer, 1992), pp. 42–44.

36 Kelley in "Isabelle Graw in Conversation with Mike Kelley," p. 41.

37 Kelley, interview by Jocks, p. 8.

38 Ibid., p. 10.

39 Ibid., p. 11.

40 Kelley, interview by Antoine, p. 114.

41 Kelley, interview by Jocks, p. 13.

42 Kelley, interview by Antoine, p. 118.

43 Of Öyvind Fahlström and Peter Saul, for example, Kelley noted that "my teachers considered [them] to be minor artists—Rauschenberg and Johns were their heroes. Now I think more people would agree that these artists were important artists." Mike Kelley, interview by Miller, p. 36.

44 Ibid., p. 8

45 Kelley, interview by Fialka, p. 9.

46 Kelley, interview by Sentinery, p. 18.

47 Mike Kelley, interview by Jean-François Chévrier, *Galeries* (Paris, 1991), p. 55.

SECTION I

URBAN GOTHIC

JCW *While he had published excerpts from his performance scripts in venues such as* High Perfor-
mance and the Journal *of the Los Angeles Institute of Contemporary Art (LAICA) since 1979, "Ur-
ban Gothic" was Kelley's first essay to appear in print, coming out in the third issue of the
short-lived Los Angeles journal* Spectacle *in 1985. It was conceived in response to what Kelley
viewed as a "new romanticism"—with symptomatic expressions in mid-1980s film, music, and
art cultures—that layered recycled Gothic imagery over various types of industrial representa-
tion. In these cultures, urban decay is redesigned with a new infusion of the Gothic-romantic
imaginary. Unlike the darkness and decay of the* film noir *tradition, which tended to image the
social present, the new romanticism typically took forms that were timeless or transcendent.*

*"Urban Gothic" is not written in the relatively transparent style Kelley would later
adopt for his critical essays, beginning with his consideration of caricature, "Foul Perfection"
(1989), which is included in this volume. Instead, its tone is parodic and its shifts of voice and
place still related to his writing for performance. Loosely adopting the flowery prose of a deca-
dent, fin-de-siècle flâneur or romantic-era travel writer (Kelley had been reading nineteenth-
century Gothic and Orientalist writings by William Beckford [1760–1844], Joris-Karl Huysmans
[1848–1907], and others), he narrates a magic-carpet tour of the new Gothic world, in which
associative reverie is punctured by episodes of experiential sublimity. As with the multiple*

personas inhabiting his performances and character-driven "statements," the disembodied voice-of-awe foregrounded here should not, of course, be confused with the more critically objective Kelley we encounter quite consistently in his later essays.

An Architectural Hunt

H. P. Lovecraft never set his stories in his own time; they took place in his father's era. In the same spirit he dressed decades out-of-date, often wearing, in fact, his dead father's clothes.[1] His diction regressed even further—to eighteenth-century archaic usage. In his view, the eighteenth century was the last commendable epoch, because it was the last century before the advent of the machine, the symbol of modernity. In Lovecraft's personal life, however, a reversion of just one generation was enough, for even this small span of time gave him enough leeway to see the modern world, the world of constraints, slip away and fall into ruin. Apocalypse of freedom, nip this bud before it has a chance to blossom in an unsupportive environment. Get on the bus that goes back in time. Take a tour through the thirteen original colonies. Look for pure American architecture, preserved and unspoiled, hidden away in the back alleys of small towns. But make sure they don't house any Chinese cooks.

There's a conspiracy afoot—a Yellow Peril—a many-headed, slant-eyed, buck-toothed, dog-eating hydra that's worming its way through the sewers of the city.[2] So far, right now, at this moment, it is contained in the waterfront areas—places where Shanghai becomes a verb. This conspiracy converts social commentary into poetic reverie.

On the Waterfront[3]

Marlon Brando is is running down an alley, and it's not pretty. It's a backdrop for a failed life. It is decayed, overwhelming—an architecture that smashes down the already downtrodden, swallows them up and spits out weasels, crooks, and gangsters. This decay is part of a one-to-one relationship. It has the clarity of tragedy: ugly people live in ugly places. There is nothing hidden in

that, no mystery in the broken shadows that darken this alley. This black is part two of the black-and-white pair. The choice is obvious in this multiple choice: black is always bad—always the second choice.

Blade Runner[4]

same place/different time . . .

The same guy is running down the same alley but now he has a different name. He is way off in the future now. There is the same architecture, the same weasels, crooks, and gangsters now. This shows the continuity of human nature. In this slightly more high-tech future architectural decay takes on a more pleasant tinge. Everyone knows that in the future all will be slaves to machines. Environmental decay becomes humanistic in this light—slum living is freedom. Big Brother and techno-control keep their noses out of the gutter. These free-wheeling gypsies of the future are just like us! But their ruinous surroundings are somehow more beautiful. They take on the lusciousness that can only come from removal—just as the horrible parasite, once removed and viewed through the window of the microscope, becomes "pretty." This is the decadent beauty of strangeness. Have you heard the one about the rotting meat that glistens like jewels? I think Salvador Dalí told it.[5] This beauty is deceptive and is the enemy of the rational person. It flip-flops too much. It won't stay put long enough to send a clear message. This beauty mesmerizes—you don't care what it means. It could be unhealthy. Jewelry made from dead meat may spread disease.

Decadent Beauty Sightseeing Tour

All aboard! We're loading up the plane for a flight around America: through the deserts of the Southwest, over the South Bronx, and down into a Twinkie factory and a shopping mall. Sometimes we go at fast speed—sometimes we go in slow motion. The tour has an American Indian name, a name both ancient and indigenous. The name refers to the end of the world.[6] This is a tour of comparisons. Towering tenements sit next to ancient rock formations. Everything is made one. The effect is like a well-printed, glossy calendar. The sheen of the photos is more apparent than what is pictured. Factories pump out products to the beat of trance music. You are sucked into the rhythm

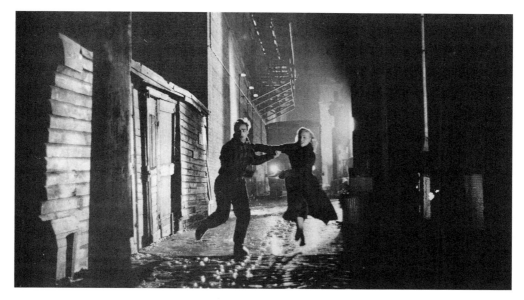

Film still, *On the Waterfront* (dir. Elia Kazan, 1954). ©1954, renewed 1982 Columbia Pictures Industries, Inc. All Rights Reserved. Courtesy Columbia Pictures.

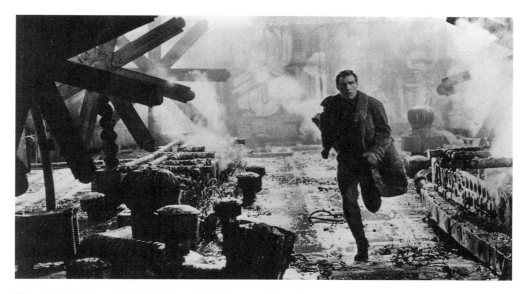

Film still, *Blade Runner* (dir. Ridley Scott, 1982). Courtesy Warner Bros.

and hum along. There is a studiousness in the extremes pictured that verges, ludicrously, on polarity. Come now, join in the group suspension of disbelief, don't think about it any more. All things are beautiful when viewed through the Vaseline-smeared lens.

First stop, South Bronx. Yes, great white hunter! I see the similarity, now, Bwana, that you have so kindly pointed out. These buildings do bear an amazing resemblance to the buttes of Utah. And it is wonderful how things have sped up. When the condemned structures are dynamited, I can see in a few minutes the erosion that in nature would take countless eons. The sight is indeed awe-inspiring.

While there we notice the curious pictographic markings made by the natives. Spray-painted scrawls cover everything.[7] Could these be the work of Lovecraft's Dark Brotherhood of impenetrable Oriental minds? We are lucky enough to capture some of these primitive artists as well as a few *bruit* musicians. We plan to bring them back with us to our own neighborhoods for entertainment. Perhaps this happy blanket of color will soon cover all of our houses as well. Sometimes a dark day needs a little brightening. Bury a corpse in loud clothes and paint the exterior of prisons plaid, I say. On the way home we take time to stop again in the desert and name all of the stones. Titling them after crumbling pseudo-Gothic structures seems most appropriate. *Dracula's Lair, Usher's Haunt, Strawberry Hill, Fonthill Abbey, Charles Dexter Ward's Address,* and *The Folly* are just a few that are rescued from obscurity.[8] Some of these gnarled rocks are used to decorate my Chinese garden. The twisted nature of the Oriental mind has already been referred to—instead of raking leaves they rake sand. The garden is also dotted with fake ruins of castles made of chicken wire coated with plaster. They are constructed and painted by professional stage set builders. The cheap construction is an asset, for with the first rains they sink into a heap and become even more poetic. Scattered among them are similar models of factories based on the paintings of Charles Sheeler.[9] These I am not so sure of—they are still a little too new, too modern. Perhaps my mind is still over-steeped in eighteenth-century gardening theory and must be updated. Modernist architecture is the most popular out-of-date architecture at the moment, but I haven't grown accustomed to the relevance of its dinosaur qualities yet, though I am making an effort. The radio blares out a song by Johnny "Guitar" Watson, "We got to strike on computers before there ain't no jobs to find."[10] He tells the tale of a music store salesman who attempts to sell him a guitar that plays itself. He resists, knowing that buying it would ultimately result in the extinction of his profession. On the TV there is

a story about workers striking to prevent the technical upgrading of their factory. Modern machines mean no work. They are unhappy. Having a foreign worker steal your job is bad enough, but having a machine do it is worse. My sentiments exactly. I like the old machines—the first ones—if I have to like them at all. As I said earlier, I'm trying to get adjusted to things modern. Now that they are dead, and the new things are postmodern, I am slowly becoming acclimated to them.

I live in a warehouse in the downtown district. Now that all of the businesses have failed, it is populated by artists. The skeletal remains of once-thriving factories can be seen from the picture window in my loft. The glisten of the Sheeler painting has darkened to the rich brown patina of a Rembrandt. Wonderful! Since the structures are no longer functioning, they have slipped into my territory—the realm of nonfunctionality, the world of aesthetics. A volume of science fiction illustrations from the 1930s sits on the coffee table. The book consists entirely of pulp magazine depictions of cities of the future. They duplicate exactly the scene outside my window! An exciting wave of confusion sweeps over me. Am I in the past or am I in the future? I clutch the book to my breast and weave dizzily. Images of art nouveau grain elevators spin in my brain until it settles on one—the perfect image of the perfect residence. I see a scene, forming like a mirage. It's of an aged corn silo standing alone in the middle of an endless plain of auto salvage junkyards. The cap at the head of the tower contains the single room. It has been decorated by the foppish hero of Huysman's novel *Against Nature*.[11] A modernized version of an old Japanese perfume-distinguishing contest is in progress.[12] Instead of scent, the contestants sniff and differentiate various brands of gasoline. This is my ivory tower. I am Rapunzel. My hair immediately grows to floor length whilst I pluck a lute and blow panpipes. Yes, my cornsilk-colored tresses stream down the tower's side like cum down a masturbated phallus. It stands erect and alone—my ivory tower.

Slowly I recover my senses and come back down to earth. When I reexamine the phantasmagoria that has just transpired, one image stands out more clearly than all the rest—the infinite junkyard. Ron Cobb's moralistic political cartoons of the 1960s come to mind—images of the world as one vast consumer dumpsite.[13] These pictures are distasteful; there is no heroism here. Pick up, instead, the new walking guide to WPA murals and, staff in hand, set out.[14] The Grand Canyon of industrial murals resides in Detroit: Diego Rivera's depiction of a Ford auto assembly plant.[15] The quaintness of the technology brings a smile to knowing lips. Though as jumbled as a junkyard, these portraits of metal pieces still maintain their majesty. No, it isn't the newness that makes them

appealing. The painting is too dated for us to believe that these components, once assembled, would make a new automobile. The sublimity lies in the idea of backward time travel; that in destruction the manufactured objects fall to pieces in the same order in which they were constructed.

The smell of the grease monkey and the roar of the crowd. Metal shrapnel is flying everywhere. The racetrack is filled to capacity, but first we stroll through the handicraft pavilions. One room contains massive Dennis Oppenheim sculptures that are spinning and shooting fireworks.[16] These are unfulfilling as allegory—weak sparks of interior pyrotechnics. No more of this sitting in Buddha-like introspection! The real event is going on outside! The half-time show is in full swing. Some machines from San Francisco are engaged in battle.[17] They rip, tear, and blow holes in each other. Ah, youthful vigor—they don't just sit on their fat asses, they fight. The crowd screams for more but it's time to move on to the big spectacle—a simultaneous program of demolition derbies, figure-eight racing, and most impressive of all, a specially altered, giant pickup truck with fifteen-foot tires that slowly churns over artfully arranged rows and heaps of Japanese cars. The truck, appropriately named Bigfoot, spits fire and sprays auto parts as it goes.[18] At game's end the arena floor is an ocean of equal-sized metal filings.

The sound of metal slamming together is intoxicating. H. P. Lovecraft wrote that literary style ended with the advent of the machine. Luigi Russolo, the Italian futurist, claimed that music, or its modern version, noise, started with the invention of the machine. In his 1913 manifesto "The Art of Noise," he states that before machines the world was mostly silent, its boring calm interrupted only occasionally by tumultuous natural events such as tornadoes, hurricanes, and avalanches.[19] The band stepping up now is heir to this master's teachings and has transcended the quietness of the bubbling brook and arrived at festive urbanity. These captured *bruit* musicians turn out to be not Bronxian but German.[20] Far from being displeased, the inner landscape assumes the picturesque view of crumbling castles along the Rhine. The band's name, in translation from the mother tongue, refers to modern buildings collapsing. This connection with modern apocalyptic imagery doesn't quite jibe with my previous conception of destruction through decay. The original futurists were slightly more in line, in that they believed in blowing up old buildings—museums mostly[21]—and these assisted ruins, like the aforementioned castle garden decorations, still have the soothing feel of natural decomposition about them. Anyway, the Teutons step into a ring of fires burning in old oil drums and begin bashing metals of various types together. We are joined

together in a railroad yard and at each number's climactic chorus a train speeds through the site, adding force to the moment. The bodily scarification patterns of certain primitive Negroes are approximated on the performers by heroin needle tracks in elaborate patterns—skulls are a popular motif. Oh, you bad boys! The young *poètes maudits* are striking a chord in the very soul. This is the perfect musical accompaniment for watching splatter films. What a delightful horror. Feel sorry for the parents whose delicious terror is restricted to Gothic romances and the tepid writings of Mrs. Ann Radcliffe![22] What's an owl? What wind? These natural signifiers of unease from 1930s Hollywood chillers are long since dead, like the movie stars who responded to them.

The sonic meeting of two pieces of junk is sometimes so overwhelming I feel on the verge of fainting. It gets confusing as to whether it is the sound that produces this effect or the image resulting from the chance combination of objects randomly picked out of a pile to be struck together. The vibrations between two objects in relation to each other offers the pleasure of magical thinking—where aesthetics can truly affect life. The proper placement, the proper arrangement can set off unnatural forces, altering reality in a way that is simpler and impossible for willful action to do. Turn back the clock hands and turn back the hands of time to the good-old-days. The way in which H. G. Wells's time machine is pictured in the movie version of the book is embarrassing.[23] A simple-looking contraption—a spindly, Victorian design—it looks so basic that a child could have built it from spare parts in the basement. So boring—tepid as the overused analogy between time and clocks itself.

Let's go down into the chapel of my basement—the shadowed domain of the tinkering genius. Every furnace, water heater, meter, and pipe is the image of Morton Schamberg's *God* (1917).[24] Freed now from dadaistic modernist nihilism, it reassumes its proper numinous place. Who is responsible for this construction and design? Whose aesthetic is this? Like others who have marveled over the wonders of antiquity I incline toward accepting the idea of alien interventions as a possible explanation for its strangeness. Stroll with me now through the factoryscapes celebrated on album covers labeled "industrial."[25] Music from movie soundtracks often tells a story all its own. In this case it tells a horror story. No, architecture itself doesn't frighten anyone—it is its foundation in social architecture that does so. But this, like the ghost of a ghost story, is invisible. After a while its presence is doubted and its actions are attributed to another, more obvious, cause. Still, one pauses to wonder—that which lies on the surface is often not of the same material as that which lies below it.

NOTES

1 The selected fiction, poetry, essays, letters, and miscellaneous writings of the supernaturalist H. P. Lovecraft (1890–1937) are available from Arkham House (Sauk City, Wisconsin) and Necronomicon Press (West Warwick, Rhode Island). On Lovecraft's wearing his father's clothes, see L. Sprague de Camp, *Lovecraft: A Biography* (New York: Ballantine, 1975), p. 32; on his affecting eighteenth-century language, see ibid., p. 5.

2 The "Yellow Peril" refers to racialist perceptions in the U.S. and elsewhere of threatening territorial, labor, or economic expansionism by the peoples of the Far East, especially China, Japan, and Korea. A series of anti-immigration laws were passed in and after 1899 to address this "threat." De Camp notes that "Lovecraft was ethnocentric to the point of mania. In the abstract, he hated all foreigners, immigrants, and ethnics, calling them 'twisted ratlike vermin from the ghetto' and 'rat-faced, beady-eyed oriental mongrels.'" Ibid., p. 6.

3 Directed by Elia Kazan and starring Marlon Brando, *On the Waterfront* (1954) was shot on location at the Hoboken docks in New Jersey.

4 *Blade Runner* (1982), the cult futuristic *film noir* directed by Ridley Scott, is an adaptation of Philip K. Dick's novel *Do Androids Dream of Electric Sheep?* (1968), set in the dystopic industrial wastelands of Los Angeles in 2019.

5 "Nothing can convince me that this foul putrefaction of the ass is other than the hard and blinding flash of new gems." Salvador Dalí, "The Stinking Ass," trans. J. Bronowski, *This Quarter* 5, no. 1 (September 1932); reprinted in Lucy Lippard, ed., *Surrealists on Art* (Englewood Cliffs, N.J.: Prentice-Hall, 1970), p. 99. This image clearly fascinated Kelley: he refers to it in "Playing with Dead Things" (1993), his essay on the uncanny (in this volume), while an extended citation from "l'Ane pourri" makes up the headtext to his essay on Paul Thek, "Death and Transfiguration" (also in this volume).

6 Kelley is referring here to the film *Koyaanisqatsi* (dir. Godfrey Reggio, 1983), with music by Philip Glass. Taking its title from the Hopi word meaning "life out of balance," this film, the first of the Qatsi trilogy, offers an apocalyptic vision of the natural and urban worlds in collision.

7 The allusions here are to the origins of hip hop and graffiti culture in the South Bronx, and to representations of its interface with the East Village art scene such as Charlie Ahearn's film *Wild Style* (1982), with music by Grandmaster Flash, Busy Bee, and co-star Fab 5 Freddy.

8 Kelley consulted M. J. MacInnes, *Nature to Advantage Dress'd, Being a Study of the Sister Arts of Painting, Poetry & Gardening as Practis'd in Diverse Countries of Europe during the Years 1700 to 1800 with Remarks on Architecture* . . . (Minneapolis: Ross and Haines, 1960), which reproduces James Wyatt's Fonthill Abbey (1796–1807; figs. 92–94); Sir Horace Walpole's Strawberry Hill in Twickenham (1750–1776; figs. 86–87); as well as artificial Gothic ruins or "follies" (e.g., fig. 95).

9 Charles Sheeler (1883–1965), the American painter and photographer of machines and industrial subjects, was associated with the precisionist movement.

10 Johnny "Guitar" Watson (1935–1996) was a virtuoso blues, jazz, funk, and R&B guitarist. Kelley's reference is to his 1984 album *Strike on Computers*.

11 The most recent English edition of *À rebours* (Paris: Charpentier, 1884) by Joris-Karl Huysmans (1848–1907) is *Against Nature,* trans. Margaret Maulden (Oxford: Oxford University Press, 1998).

12 Perfume contests are referred to in Murasaki Shikibu, *The Tale of Genji,* trans. Edward G. Seidensticker (New York: Alfred A. Knopf, 1983).

13 Part of the animation team for Disney's *Sleeping Beauty* (1959), Ron Cobb published his first political black-and-white cartoon in *Los Angeles Free Press* in 1963 and subsequently published cartoons in the alternative and underground press worldwide. He also contributed designs for movies including *Star Wars* (1977) and *Alien* (1979).

14 As part of the WPA (Works Progress Administration, founded in May 1935), the Federal Writers' Project (1935–39), directed by Henry G. Alsberg, produced the American Guide Series, comprising guides for all the states (then forty-eight) as well as principal cities. On the WPA murals, see Richard D. McKinzie, *The New Deal for Artists* (Princeton, N.J.: Princeton University Press, 1973).

15 The Mexican painter Diego Rivera was commissioned in 1932 by Edsel Ford to paint a series of murals in the Garden Court of the Detroit Institute of Arts on the theme of America's industrial might. See Linda Bank Downs, *Diego Rivera: The Detroit Industry Murals* (New York: Norton, 2000).

16 Moving away from his earlier land- and body-based art, Dennis Oppenheim (b. 1938) made a series of machine pieces from 1979 until the late 1980s, exhibiting, for example, in *Modern Machines* at the Whitney Museum of American Art at Philip Morris, in New York in 1985. For Kelley, Oppenheim's idea of the machine as a kind of surrogate consciousness, or a mechanical object with humanlike proclivities, was antithetical to the raw, anarchic machine autonomy with its threat of violence and destruction suggested by the performances of Survival Research Laboratories. Oppenheim described the effect of his "Fireworks" series (mechanical configurations using electric motors and fireworks, begun around 1980), for example, as something akin to a "cerebral map"; see S. Boettger, "Interview with Dennis Oppenheim," July 12, 1995, Smithsonian Archives of American Art (at http://artarchives.si.edu/oralhist/oppenh95.htm).

17 Founded in 1978, Survival Research Laboratories (Matthew Heckert, Mark Pauline, Eric Werner, and other collaborators) staged machine-oriented spectacles which earned them a cult following. See *Survival Research Laboratories* (Berlin: Vogelsang, 1988); and Kelley's "Mekanïk Destructïw Kommandöh: Survival Research Laboratories and Popular Spectacle," in this volume.

18 The Bigfoot Monster Truck team, whose designer, Bob Chandler, has developed numerous Bigfoot incarnations, celebrated its twenty-fifth anniversary in 2000. The Monster Truck Racing Association (MTRA) was founded in 1987, with Chandler as president.

19 The manifestos on music and noise by Luigi Russolo (1885–1947) are collected in *The Art of Noises,* trans. with an introduction by Barclay Brown (New York: Pendragon Press [Monographs in Musicology, no. 6], 1986).

20 The band is Einstürzende Neubauten (which roughly translates as "collapsing new buildings"), formed in 1980 around Blixa Bargeld, N. U. Unruh, and F. M. Einheit. Their first album was *Collapse* (1981); later productions include *½ Mensch* (1985) and *Haus der Luge* (1989), as well as music for several works of

experimental theater and radio-theater. Einstürzende Neubauten's music is largely improvised, using "instruments" found on construction sites (drills, hammers, saws, steel plates, etc.).

21 Item no. 10 in Filippo Tommaso Marinetti's "The Founding and Manifesto of Futurism" (first published in *Le Figaro* [Paris], February 20, 1909), in *Marinetti: Selected Writings,* ed. R. W. Flint (New York: Farrar, Straus and Giroux, 1972), states: "We will destroy all museums, libraries, academies of every kind" (p. 42).

22 Writing in domestic seclusion, Mrs. Ann Radcliffe (Ward) (1764–1823) was one of the pioneers of Gothic literature, her stories including *The Castles of Athlin and Dunbayne* (1789); *A Sicilian Romance: A Highland Story* (1790); *The Romance of the Forest* (1792); *The Mysteries of Udolpho: A Romance* (1794); and *The Italian: or, The Confessional of the Black Penitents* (1797).

23 H. G Wells's short novel *The Time Machine* was published in 1898; George Pal's film version was released in 1960.

24 Assisted by Elsa von Freytag-Loringhoven, the American dadaist, Morton Livingston Schamberg (1881–1918) made *God* (1917 or 1918, in the Philadelphia Museum of Art) just before his death in 1918, from a carpenter's miter box and cast-iron plumbing trap. Some commentators attribute *God* to Freytag-Loringhoven.

25 See *Industrial Culture Handbook, RE/search* (San Francisco) issue 6/7 (1983). The romanticized industrial landscapes used for Pere Ubu album covers, including *Dub Housing* (1978) and *Datapanik in the Year Zero* (1978), were photographed by Mik Mellen.

EMPATHY, ALIENATION, THE IVAR

JCW *This unpublished, undated short piece was probably written in 1985, following a visit by Kelley to the Ivar Theater. Located at 1605 Ivar Street in Hollywood, California, the Ivar was a traditional theater until the early 1960s, when it began to be used as a concert venue. It functioned as a strip joint in the 1980s and early 1990s, then housed the Los Angeles Inner City Cultural Center in the mid-1990s, before being abandoned—and resuscitated once more in 2000. One prompt for this reflection on the formal structure of strip-dancing was Kelley's interest at the time in the model-ramp, particularly in the kinds of relation it brokered between performers and audience. Kelley used such a ramp in his performance* Plato's Cave, Rothko's Chapel, Lincoln's Profile *(with the band Sonic Youth, at Artists Space in New York, December 1986), where it acted as the stage for an intermezzo of manic dance and other disruptive actions, breaking the rhythm of the poetic/dramatic dialogues of this complex piece.*

––––––––––––––––––

The structure of the performances at the Ivar is strictly regimented, but at the same time, extremely sloppy. The constant interplay of performative facade followed by the breakdown of the pose is truly Brechtian. A number of dancers strip in rotation on a curtained proscenium stage. A dancer

makes her entrance, walks out onto a stripping ramp that extends into the middle of the audience area, and dances to three songs of her own choice. With each song progressively more clothing is removed until, by the final song, she is completely naked (except for fetishistic adornments like shoes, belt, or necklace). Most of the men in the audience sit in the seats adjoining the ramp so they can lay dollar bills on it for the dancers they particularly admire. At the end of their sets the women pick up the money left for them and leave by way of the stage, the same way they came in. All the women follow this format; the structure is constant.

Yet there is an incredible amount of variation within the limits of these rules. Some dancers enter the stage with the front curtain completely open, while others choose to have the curtain opened partially, like a doorway entering onto the stripping ramp. Some exit the stage between songs to remove items of clothing out of the sight of the audience, while others perform this operation on the ramp, incorporating the act of stripping as a segue from one song into the next. In all cases, though, clothes come off in regulated steps organized in relation to the songs. The rules governing the flow of action are so obvious that whenever there are glitches it is embarrassingly evident. One stripper, for example, who chooses to leave the stage to remove her clothing after each song, takes far too long to return. The choreographic flow of the strip is interrupted; when she gets back, it's as if she is starting all over again from scratch.

Technical problems are constant—amazing, considering the simplicity of the performance structure—and so numerous they seem to be a purposeful part of the show, as if the director (if there is such a person) has consciously employed modernist theatrical techniques to alienate the audience. The jobs of opening and closing the curtain, calling out the names of the dancers, and timing the playing of the music cassettes are handled by one man, located above and in the rear of the theater—in the position occupied by the projection booth in a movie house. His voice crackles an introduction out of a loudspeaker, the music starts, and the dancers enter. There are constant false starts, clumsy stops, wrong name-calls, music that starts in the middle or comes on blaringly loud— or inaudible—and much dead time where nothing much happens at all. Once more, the sheer number of mistakes is almost inconceivable given the simplicity of the format, which is repeated over and over again in what amounts to a never-ending "rehearsal." The women do not even attempt to conceal these problems. If the music is too loud or too soft, they simply stop in the middle of their act and yell up to the technician to fix it, sometimes making comments to the audience about his

ineptitude. One woman does actually leave the ramp, to start over again from the beginning after the wrong music is played.

The dancers' routines are technically flawed as well, causing the viewer to become uncomfortably aware of the nature of their construction. The dances are rather "theatrical" and the women adopt various personas—some sluttish, some girlish, some tough, some show-biz professional—but all share a defining pose of ecstatic sexual absorption. The men are intoxicated by this "leading role," and drawn into it as if in a dream. The experience is similar to watching a traditional play in which one becomes entranced by the believability of a character. And, as in acting, craft plays a role in delivering this credibility: clumsy transitions threaten the believability of the pose.

The world of fantasy does not allow for the intrusion of worldly problems. Consider the final act of removing the G-string to expose the genitals. Of course, this is the climax of the dance, what everybody has been waiting for, and there is much anticipation—and worry attendant to it. The action must be performed correctly or the whole lead-in structure of the rest of the dance will have been for nothing. The removal of the G-string can be a recipe for disaster. It gets caught on the shoes, it snags up, comes off unsymmetrically, or gets dragged up and down the ramp like a piece of toilet tissue unbeknownst to the dancer. All eyes are fixed on this tiny garment, and if it doesn't come off smoothly and is not disposed of correctly it suddenly becomes the center of attention, overshadowing even the genitals it is designed to spotlight. The dance is a failure. (It is probably in response to such potential problems that some of the women choose to leave the stage to remove their garments—a gesture that in the end reveals the dancer as lazy or technically unsophisticated.) One mark of the event's "quality" resides in the ability of the dancer to perform this action gracefully, or to blend any mishaps skillfully into the routine. One dancer does this quite well. Appearing in a blatantly antifeminine punk persona, she makes no attempt to be sexy and thrashes about to heavy metal music. Her appeal lies in her confrontational wildness. When it comes time to take off her underwear she pauses for a second, then pulls them down dramatically, adopting the ludicrous attitude of a prim little girl, knees held together as if caught in the act. The contrast of this infantile pose to her previously belligerent persona reads as a searing slap in the face to the girlishly coy stance adopted by most of the other strippers. But she doesn't stop there. She makes an extended display out of the removal of her panties, clumsily plopping down on her butt to pull them unceremoniously off, and then getting them tangled-up in her high heels. For a minute she

lies there in this embarrassing position, feet held in the air tied together in the tangled G-string to milk every pitiful drop from the tableau. The mistake is turned into an asset and revealed as a critical part of her act.

All the strippers strive for a unique image—an economic necessity since their entire pay for the evening derives from the tips laid down on the stripping ramp. Their rewards are a direct result of the impression they make on the viewers. The women are in competition with each other to extract money from what is clearly a limited resource. Women who are less attractive must make up for it by being better dancers, more exotic, more alluring in some sense than the others. The range of types is actually quite varied. Today's group consists of a Lolita-ish young woman, looking barely old enough to be in high school, who does much feline stretching upon the floor and who has subtly decorated her blonde pubes with glitter; a fleshy young woman who adopts a "natural" attitude, doing no floor work, leg spreading, or other typical stripper moves, who dances with her eyes closed, lost in interior reverie while mouthing the words to her songs—most radically, she dances barefoot (every single other dancer has worn high heels); an "exotic," older woman, perhaps Latin, whose show-stopping finale is to lie on her back and wink her vagina; a jazz-oriented dancer very good at sinuous leg undulations, who performs a very funny confrontational sight gag: she rhythmically slaps the inner thighs of her spread legs while, as if playing with a baby, she looks a man in the eyes, shakes her head back and forth ("no") and then, finally, up and down ("yes"); a hefty woman who lolls on the floor fingering herself and running a pearl necklace between her vaginal lips all the while making kissing and sucking sounds; and, finally, the heavy metal chick whose iconoclasm takes her beyond the boundary of the ramp into the adjacent seats, where she musses balding hairdos, while staring defiantly into the men's faces making a spectacle of her disdain. Like all the others, of course, she must carefully weigh her actions and decide how far to go, because, like every other stripper, she is still there to collect the money tossed up on the ramp. Alienation can only go so far.

The separation between audience and dancer at the ramp's edge is the most important feature of the event. It functions in a manner quite unlike traditional theater, where the invisible "fourth wall" acts as a portal into a separate reality. No such suspension of disbelief ever truly occurs at the Ivar. The situation at the Ivar is closer to avant-garde stage practice, where the gap between audience and fictional reality is accentuated to promote shifts in the viewer's mode of

attention. The male viewers at the Ivar are torn; they quickly vacillate between being absorbed in their erotic fantasies and being made aware of their actual, restrained situation. In a film or theatrical play, the viewer watches the action as a voyeur, getting lost in fantasy, and thus losing his or her sense of physical presence in the theater. At the Ivar, the sense of physical presence of the viewer must be maintained, otherwise the men will not pay to see more. Also, the evocation of fantasy in the men at a strip club is potentially too volatile to allow for full suspension of disbelief. The men at the Ivar literally have their noses pressed right up against the dividing line between "fiction" and "reality." The actresses play out the men's fantasies just inches away from their grasp. They come right up to the men, tempting them: they beckon them to touch them, look them right in the eye, and dare them. They shove their genitals right in their faces. More than anything these men want to break through the "fourth wall" and merge with their fantasies. But they dare not. If a hand starts to move toward a dancer she warns, "don't touch"; if this command is ignored, burly bouncers are poised to roughly escort it out of the theater.

Pity the poor avant-garde dramatist who has to compete with the Ivar, who aspires to "distance" an audience from the unrealities of theatrical stage action it doesn't even care much about—that it is already distanced from anyway. The avant-gardist would give anything for an audience as strongly connected to its fantasies as the men at the Ivar.

Again, it is obviously a necessity to keep the men at the Ivar from getting too caught up in their fantasies. They must be reminded continuously of the restrictions placed upon them, made aware that they are under constant scrutiny. In addition to the ominous presence of the bouncers, one means by which they are periodically jarred back into reality is the very looseness of the theatrical structure and the performative "mistakes" described earlier. The "acting" styles of the women who veer in and out of their personas, betraying their relationship to their characters, perform the same function. The *coup de grâce* occurs at the end of the strip when the dancer stoops to pick up her money. As soon as the music stops, the facade ends. She immediately ceases pretending to be interested in the men, makes a sarcastic show of thanks—if she offers one at all—then grabs the money and runs.

The performers leave the theater through a side door located within the auditorium itself, so that the audience sees the previous dancers exit, in their street clothes, as new dancers enter the stage. The off-stage dancers and bouncers talk openly throughout the performances about

scheduling and other matters in the foyer of the theater, making no attempt to conceal such functional issues from the patrons. It all seems like a planned conspiracy to keep the men mindful of their unempowered position within this theatrical world. And yet, the house recipe has to include enough imaginative freedom, enough "facade," enough dreamtime so that the experience isn't completely alienating. The men have to derive some measure of pleasure. But the situation at the Ivar is *so* alienating, one is left to wonder what this pleasure could possibly consist of.

The behavior of the audience at a strip house reveals a strange double bind at the interface of intense fantasy and overt restriction. Unlike the fictional, cinematic depiction of male audiences at strip houses as boisterous, cheery, and rowdy, the opposite is actually the case. Séances are livelier. There is no show of emotion, no hooping, hollering, or wild applause. In small private interactions when a woman is confronting a man one-on-one, you might see some lip-licking or kiss-blowing performed by the man, but these gestures are restrained, secretive—like bids at a high-end auction. As if drugged in a dentist's chair, the men sit frozen and immobile, lost in interior thought. Their stiffness of demeanor reveals the intense concentration, their incredible will to block out all that is going on around them, all that is trying to impose on and destroy their fantasies. Like obstinate children that have been denied what they wish, they withdraw into a stubborn, rocklike trance, clinging to their individual mental images. No one is allowed to come close, the boundary line of fantasy must not be crossed—the seats on either side of each audience member are empty. The only action allowed is the most symbolic—the action that allows a momentary trespass into the stage area; the laying down of the dollar bill on the ramp next to the dancer. It's as if a symbolic penis has broken through the line of demarcation, the barrier between, into the world of desire. That's all you're going to get at the Ivar.

FOUL PERFECTION: THOUGHTS ON CARICATURE

JCW *Commissioned by and first published in* Artforum *(vol. 27, January 1989, pp. 92–99), this essay was written partly in response to what Kelley called the "new mannerism" of the late 1980s—a term that embraces the recycling of reductive high modernist tropes in the more attenuated forms of "commodity art," neo-geo, and the like, as well as new styles of art-making that sexualized modernist imagery of the "natural," especially biomorphic abstraction. He aimed to offer desublimated readings of the work of some of his contemporaries by probing the assumptions of modernist discourse around the counterclassical themes of the grotesque body, low culture, and irony, and to question modernism's negatively coded assumptions about these kinds of reference. The text that follows combines some of the editorial changes made by David Frankel at* Artforum *with modifications, including the provision of new endnotes, made by Kelley and myself for the present volume.*

The term "caricature" calls to mind the shoddy street-corner portrait, comic depictions of celebrities that line the walls of bars, or the crude political cartoons in the opinion section of the daily newspaper—"philistine" images, which provoke indifference or disgust in the "educated" art-

lover. In part, perhaps, because of these strong negative connotations, numerous artists have attempted to draw caricature into the sphere of fine art. We encounter new evocations of caricature in the hot "let's-have-fun" populism of funk and East Village art and in the moralizing "let's-get-serious" populism of agitprop, as well as in the cooler arena of pop and the post-Rauschenberg formalism of painters such as David Salle. In most of these efforts at incorporation, the line between low art and high art remains firm: caricature is an alien element, tamed, digested, and transformed from its lowly status to a "higher" one through the magic intervention of "art." At present, the cooler aesthetic dominates—and is more critically sanctioned. Much contemporary artwork is made and interpreted with reference to the issues—and history—of reductivist practice, especially minimalism. But the low-art/high-art distinction has become cloudy in some of this work, for the incorporation of caricature is no longer the leading strategy as the work actually *becomes* caricature. The historical referencing of reductivist paradigms here is only a legitimizing facade, concealing what is, in effect, a secret caricature—an image of low intent masquerading in heroic garb.

The genre of caricature we know today—a portrait that deliberately transforms the features of its victims so as to exaggerate and thus expose their faults and weaknesses—is of relatively recent origin. Unknown before the sixteenth century, its development is usually attributed to the Italian baroque painters Ludovico and Annibale Carracci. According to its earliest definitions, caricature—from *caricare:* to load, as in a "loaded portrait"—was associated, primarily, with an "aggressive" gesture. Yet, at the same time, a writer in the circle of Gianlorenzo Bernini claimed that "caricature seeks to discover a likeness through abbreviation."[1] By such means, he suggested, it comes nearer to "truth" than does reality.[2] As the Carracci themselves realized from the beginning, caricature is at root based on the idea of an essence or inner truth. With this aim in mind, caricature has a kind of "good" twin in less discordant attempts to essentialize the human form. As Ernst Kris suggests:

"Art" to the age of the Carracci and of Poussin no longer meant a simple "imitation of nature." The artist's aim was said to be to penetrate into the innermost essence of reality, to the "Platonic idea" (Panofsky, 1924) . . . inspiration, the gift of vision that enabled [the artist] to see the active principle at work behind the surface of appearance. Expressed in these terms the portrait

painter's task was to reveal the character, the essence of the man in an heroic sense; that of the caricaturist provided the natural counterpart—to reveal the true man behind the mask of pretense and to show up his "essential" littleness and ugliness.[3]

As Kris points out, although they may appear on the surface to be very different, caricature, which uses deformation in the service of ridicule, and the idealized, heroic, classicist portrait, are founded in similar essentialist assumptions. Albert Boime underlines this idea in a discussion of Jacques-Louis David's neoclassical paintings and monstrous political cartoons—on which he worked side by side.[4] The duality of distortion apparent here—making things better, on the one hand, and making them worse on the other—announces, I think, a primary dichotomy in modernist art. For the "distortions" of modernist art seem to be realized, predominantly, in one of two modes: expressive abstraction or reduction.

My own undergraduate art education was organized around an endless succession of assignments that aimed to perfect these binary methods of producing art objects. Two examples will suffice: one was a life-drawing exercise in which, once comfortable with the depiction of a figure, the hand was allowed to roam on its own, producing an extension of the figure linked by "essence" to the original model but dissimilar enough to have a life of its own. The second had to do with drawing from reproductions of old master paintings, but reducing them down to their primary forms, the essential cubes, spheres, and cones that constitute them, or, more essential yet, the squares, circles, and triangles.

This latter effort was clearly a contemporary sort of Platonism, though where once the painter built up from ideal forms, we moderns were expected to reduce back down to them. As for the first exercise, it was obviously related to the intentional distortions of caricature. Yet it was idealized, stripped of caricature's aggressive tendencies. The exercise posited modernist expressionism as an essentialism that dispensed with the negative. This was appropriate, since "fine art," art associated with the "high" ideas of culture, is, traditionally, seldom confrontational or vituperative. Despite the contributions of artists like George Grosz or John Heartfield, much modernist art was ostentatiously "high." This was as true of expressionists like Willem de Kooning as it was of reductivists like Piet Mondrian. In general, the difference for which the expressionist artist strove was situated around the split not between the "bad" and the "good" but between the orderly and the expressive. This

polarity, however, was seldom able to function outside of a whole set of intertwined dichotomies: organic/geometric, adorned/unadorned, soft/hard, personal/social, female/male. Modernism may have imagined itself "above" caricature, but it progressed unavoidably into what it was trying to avoid: bad vs. good, and the aesthetics of morality.

It seems appropriate here to bring up the old distinction between caricature and the grotesque. At first the word "grotesque" was used to describe the kind of fantastic, intricately patterned decorations—pastiches of satyrs, cupids, fruit, foliage, festoons, knots, bows—that came into use after the discovery (in the fifteenth century) of such earlier inventions in the ruins of ancient Rome.[5] Vasari describes the pleasure taken by Renaissance artists and their patrons in these newly unearthed models, and Michelangelo began his career as a painter of them.[6] Part of the appeal of the grotesque was the notion that it was a product of pagan painters who were at liberty to invent whatever they pleased—it represented artistic freedom. Implicit in this notion was an equation of paganism with hedonism, and it is interesting to note that the blame for pornography as well as for the grotesque has been attributed to pagan culture. In *The Secret Museum: Pornography in Modern Culture,* Walter Kendrick traces the roots of modern pornography back to the discovery of the erotic murals in Pompeii.[7] Deemed suitable for both public and holy places, and clearly much admired in Roman times, grotesque ornament eventually fell from grace. With the rise of Vitruvian notions of architecture, the motifs of the grotesque, which Vasari had described as "divine," "beautiful and imaginative fantasies," were equated with the irrational, the irregular, the licentious, and the immoral. To the Vitruvians, the noblest art was a classically based "mathematical and pure abstraction which reflected the perfect harmony of God's universe."[8] They soon discovered that although the ornaments of Nero's Golden House[9] were products of classical culture, they came from its "decadent" phase—they were manifestations of Rome in decline. Soon, the word "grotesque" became associated with the foul and ugly. By the nineteenth century it was closely linked to caricature, so that an image that employed distortion might be described almost interchangeably by either term. Thus the fantasticness of grotesque decoration took on an overtly negative connotation.

By the early 1900s, decoration and ornament were viewed as the antitheses of good practice by the "form follows function" school of architecture and the reductivist design sensibilities of modernist groups like De Stijl. At issue were not just principles of utilitarianism but moral

fundamentals. A strain of high modernist extremism pronounced that decoration was "primitive," uncivilized, even repugnant. Writing in 1898, the architect Adolf Loos put it this way:

The less civilized a people is, the more prodigal it will be with ornament and decoration. The Red Indian covers every object, every boat, every oar, every arrow over and over with ornament. To regard decoration as an advantage is tantamount to remaining on the level of a Red Indian. But the Red Indian within us must be overcome. The Red Indian says: That woman is beautiful because she wears golden rings in her nose and in her ears. The civilized person says: this woman is beautiful because she has no rings in her nose and in her ears. To seek beauty only in form and not to make it depend on ornament, that is the aim towards which the whole of mankind is tending.[10]

Gombrich also quotes from Loos's later essay, "Ornament and Crime" (1908):

The Papuans slaughter their enemies and eat them. They are not criminals. If, however, a man of this century slaughters and eats someone he is a criminal or a degenerate. The Papuans tattoo their skin, their boats, their oars, in short everything within reach. They are not criminals. But the man of this century who tattoos himself is a criminal or a degenerate. . . . The urge to ornament one's face and everything within reach is the very origin of visual arts. It is the babbling of painting. All art is erotic.

Loos's evolutionist association of ornament—and eroticism—with tribal beliefs that are still residual in modern times recalls some of the evolutionist arguments and assumptions of Sigmund Freud. In "The 'Uncanny'" (1919), Freud attributes feelings of terror produced by ordinary, familiar things to a repressed belief in the "omnipotence of thoughts," a belief once held by our ancestors that we carry in us as a kind of racial memory:

The uncanny [is] associated with the omnipotence of thoughts, with the prompt fulfillment of wishes, with secret injurious powers and with the return of the dead. . . . We—or our primitive forefathers—once believed that these possibilities were realities and were convinced that they

actually happened. Nowadays . . . we have surmounted these modes of thought; but we do not feel quite sure of our new beliefs, and the old ones still exist within us ready to seize upon any confirmation. As soon as something actually happens in our lives which seems to confirm the old, discarded beliefs we get a feeling of the uncanny; it is as though we were making a judgment something like this: "So, after all, it is true that one can kill a person by the mere wish!"[11]

For Freud, our "primitive" history accounts for both occasional feelings of uncanniness and our enjoyment of modes of entertainment that evoke these sensations in a controlled way. For Loos, our ancestral background is "criminal." His world conception precludes the experience of pleasure in images of sublimation, which he sees as mirror reflections of what is being sublimated, and thus as tokens or embodiments of the continuance of such feelings in the present. For Loos, the preservation of "criminal, erotic" ornament only serves to maintain criminality and eroticism in the world. Its erasure, on the other hand, would, he felt, help engender a chaste and orderly society. Loos himself is prone to a kind of "primitive" thinking—to a belief in the magic of the image, in the notion that "like" effects "like," that the image is in essence the same as what it shows. Hence the intensity of his iconoclasm—for the belief in the equality of image and imaged is the hallmark of the censor. As Kris suggests, "Wherever it is not considered a joke but rather a dangerous practice to distort a man's features, even on paper, caricature as an art cannot develop." Contrary to Loos, the action of the grotesque caricature is in some sense internal, an idea more than an event. Kris continues:

The caricaturist's secret lies in the use he makes of controlled regression. Just as his scribbling style and his blending of shapes evokes childhood pleasures, so the use of magic beliefs in the potency of his transformations constitutes a regression from rationality. . . . For this to happen the pictorial representation had to be removed from the sphere where the image stimulates action. . . . The hostile action is confined to an alteration of the person's "likeness" . . . only this interpretation contains criticism. Aggression has remained in the aesthetic sphere and thus we react not with hostility but with laughter.[12]

The world Loos envisioned, of course, has not and could not come about. For its emergence would demand the excision of that signal part of the human persona that expresses itself in

the ornament against which Loos contended, or in the grotesque and in caricature. Discussing David's political cartoons, Boime notes that caricature's use of deformation relates specifically to a Freudian model of the unconscious:

The Oedipal complex constitutes the beginnings of the forms of political and social authority, the regulation and control through the superego or conscience. On the other hand, the political caricature permits the displaced manifestation of the repressed aggressive desire to oust the father. The political enemy, or the subject of distortion, becomes the projection of the hated parent and through caricature can be struck down.[13]

Alluding to Freudian theory, Boime adds that

Children bestow upon the anal product the status of their own original creation, which they now deploy to gain pleasure in play, to attain the affection of another (feces as gift), to assert personal ownership (feces as property), or to act out hostility against another (feces as weapon). Thus some of the most crucial areas of social behaviour (play, gift, property, weapon) develop in the anal phase and retain their connection with it into adulthood. . . . By exposing the disguised (sublimated) anality behind neoclassicism (rational state, organized religion, hierarchal authority), David reaffirmed the connection between political caricature and his "high art."[14]

Scatological imagery abounds in caricature and other forms of satire. From Greek comedies through the writings of François Rabelais (1483?–1443) and Jonathan Swift (1667–1745) to contemporary forms of low humor, anal and fecal imagery are frequently used in a political context. (Sandor Ferenczi goes so far as to claim that diarrhea is anti-authoritarian—in that it reduces "educational measures"—toilet training—"to an absurdity." It is a mockery of authority.)[15] If feces can be an agent of besmirchment, so can any foul substance associated with taboo, and thus with repression. The use of bodily fluids, entrails, garbage, and animals such as frogs, toads, and snakes to "decorate" an authority figure is a literal enactment of Loos's conception of "criminal" ornamentation.

An aside. The current television game show called *Double Dare* features on-the-verge-of-adolescent boy/girl teams in "sports" activities that often require them to cover each other in gooey

foodstuffs.[16] At certain points they must fish into suspicious, tactile substances labeled "brain juice," "mashed maggots," "fish lips," "dead worms," and so on, in order to win prizes. Part of the show's attraction to kids that age surely arises from their fear of their dawning sexuality, which is associated with taboo, or "disgusting," activities and substances. Bruno Bettelheim's discussion of the frog prince fairy tale is relevant here: a young girl must sleep with or kiss a frog, and feels revulsion at having to do so; but when the task is completed, the frog becomes a desirable prince. The story, Bettelheim remarks, "confirms the appropriateness of disgust when one is not ready for sex, and prepares for its desirability when the time is ripe."[17] The format of *Double Dare* was modified as *Family Double Dare* in 1988, with the additions of moms and pops, whose submersion in gunk obviously has a different meaning: the pure pleasure of defiling an authority figure.

In low comedy and political cartoons, reductive and distortional practices exist side by side. Here, both approaches are set up to attack false or hated authority, for in the context of caricature's distortions, the refined heroic figure becomes a comic butt. In "fine art," on the other hand, reduction tends to be associated with the revelation of the ideal. Today, probably the most common type of public sculpture is made with geometric forms and volumes. And fine artists tend to keep distortion and reduction apart: predicated on assault and distortion, David's political cartoons, for example, were meant for the popular audience, while his salon paintings were based on idealizing classical principles. Both reduction and distortion are rarely used aggressively in fine art. In one of his pair of etchings, *Dream and Lie of Franco* (1937), Picasso depicts the dictator as an entrail-like being who at one point gives birth to a litter of frogs and snakes.[18] But the mimicry of popular political forms here is atypical. More commonly, Picasso moves toward essentialist reduction. In works such as *Wounded Bull, Horse and Nude Woman* and *The Bull-Fight* (both 1934) from the 1930s (his most "bodily" period), he subjects some of his most potentially violent images—the swooning woman, the well-hung bull, the eviscerated horse—to a process of reduction and crystallization.

But as we can see by comparing Picasso's stylization of organic forms to the treatment of a similar theme in J. G. Ballard's science fiction novel *The Crystal World* (1966), reduction can signify more than ennoblement. If Picasso's reductions tend to accentuate the tragic, intensely emotional nature of his subjects, Ballard's are deadening and ultimately apocalyptic. In *The Crystal World* (1966), *The Drought* (1965), *The Drowned World* (1962), and other fictions, Ballard

approaches the theme of the end of the world not as a cataclysm but as a slow process of homogenization. Time stops when things have been reduced to one essential property—crystal, earth, water. The positive aspects of this transformation—a version of the mystical notion that "all is one"—are here equated with a kind of addiction: in *The Crystal World,* characters previously crystallized but now revived seek to return to their pleasant, former state of nonidentity. The impulse brings to mind Roger Caillois's definition of mimicry in nature as *"depersonalization by assimilation to space"* [19] and, ultimately, Freud's concept of the death instinct—the desire to annihilate the ego reflecting a desire to return to the uterine existence before the ego's formation.

The death instinct is embedded in a good deal of the art production of the 1960s and 1970s, especially minimalism and serial practices concerned with the objectification or freezing of time through repetition. Though the surface meaning of much of this art has to do with structure and material, such works ultimately refer back to and mirror the bodily presence of the viewer. The basis of Michael Fried's attack on minimalism,[20] this thesis was borne out in later body art, which applied reductivist tendencies to complex psychological and corporeal issues. If minimalism was well mannered, this work was viewed as confrontational—even grotesque. Bruce Nauman's films of repeated body movements and manipulations (e.g. *Pulling Mouth,* 1969; *Face Up,* 1973), Vito Acconci's evocation of architectural libido in *Seedbed* (1971), Chris Burden's packaging of the fear of violence as sculpture in *Shoot* (1971)—were all posed across the modernist moral schism between form and decoration: they proposed an aesthetic of sculpting with flesh. The very practices that Loos had attacked as "criminal" were in body art perversely redefined as essential gestures—marking the body, piercing it, distorting it. Yet all this was done in a removed, formal way. The difference between the distortion of the body in much body art and in expressionist performance and painting can in some ways be compared to one distinction between the grotesque and caricature: in caricature, distortion serves a specific purpose, in most cases to defame, while in the grotesque it is done for its own sake, as a formalized displacement of parts. Its only purpose is to surprise the viewer.

From this formalist point of view, the whole low-art pictorial tradition of the monster can be viewed as an expression of the pleasure of shuffling the components of a form. (Psychologically, however, there is a great difference between shuffling squares on a paper, or flowers in a vase, and reordering the human figure.) The grotesque displacement of the order of the body is a mainstay of popular art. Cartoons and horror films provide numerous examples of it, and in many of these the move toward abstraction is consciously erotic. The ambiguous humanity of these distorted images

creates a tension between attraction and repulsion. As it is disordered, the whole comes to take on the image of its parts, and the parts that most often come to the foreground are the genitals. The monstrous figure truly becomes an erotic ornament. The dichotomy of soft and hard becomes dominant, and animated and still cartoons are filled with jokes about various parts of the body replacing genital capacity for flaccidity or erection. The best examples are in the work of Tex Avery, Basil Wolverton, and the 1960s car-culture monster artists Ed "Big Daddy" Roth and Mouse.[21] Although these artists treat the whole body as erectile, the eyes and tongue are the most common genital substitutes: Avery's animated films of the 1940s are nonstop visual jokes. *Little Rural Riding Hood* (1949), for instance, features a wolf in extreme states of sexual arousal manifested by his eyes blowing out of their sockets or his tongue rolling out of his mouth onto the floor. The forte of Wolverton's work from the 1940s through the 1970s is the monstrous depiction of disordered, exaggerated faces, often accompanied by ludicrous explanations as to how they got that way. Once again, huge, distended eyes often play a major role. And the 1960s images of Roth and Mouse link these same characteristics to the images of the "outlaw" biker and the car fanatic. Their work pairs the grotesque with the dirty, the criminal, and the hedonistic. The caption of a Rat Fink drawing in the *Ed "Big Daddy" Roth Monster Coloring Book* reads, "What is Colored 'Rotten' to the Core, 'Garbage' and 'Gore,' 'Poison' in Every Pore, and 'Warped' Forevermore?. . . . Yours Truly, R.F.!"[22] Surprisingly, though, the usual order is reversed in these drawings; the association of the grotesque with the disgusting is positive here— these monstrous figures are meant to be role models.

Popular horror, crime, and pornographic film and literature all explicitly address the disordered sexual body. In his dystopian science fiction novel *Dr. Adder* (1984), K. W. Jeter, for example, inverts Loos's utopian evolutionary development: instead of moving away from the sculpting of the body, the society of the future makes it a mainstay. In the world Jeter describes, plastic surgery has reached such a point of refinement that bodily, and especially genital, transformation can be based directly on repressed sexual trauma; a one-to-one relationship can be created between one's unconscious and one's physical shape. The book's descriptions of genitals reworked into "baroque, pathetic convolutions of the vulva, other parts shining wet like fleshy sea plants"[23] obviously reflect preadolescent misunderstandings of the sexual body, and playfully elaborate on the connection between the ornamental and the erotic. Again, most of David Cronenberg's films are concerned with an "uncanny" depiction of the sexual body in which the parts that constitute us become frightening and unfamiliar. In *Dead Ringers* (1988), for example, we follow the

DR. SPOCKTOR PROCTOR, SURGEON, HAS REARRANGED HIS HEAD TO SUIT HIMSELF. HE HAS HUNG HIS EYES OUT HIS NOSTRILS SO THAT HE CAN SEE BETTER THAN OVER HIS NOSE, AND HAS ALSO ROUTED A BRANCH OF WINDPIPE OUT AN EAR IN CASE HIS EYEBALLS RETRACT AND PLUG HIS NOSTRILS. AN OPENING ABOVE HIS ADAM'S APPLE MAKES IT POSSIBLE TO EJECT FOOD HE WANTS ONLY TO TASTE BUT NOT REACH HIS STOMACH. BESIDES, THESE CHANGES IMPROVE HIS LOOKS.

Basil Wolverton, *Untitled* (1973). Comic originally printed in Wolverton's *GJDRKZLXCBWQ Comics: A Gallery of Gooney Gags.* Courtesy Glenn Bray.

development of two identical male twins from their youthful ignorance of the specifics of sexual difference to their adult careers as gynecologists and then to their double death in a black parody of sexual union and psychotic gynecological surgery.

Because it is supposedly a picture of "real" life, perhaps most disturbing is the genre of the "true crime" story. Behind the fixation in this literature on the mutilation murder is the attraction/repulsion of viewing the abstracted body. The description of the crime scene in *Killing for Company* (1985), Brian Masters's account of the career of mass murderer Dennis Nilsen, is almost loving in its detail, clinically informing us how the killer broke a body down to pack it into a series of shopping bags, carefully dissecting it until he came to the innards, which were "all mixed together in a disgusting, impersonal pottage."[24] Nilsen also made drawings of his victims, sometimes in stages of dissection, which are literally "still lifes" (*natures mortes*)—a genre quite different from the harmless aestheticization of caricature proposed by Kris. The murderer has countered the frightening complexity of the body with a counter-urge to package it, to break it down into controllable lumps, to find its essence (of course, unsuccessfully).

Recent horror films, called "splatter films" because of their copious blood and gore, continue the depiction of the body as grotesque.[25] As in the original Roman decorations, the body becomes an accumulation of pieces at odds with each other—a group of parts that refuse to become whole. While the horror film has always been concerned with the uncanny presence of the body, its recent incarnations stress the body's composite nature with increasing intensity. The monster in James Whale's *Frankenstein* (1931) may be made up of components from many sources, but it is ruled by a mechanistic notion of wholeness. Like a modernist collage, although it is fractured, composed of multiple scavenged pieces, it still operates as a totality. The erectile intestine that blows out of the torso of a walking corpse to strangle its victim in the horror film *Re-Animator* (1985), on the other hand, reflects the fetishization of the body part. Here the body is not total but corporate—a linked compilation of separate entities. Both *Re-Animator* and John Carpenter's *The Thing* (1982) feature pastiche creatures that when cut apart simply keep on existing as part-beings. What could be more horrific to an essentialist like Loos than this depiction of the world as an accumulation of animated ornaments stripped from their primary forms?

Interestingly, pornography is organized in much the same way: it tends to be body-part specific. Pornographic photographs and films often use close-ups, encapsulating the erotic entirety in the fragment, as if sex were a puppet show acted out by detached members. The whole terrain of pornographic magazines is organized according to body part or substance: there are male or female genital magazines, ass magazines, breast magazines, feet magazines, cum magazines, etc. While a cartoonist like Roth pictures the genitals obliquely, as distortions of other corporeal parts, pornography shows them literally. At the same time, pornographic parts are cut out and isolated, and thus no less metaphoric: they become objectified stand-ins and irreal substitutes for themselves. In this way they gain the distance of the fetish.[26] Repressed into abstraction, they rise pleasurably back into consciousness in their new form.

In contemporary "high" art, the work most obviously related to the grotesque image of the reordered body seems, on the surface, to be an extension of organic abstraction, as in the paintings of Bill Komoski, Lari Pittman, and Caroll Dunham. My earlier discussion of the split between hard and soft is important here. Clearly, the modernist opposition of adorned to unadorned is an extension of old ideas attributing the characteristics of gender to design motifs. The association of spareness with masculinity and ornateness with femininity has a long history. A sixteenth-century drawing, for example, substitutes male and female statues, respectively, for Doric (simple) and Corinthian (fancy) architectural columns, illustrating the Vitruvian notion of the humanization of the orders.[27] And in contemporary parlance, "hard" and "soft" are often associated with gender orientations—hard and soft rock, for example.[28] Continuing this division into the moral sphere, it is obvious that Loos's notion of ornamental "criminality" is coded feminine. Many modern artworks underline the equation of the soft and the decorative with the feminine as a negative, distortional device—a tactic of caricature. Consider Salvador Dalí's softening of the perspectival solidity of objects in the melting forms of his canvases; Claes Oldenburg's softening of consumer products and household objects in his malleable sculpture; and the softened forms in Peter Saul's versions of political representations and fine-art masterpieces. All bear witness to male artists using supposedly feminine softness to attack and destabilize rigid partriarchal order. At the same time, the appropriation of hard or geometric formats by artists such as Sherrie Levine reveals a female cooption of male order. What we confront here is a kind of artistic gender-bending. For Komoski, Pittman, and Dunham, the key referents are the essentialist picturing of the blob as an icon of nature and the expressiveness of gestural painting. Yet neither of these rings true: all the signs

Carroll Dunham, *Green* (1985–86). Mixed media on walnut. 66 x 42 ins. Courtesy Metro Pictures, New York.

of meaning turn in on themselves. The references to nature are obviously rooted in popular sources, and the "eroticism" of the decoration is a self-conscious construct, formalized to the point where it actually becomes unerotic. Nature, eros, the horrific, and the body are filtered through the codes of essentialism. This is what gives the work its double edge, and what allows it to escape the bonds of modernism's simplistic dualism.

Another contemporary camp is based around an extension of geometric reductivism, historically the more "masculine," "heroic" kind of abstraction. Here cruelty is more apparent. Perhaps softness calls for restraint. In any case, recent dialogues with the minimalist paradigm also relate to the tradition of caricature. Reductive, "essentially" heroic primal forms lend themselves easily to the role of authority figure. Thus it is only right that we should want to defame them. Aimee Rankin (now Aimee Morgana), Debby Davis, and Liz Larner are female sculptors who all defy the chastity of minimalism to reinscribe the body. On first view, Rankin's exhibitions resemble rows of Don Judd-like wall pieces, but on closer inspection her cubes reveal themselves as Pandora's boxes, filled with scenes of cruelty and eroticism. Davis reveals the cruelty of the primal form itself by using it to shape casts of dead animals—a cube of cast chicken carcasses, say. Larner makes antiseptic geometric receptacles to reveal geometry's destructive "soul": a cube is formed of bomb-making and bronze sculpture casting materials, or a clear glass rectangle holds a petrie dish of bacteria. The work of John Miller and Meyer Vaisman operates similarly, Miller's by overlaying a politics of anality on geometric formalism, Vaisman's by pairing a generic stand-in for painting with references to the taboo, the infantile, and the sexual—rubber nipples, toilet seats, greased holes, and, tellingly, caricatures.

One of the initial attractions of the caricature was the speed with which it could be executed, as if its spontaneity set it closer to the original workings of the mind than a more considered drawing. This aesthetic of haste contributed to the adoration once lavished on Michelangelo's unfinished "slave" carvings, in which the figure, barely freed from the stone, appears to be receding back into the Platonic archetype that gave it birth.[29] In 1981, Charles Ray made a sculpture called *In Memory of Sadat,* a rectangular steel box positioned on the floor from which a human arm and leg extend. These organic marks on the geometric primal form are a distortion. A fouled primal form is a caricature of the very notion of perfection . . . and when we see this, like the children on *Double Dare* when they see their parents and teachers covered in a disgusting mess, we cannot hold back a shout of glee.

Liz Larner, *Used to Do the Job* (1988). Steel, aluminum, coal, copper saltpeter, trinitrotoluene, ammonium nitrate, and other natural and unnatural ingredients suspended in micro-crystalline wax on lead-sheathed base container. 48 x 25 x 24 ins. Courtesy Regen Projects, Los Angeles.

Charles Ray, *In Memory of Sadat* (1981). Artist's body directly incorporated into a steel sculpture.
Courtesy Regen Projects, Los Angeles.

NOTES

1 See Ernst Kris (in collaboration with E. H. Gombrich), "The Principles of Caricature," in Kris, *Psychoanalytic Explorations in Art* (1952; New York: International Universities Press/Schocken Books, 1964), p. 189.

2 Ibid., p. 175.

3 Ibid., p. 190.

4 See Albert Boime, "Jacques-Louis David, Scatalogical Discourse in the French Revolution, and the Art of Caricature," *Arts Magazine* 62, no. 6 (February 1988), pp. 72–81.

5 Frances K. Barasch, introduction to Thomas Wright, *A History of Caricature and Grotesque in Literature and Art* (New York: Frederick Ungar, 1968), p. xxiii.

6 Ibid., p. xxv.

7 Walter Kendrick, *The Secret Museum: Pornography in Modern Culture* (New York: Penguin, 1988).

8 Barasch, *A History of Caricature,* p. xxvii.

9 Ibid., p. xxiii.

10 This and the following passage are cited in E. H. Gombrich, *The Sense of Order* (Oxford: Phaidon Press, 1979), pp. 60–61. The first passage comes from Loos's "Ladies Fashion," first published in *Neue Freie Presse,* August 21, 1898; reprinted in Adolf Loos, *Spoken into the Void: Collected Essays 1897–1900,* trans. Jane O. Norman and John H. Smith (Cambridge, Mass.: MIT Press, 1982). The main ideas in this citation are repeated in "Ornament and Crime" (1908), an English translation of which can be found in *The Architecture of Adolf Loos* (London: Arts Council of Great Britain, 1987), pp. 100–03.

11 Sigmund Freud, "The 'Uncanny,' " in *The Standard Edition of the Complete Psychological Works of Sigmund Freud,* vol. 17, ed. James Strachey (London: Hogarth Press and the Institute of Psycho-Analysis, 1955), pp. 24–48.

12 Kris (with Gombrich), "The Principles of Caricature," pp. 202–23.

13 Boime, "Jacques-Louis David," p. 72.

14 Ibid., pp. 75–76.

15 See Sandor Ferenczi, *Thalassa: A Theory of Genitalia* (first German edition, 1923), trans. Henry Alden Bunker (London: Maresfield/Karnac, 1989), p. 13.

16 Hosted by Marc Summers until 1993, *Double Dare* premiered on Nickelodeon in 1986. Two years later the show was Oedipalied with the addition of a mom and pop into *Family Double Dare,* which aired during prime-time on the Fox network in 1988, moving back to Nickelodeon in 1990. "Meanwhile, the original *Double Dare* changed its name to *Super Sloppy Double Dare,* upping the ante of gross games and messy mayhem." See http://www.yesterdayland.com/popopedia/shows/saturday/sa1714.php.

17 Bruno Bettelheim, *The Uses of Enchantment* (New York: Vintage Books, 1977), p. 290.

18 See Anthony Blunt, *Picasso's Guernica* (Oxford: Oxford University Press, 1969), pp. 9–10, where both etchings are illustrated.

19 Roger Caillois, "Mimicry and Legendary Psychasthenia," trans. John Shepley, *October* 31 (Winter 1984), p. 30.

20 See Michael Fried, "Art and Objecthood," *Artforum* 5, no.10 (Summer 1967), pp. 12–23.

21 During his heyday at Warner Brothers, MGM, and Universal between 1935 and 1955, Tex Avery (1908–1980), a contemporary of Walt Disney, created such classic cartoon characters as Bugs Bunny, Daffy Duck, and Droopy Dog. Basil Wolverton's magazine features, including *Spacehawk* and *Powerhouse Pepper,* appeared in comic books between 1938 and 1954. In 1946 he won a contest promoted by Al Capp's *Li'l Abner* comic strip to image *Lena the Hyena,* Lower Slobbovia's ugliest woman. The judges were Salvador Dalí, Boris Karloff, and Frank Sinatra. (See *Lena's Bambinas* [Seattle: Fantagraphics Books, 1996].) From the mid-1950s he worked regularly for *Mad* and other humor magazines. Ed "Big Daddy" Roth (1932–2001) designed and custom-painted cars and hot-rods from the late 1950s, supporting himself by drawing monsters (the most famous of which is Rat Fink) and selling T-shirts and popular model kits. His work can been found in comic books, art galleries, and tattoo parlors. Stanley "Mouse" Miller, another Kustom Kulture artist, is known for his signature hot-rod creation, Freddy Flypogger, probably a model for Roth's eventually more successful Rat Fink. Moving from Detroit to San Francisco in the 1960s, Mouse was co-founder of Monster Company, which pioneered four-color, screen-printed T-shirts. Work by Roth and Mouse was included alongside that of younger artists in the exhibition *Customized: Art Inspired by Hot Rods, Low Riders and American Car Culture,* organized by the ICA, Boston (Fall 2000).

22 Ed "Big Daddy" Roth, *Monster Coloring Book,* edition 1, vol. 1 (Maywood, Calif.: Ed Roth Studios, 1965), n/p.

23 K. W. Jeter, *Dr. Adder* (New York: Penguin, 1984), p. 28.

24 Brian Masters, *Killing for Company* (New York: Stein & Day, 1985), p. 16.

25 See e.g. John McCarty, *Splatter Movies: Breaking the Last Taboo* (Albany, N.Y.: FantaCo, 1981) for a general overview of the genre; and Robert S. Parigi, "Reading the Entrails: Splatter Cinema and the Post Modern Body," *Art Criticism* (State University of New York, Stony Brook) 4, no. 2 (1988), pp. 1–18.

26 See Steven Prince, "The Pornographic Image and the Practice of Film Theory," *Cinema Journal* 27, no. 2 (Winter 1988), pp. 34–35; compare chapter 4, "Fetishism and Hard Core," of Linda Williams, *Hard Core: Power, Pleasure and the "Frenzy" of the Visible* (Berkeley: University of California Press, 1989), pp. 93–119.

27 Fig. 209 in Gombrich, *The Sense of Order,* p. 176, reproduces "Doric and Corinthian Orders" (1563) by John Shute.

28 On "soft" and "hard," see Robert Morris, "Anti-Form," *Artforum* 6 (April 1968), pp. 33–35; reprinted in *Continuous Project Altered Daily: The Writings of Robert Morris* (Cambridge, Mass.: MIT Press, 1993); and Donald Kuspit, "Material as Sculptural Metaphor," in Howard Singerman, ed., *Individuals: A Selected History of Contemporary Art 1945–1986* (Los Angeles/New York: Museum of Contemporary Art/Abbeville, 1986), pp. 106–125.

29 Kris (with Gombrich), "The Principles of Caricature," p. 198.

HOLLYWOOD FILMIC LANGUAGE, STUTTERED: *CALTIKI THE IMMORTAL MONSTER* AND *ROSE HOBART*

JCW *This text was originally written as an informal introduction to Kelley's contribution to a course on film called "The Seven Deadly Sins" taught by the seven core graduate MFA faculty at Art Center College of Design, Pasadena, in 1992. Each faculty member selected and introduced two film screenings during the fourteen-week semester. The choices Kelley presents here reflect his desire to focus on movies outside the canon of "art films," as well as his effort to figure out exactly what it was that he liked about these pieces. As he notes below, Kelley had heard and read about* Rose Hobart *(1939) but had never seen Joseph Cornell's film before the Art Center screening. Unsure whether it had a soundtrack (it did), he brought along a stack of period music. As he reported later, his first viewing of the film confirmed most of his preconceptions—though the print he ordered didn't have the expected blue tint, so Kelley projected it through a filter. A version of this piece appears in* More & Less, *ed. Sylvère Lotringer (Pasadena, Calif.: Art Center College of Design, 2001), pp. 125–131.*

Ideally, the film theorist should be someone who both likes and dislikes the cinema. Someone who once loved film but who has stopped loving it in order to approach it from another angle, making cinema the object of the same visual instinct that had once made him a fan. Someone who has broken off his affair with movies as people sometimes break off love affairs, not to take on a new lover but to dwell upon the old one from a more elevated position. Someone who has incorporated the cinema into his own psyche, so that it is susceptible to self-analysis, but incorporated it as a distinct organism rather than as an affliction of the ego, an infection that paralyzes the rest of the self in a thousand tender and undemanding ways. Someone who has not forgotten what being a fan was like, with all its emotional vicissitudes and palpable immediacy, and yet who is no longer overwhelmed by those memories. Someone who has not allowed his past to give him the slip but who keeps it under close watch. To be and not to be: ultimately, in order to speak, one must both be and not be involved.

Christian Metz, Le Signifiant imaginaire [1]

I feel the kind of separation from film that Metz describes. However, I am a critic only by default, because my removal arose not out of a conscious decision, but was simply a natural fading away from film. These days, I no longer feel great pleasure in watching films. But this was not always the case. When I was a child, and especially in my college years, I was a film buff. I went to films constantly and enjoyed the sensation of becoming engrossed in them. When I go to the theater now, all I can see of the film is a series of edits and framing decisions. I find that I am more interested in watching the audience watch the film or in, say, the collision between the theater architecture and the window of wonder it enframes. And it seems that I am not alone. Since the 1970s I've noticed that audiences increasingly refuse, or are simply unable, to become quietly consumed by films. Instead they talk back to the screen, vocally trying to second-guess the action, or they ignore the film altogether and chatter right through it about some unrelated subject. Perhaps this is because, today, we *are* films. We have become filmic language, and when we look at the screen all we see is ourselves. So what is there to fall into or be consumed by? When looking at something that purports to be you, all you can do is comment on whether you feel it is a good resemblance or not. Is it is a flattering portrait? This is a conscious, clearly ego-directed, activity.

Film still, *Caltiki the Immortal Monster* (dir. Robert Hampton a.k.a. Riccardo Freda, 1959).

I want to discuss two films that predate the onset of my "critical" frame of mind. They are both films that once quite moved me. The first, *Caltiki the Immortal Monster* (1959), awed and disturbed me as a child. One particular scene—where the blob sucks a man in and spits out the skull—has become permanently lodged in my memory. Seeing the film again recently, I was surprised that it still has an effect on me. Surprised, because I have many memories of film experiences from my youth, and they are rarely confirmed when rewatching the films as an adult.

The second film is a short called *Rose Hobart* made by the artist Joseph Cornell.[2] Up until now I have not even seen this film. Yet I always *wanted* to see it. I have always loved both the descriptions and the idea of the piece. I hope my discussion here is somehow confirmed when I finally get to see the film—but if not, I'll cross that bridge when I come to it. Both films have a relationship to Hollywood films, but at the same time *are not* Hollywood. They have an investment in the dominant visual language we share, yet stand outside of it. As Metz suggests, this double address somehow positions them as "critical films."

Made in 1959, *Caltiki the Immortal Monster* is an Italian B horror film directed by Riccardo Freda under the English-sounding pseudonym Robert Hampton. In Italy the horror genre is associated with the Gothic, which is considered an Anglo-Saxon form. When Freda began making horror movies, there was really no history in Italy of this genre, and, though critically admired, Freda's first attempt (titled *The Devil's Commandment* [1957] in English) was a flop. For his second film, *Caltiki,* he and the entire crew adopted American-sounding names. Viewed and reviewed in Italy as an "American" film, it was a commercial success. *Caltiki* is credited with originating the trend of European filmmakers using English-sounding pseudonyms to gain more widespread local acceptance.[3]

As for the film *looking* like an American film—it doesn't. American Gothic horror films, like such Universal Pictures gems from the 1930s as *Frankenstein* (1931) and *Dracula* (1931), were long gone by the 1950s, replaced by sci-fi, "red scare," and nuclear paranoia films—all less "psychological," and with a veneer that was much more *present* and socially concerned—or by films geared toward the new upwardly mobile teen audience. These last include tongue-in-cheek horror films like *The Blob* (1958), a truly "pop" film about the exploits of a group of pretty teenagers in hot rods interacting with a giant piece of bubble gum-like goo. Produced a year later, *Caltiki* could be considered a remake of the highly popular *Blob.* But what a difference! It's hard to believe that the film was actually taken for an American film. The pace is too slow, the mise-en-scène too dismal, and the acting too melodramatic. Superficially, the film is a standard Gothic toss-off. It

has all the traditional elements: primal evil is encountered in a remote, ancient, primitive locale and transported back to our more civilized one where it causes a fuss but is finally mastered.

It replays the symbolically familiar horror film scenario in which repression erupts, only to be happily contained. But in this case, I find I am attracted to all its particulars, despite the tired plot line. I like, for example, the overbearing Freudian imagery. When discussing psychoanalysis, Freud's most common metaphors are archeological ones: going down is going inward.[4] Our hero in *Caltiki* is an archaeologist who journeys down into a cave, then further down into a watery pit of death. To discover what? A formless pulsing shit pile. Formless blob monsters are my favorites—by far. I much prefer them to thinly veiled genital stand-ins. They are sublime in their unparticularity. I like them for the same reason I like another guilty pleasure: biomorphic abstraction. They are dirty pictures that you can make into whatever you want.

The perfect image of a class-conscious monster, Caltiki closely resembles a filthy janitor's rag. Yet he/she/it is imbued with a certain subtle, festive quality, as if coated with a light dusting of glitter. The film as a whole has a dirty, murky, soiled look to it, as if we are peering through a muddy windshield; it seems to have been shot entirely day for night, so every scene is uniformly gloomy. Yet it has a real visual beauty that overpowers its narrative ineptitudes, and it convinces us (by virtue of this very combination) that its flaws are purposeful. It's easy to see how a film like this could lead to later neosurrealist films such as David Lynch's *Eraserhead* (1977), in which programmatic disparities are consciously deployed.

A few of my favorite scenes:

(i) The initial tracking shot of the ruins, so dark they are barely legible, coupled with dramatic voice-over.

(ii) The amazing transition from the painted backdrop of a ruin with a spurting volcano to the jungle camp set.

(iii) The pulsing blob in its Tupperware case (great suburban horror).

(iv) Of course, the main scene is the finale in which the growing blob literally fills the luxurious mansion, oozing down the halls as if they were intestinal canals.

(v) The trek of the madman after he escapes from the hospital. I particularly like when he falls face down into the flower patch. And the scene of him exiting over the hill (oddly enough, one of the brightest spots in the film).

Rose Hobart was the first film made by the homegrown American surrealist Joseph Cornell. Done in 1936, it is one of the few films, if not the only one, he completed himself. Many were finished later, in the 1960s, by younger avant-garde filmmaker friends including Ken Jacobs and Stan Brakhage. Known mostly for his dreamlike box constructions, Cornell was also an avid collector of films and film stills. *Rose Hobart* is a reediting, down to less than twenty minutes, of the exotic Hollywood action feature *East of Borneo* (1931). Cornell removed the soundtrack, replacing it with two alternating Latin American dance tunes from *Holiday in Brazil* (the original screening instructions called for the entire album to be played in darkness before the film began). Also, the film was projected through blue-tinted glass. The title *Rose Hobart* derives from the name of the popular female star of the earlier film, and Cornell's film can be seen as a kind of film portrait, the byproduct of desire. What interests me most in this piece is the idea of editing down, or condensing, and the relationship of this process to desire itself. It could be that Cornell is simply "getting to the good parts," picking out what were on his reckoning the choice pieces of the older movie and throwing the rest away in a gesture that recalls the tactics of the Italian futurists. In his manifesto "The Variety Theater" (1913), Marinetti, for example, called for the condensation of all Shakespeare's plays into a single act, or the presentation of all the "Greek, French, and Italian tragedies, condensed and comically mixed up, in a single one evening."[5] But the futurist celebration of speed, power, athleticism, and worldliness runs completely counter to Cornell's reserve, his pulling back, his denial. For Cornell, what is important is not just a compilation of the desired object, but also a condensation of the mise-en-scène that charges it. The overall blue tone pushes the film further away into the depths of the screen, yet at the same time intensifies it and makes the film materially more present.

All narrative film condenses time, yet part of our acceptance of filmic convention is predicated on our ignoring this fact. We experience film time as real time. Cornell further condenses this condensation into stillness, into an uncanny frozen movement that has the sense of being both dead and alive. When asked about his films, Cornell would rarely say anything specific. Instead, he would tell an anecdote recalling the cover of a film magazine he had once seen, or an empty film set lying unused at night.[6] These were always things related only obliquely to film, though enlivened by conjunction with it, and given movement by association. This quality is present in his box sculptures, where time seems frozen, and dead objects appear to have a life that has just left them.

Film still, Rose Hobart in *East of Borneo* (dir. George Melford, 1931).

It's also a quality shared with the earlier pictorial surrealists and their affiliates—especially Giorgio de Chirico. With Cornell, film becomes a "found object" in the surrealist sense. It is an object encountered by chance, one that is outside of you, yet *is* you. The mysterious attraction that you have for it is an indicator of the hidden part of yourself that resides in it. It is up to you to develop the strategy to mine that secret.

Caltiki and *Rose Hobart,* then, are two films that comment on standard filmic language in interesting ways: one by default, through unfamiliarity or ineptitude, and the other through willful readjustment. To me, the inept film has more latitude. For what we get from Cornell's reediting is more a portrait of Cornell's desire than anything we can share. In *Caltiki,* on the other hand, we are left to go through this process on our own. We make our own edits, mentally. Yet, the film remains a whole, taunting us, asking us to experience it in terms of an "us" rather than as an "I." Its very failure to do that, its uncomfortable double nature, makes it a success.[7]

NOTES

1 Christian Metz, *Le Signifiant imaginaire,* cited as a head text by Serge Guilbaut in *How New York Stole the Idea of Modern Art: Abstract Expressionism, Freedom, and the Cold War,* trans. Arthur Goldhammer (Chicago: University of Chicago Press, 1983), p. 1.

2 For an account of *Rose Hobart* and its context, see Deborah Solomon, *Utopia Parkway: The Life and Work of Joseph Cornell* (New York: Farrar, Straus and Giroux, 1997), pp. 85–89. Working with a found 16-millimeter print of the jungle B-movie *East of Borneo,* Cornell used scissors and tape to cut the 77-minute feature down to around nineteen and a half minutes, excising most of the action sequences and concentrating on shots of the heroine, Rose Hobart. As Solomon notes, the premiere of the film at the Julien Levy Gallery in New York took place in December 1936, shortly after the opening of Alfred H. Barr, Jr.'s, landmark exhibition *Fantastic Art, Dada, Surrealism.* Salvador Dalí, in New York for the exhibition, attended the screening, and created a scene, apparently because Cornell had realized a film as a kind of assisted readymade, a project he later claimed to have been planning himself.

3 These details about *Caltiki* are taken from Carlos Clarens, *An Illustrated History of the Horror Film* (New York: Capricorn Books, 1968), pp. 155–56.

4 Sigmund Freud, "Constructions in Analysis" (1937), cited in Melanie Klein, *The Writings of Melanie Klein,* vol. 3, *Envy and Gratitude and Other Works 1946–1963* (New York: Free Press, 1984), pp. 177–78.

5 Filippo Tommaso Marinetti, "The Variety Theater" (first published in *Lacerba* [Florence] and, in a shorter version, in the *Daily Mail* [London] in 1913), trans. R. W. Flint, in Umbro Apollonio, ed., *Futurist Manifestos* (London: Thames and Hudson, 1973), p. 130.

6 See Annette Michelson, "*Rose Hobart* and *Monsieur Phot:* Early Films from Utopia Parkway," *Artforum* 11 (June 1973), pp. 47–57.

7 [At the end of his lecture, Kelley recommended to his audience several essays for further study.] I suggest two readings, mostly in response to *Caltiki the Immortal Monster,* on the ramifications of resuscitating a forgotten and generally dismissed film, which introduces wider considerations of "cult," "bad," and "camp" film. They are: Jack Smith, "The Perfect Filmic Appositeness of Maria Montez," *Film Culture,* no. 27 (Winter 1962), pp. 28–36; and "Belated Appreciation of V.S.," *Film Culture,* no. 31 (Winter 1963–64), pp. 4–5. Jack Smith was a New York-based avant-garde filmmaker, actor, and playwright. Most famous for his film *Flaming Creatures* (1962), which was banned as pornographic, he is widely acknowledged as one of the major influences in American independent film and theater of the 1960s and 1970s. His influence can be seen in the development of both structural and camp aesthetics, in the work of Richard Foreman, Robert Wilson, the film work of Andy Warhol, and in the development of popular drag queen and glitter aesthetics. [Smith's writings are collected in *Wait for Me at the Bottom of the Pool: The Writings of Jack Smith,* ed. J. Hoberman and Edward Leffingwell (New York: High Risk, 1997)].

[The second reading is] Allison Graham's "Journey to the Center of the Fifties: The Cult of Banality," in J. P. Telotte, ed., *The Cult Film Experience: Beyond All Reason* (Austin: University of Texas Press, 1991). Professor of communications and director of Women's Studies at Memphis State University, Graham concludes that cult films affirm the very social stereotypes that the camp viewer sees them as questioning. I find her reading too simplistic. In many cases cult films are only politicized through camp viewership. Such films are embraced because the camp viewer recognizes something within them at odds with dominant notions of spectatorship and audience. These concerns do not necessarily reflect the intentions of the film's director. Thus, to condemn cult films for being politically regressive strikes me as moot. Despite my disagreement with Graham's analysis of the cult film phenomenon, I find her essay of interest because of the questions it raises about the problematic politics of camp, which are complex because they relate, primarily, to viewership, not authorship.

FILMIC REGRESSION: *THE BABY* AND BABY HUEY

JCW *The second of two pieces Kelley wrote as introductions to film screenings in the MFA program at Art Center College of Design in the early 1990s (see also "Hollywood Filmic Language, Stuttered," above in this volume), "Filmic Regression:* The Baby *and Baby Huey" is a meditation on the regressive experience of film viewing read through two lurid representations of infancy, in Ted Post's* The Baby *(1973) and the character Baby Huey, introduced by Paramount/Famous Studios in 1951. A particularly violent Baby Huey cartoon,* Starting from Hatch *(dir. Seymour Kneitel, 1953), was screened. Ted Post attended the presentation and revealed that the script of* The Baby, *based on real-life events, was so shocking that he decided to shoot the film in a "flat," realistic manner in order to defuse its exploitational qualities. Kelley's discussion of "filmic regression" originally bore the subtitle "Cinema, Mommy's Little Helper," which points to the key suggestion Kelley offers here: that film is a replay of infantile experience. This proposition relates to his career-long, intermedia inquiry into regression, repression, and adolescence, especially visible in his work with stuffed toys and craft materials (which commenced in the later 1980s), and in more recent activity such as the investigation of memory pathologies, including Repressed Memory Syndrome, in projects such as* Educational Complex *(1995). A similar version of the text was published in* More & Less, *ed. Sylvère Lotringer (Pasadena, Calif.: Art Center College of Design, 1999), pp. 125–33.*

Film still, *The Baby* (dir. Ted Post, 1973). Courtesy TV Matters.

First of all, the film experience is one of regression. You couldn't speak of "suspension of disbelief" if this weren't true. For what is being suspended is some notion of a critical egotistical "me" which allows for domination by something perceived of as "outside" the self. Freud's concept of the death instinct, the desire to return to the pleasurable, egoless state of prenatal existence in the womb, is important here.[1] Like many religious temples that refer to the body of the "great" Mother, the dark theater where we experience cinema could be considered a womb substitute. But the film event is a shared experience, involving something more complex than a simple autistic abandonment of the ego. Witnessed, even if dimly, by others around us, our experience, we could say, is a socialized, superego-dominated form of regression predicated on an outside object.

Melanie Klein argues that "object relations" exist from the beginning of life. The first, or "primary," object, she argues, is the mother's breast, and other object relations develop from an initial relationship to this object.[2] Psychoanalytic film theory offers many correlations between the

breast and the film screen, of which the scale of the screen to the viewer is, perhaps, the most obvious. In his book *Film and the Dream Screen,* Robert T. Eberwein suggests several further analogies, ranging from the relationship between opticality and orality in the infant (sucking motions signal the advent of REM sleep), to a discussion of Julia Kristeva's contention that the breast, being a focal point, becomes a "there," an initiation into space.[3] Even at this point it is not an "outside" space but—to borrow D. W. Winnicott's term—a "potential space":[4] a space the infant cannot separate from itself. In this scenario the breast is an illusion, something the baby creates out of itself for its own needs. How like the film experience, where we see the film action as some necessary projection of ourselves.

Developing her discussion of the breast as primary object, Klein explains how the breast, once experienced as an other, becomes split into a good (gratifying) breast and bad (frustrating) breast. She argues that this consciousness of the breast as other arises from envy of the breast's ability to give, which is proven by its capacity to withhold. The infant then projects this envy, or desire to take in and control the breast, onto the breast itself—which becomes a devouring, controlling, critical breast.[5] This notion of the critical breast could also be applied to the film experience. A film that "gives," that absorbs and gratifies us, is a "good" one. A film that denies or frustrates us, leaves us self-conscious, and refuses to absorb us, is a "bad" one.

Looked at in this way, it is easy to see how someone like Adorno could interpret mass culture as negatively regressive in that it "infantalizes" the audience. He writes, "The tone adopted by every film is that of the witch handing food to the child she wants to enchant or devour, while mumbling horribly: 'lovely, lovely soup. How you're going to enjoy it,'" and he concludes that "the culture industry not so much adapts to the reactions of its customers as it counterfeits them."[6] Here Adorno adopts the role of "adult" critic—one who refuses to be absorbed. This is also the role of avant-garde cinema and the "art film," where disruption techniques and alienation devices are applied to standard filmic language to expose its seductive and devouring nature.

What interests me, in particular, is how a certain theme can have the same disconcerting effect as deconstructive film techniques, even when this theme is packaged according to the most normalizing Hollywood conventions. Infantilism, it seems to me, is one such theme. Ted Post's *The Baby* (1973) is a profoundly disturbing, I would even say radical, film largely because it does not allow viewers to immerse themselves in it in any simple sense. On the surface, infantilism might be the *perfect* subject for a Hollywood film—as understood by Adorno, at least—precisely because

of the apparent parity between subject and effect: regression delivers regression. But things don't always work like this, especially in *The Baby.* Perhaps there's a kind of double negative at work here, where regression plus regression equals self-consciousness. But the main reason I think *The Baby* is so disturbing is because it is a drama. Highly problematic subjects are generally dealt with in genres that have license to be more "unrealistic." In both horror and comedy films, for example, there is more distance and removal. Infantilism has been a fairly common theme in Hollywood recently, as evidenced by a number of role-reversal comedies, such as *Big* (dir. Penny Marshall, 1988). The problems that *The Baby* posed are revealed very clearly in how the film was packaged and publicized. The print ads portray the film as either horror or soft-core porn, neither of which is really accurate. The film is shot in a very unexpressive, "realist" style, and there is nothing in it that points overtly to its *filmic* nature. No embellishments such as fancy color, elaborate camera movement, or disruptive cinematography break through its uniform facade. In fact, the film reminds me quite a bit of a television docudrama—hardly surprising, since Ted Post has been one of television's longest-working directors.[7] In the end the repressive, almost puritanical, style directs our full attention to the film's story line.

But this absorption does not come easily, however, because the film is decidedly amoral. When dramas tackle controversial subjects, they generally do so by taking on the role of a doctor. They seem to issue an implicit, but terse, command: "This is strong medicine, but it must be swallowed for your own good." It's instructive to consider *The Baby* in light of the recent popular fixation on issues of child abuse. The theaters and airwaves are flooded with dramas (such as *Bump in the Night,* dir. Karen Arthur, 1991) dealing with abuse and incest, which almost uniformly adopt the strictest of tones. In order properly to excuse the audience's morbid fascination with such themes, a clear moral message must be given, a lesson has to be learned. By contrast, *The Baby* comes off as almost surrealist. It seems to proclaim: "Desire above all." And, we are left to wonder, whose desire, what desire?

The dynamics of viewer and character identification in *The Baby* are very complex. At one level, the film could be seen as a simple Oedipal fantasy in which a person (male) is allowed to stay an infant in what would normally be a completely nurturing (female) universe. But, as it turns out, gender roles are not so clear in this film. The mothers are *bad* mothers, and, following from this, in a sense become "fathers." Baby *is* saved, but how is he saved? He is rescued not to be gently ushered into adulthood—as we are at first led to believe—but to remain a baby and to *be mothered*

well. He is literally allowed no voice, a truth chillingly depicted in a scene where he is tortured with a cattle prod for uttering a single word. The figure that seems to signal baby's entry into the adult world of speech has her own agenda, and her own desire. Everything else is just facade: her choice of profession says it all—she is a social "worker."

The baby of *The Baby* is a perennial baby. As the hero of the film, he becomes our role model prompting an identification, of course, which is too painful to maintain. We are forced, rather, into the position of the bad mother. Either way, it's a no-win situation: the regression at stake here is not back to an idealized childhood or to some sexy never-never land of female bounty, and there are no heroes to emulate and no morals to be learned. The only escape route is into black humor.

Baby Huey is a classic example of sublimated regression, which is not only filtered through the form of comedy but in this case through animation as well.[8] Made at a time when cartoons were still designed for a general audience, adults as well as children, Baby Huey cartoons were made for theatrical release. Famous Studios, which produced Baby Huey as well as Casper the Friendly Ghost and Little Audrey, is credited with being the first studio to gear their cartoons specifically to very young children.[9] Today, when cartoons are relegated to Saturday morning television, this is one thing. But back in the 1950s, it was quite another situation, as the entire adult portion of a movie-going audience was forced to sit through these infantile productions. Combined with their production-line mode of creation (if a visual gag provoked laughter in three test screenings, it was put in every cartoon from then on)[10]—this is one reason historians of animation generally despise these cartoons. They signal the end of serious animation and the rise of kid vid.

Even for the child audience, Baby Huey is a baby, posed in a lower strata and clearly more inept than the young viewers themselves. For the child there must be a perverse pleasure in seeing the normal family hierarchy reversed. By virtue of its size and strength, the baby lords over the pipsqueak adults. The cartoons are funny because, despite Baby Huey's ineptitude, the adults are even more inept. Baby Huey is an uncontrollable force undaunted by the world's problems. However, for the adult viewer forced to sit through them, these cartoons are something else. It is hard to find anything pleasurable in them. Baby Huey's innocent triumph over mean friends, inattentive parents, and a pedophile fox can only be enjoyed by regression to a childhood that consists only of pain. While the child viewer might see these cartoons as a playful transcendence, the adult can experience them only as a painful reversion. Baby Huey cartoons might be entertainment to the child, but they become art to the adult forced to sit through them. Otherwise they are unendurable.

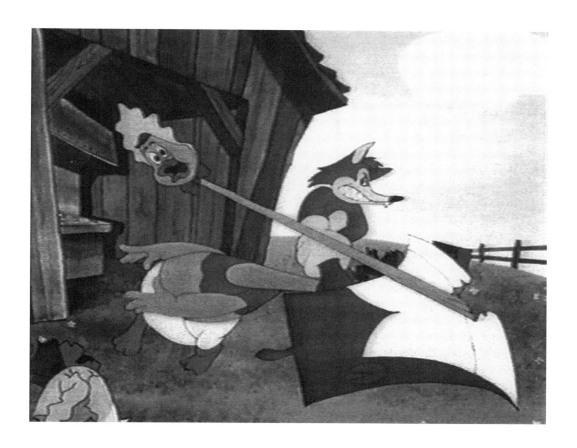

Film still, Baby Huey in *Starting from Hatch* (dir. Seymour Kneitel, 1953). Courtesy Harvey Entertainment.

NOTES

1 Sigmund Freud first outlined an extended theory of the death instinct in *Beyond the Pleasure Principle* (1920), trans. and ed. James Strachey (London: Hogarth Press, 1974), modifying and developing his ideas in *Civiliza-tion and Its Discontents* (1930), trans. Joan Rivière, revised and newly edited by James Strachey (London: Hogarth Press, 1963).

2 Melanie Klein, "Notes on Some Schizoid Mechanisms" (1946), in *The Writings of Melanie Klein,* vol. 3, *Envy and Gratitude and Other Works 1946–1963* (New York: Free Press, 1984), p. 2.

3 Robert T. Eberwein, *Film and the Dream Screen: A Sleep and a Forgetting* (Princeton, N.J.: Princeton University Press, 1984), p. 32.

4 D. W. Winnicott, cited in Eberwein, *Film and the Dream Screen,* p. 33.

5 Klein, "Envy and Gratitude," in *Envy and Gratitude,* p. 202.

6 Theodor Adorno, *Minima Moralia: Reflections from a Damaged Life* (1931), trans. E. F. N. Jephcott (London: Verso, 1974), p. 200.

7 In addition to director credit for films such as *The Peacemaker* (1963), *Magnum Force* (1973), and *Good Guys Wear Black* (1978), Ted Post (b. 1918) also directed episodes for TV series, including *Perry Mason* (1957), *The Twilight Zone* (1959), and *Peyton Place* (1964).

8 Baby Huey made his first appearance in animated form in the Paramount/Famous Studios production *One Quack Mind* in 1951. The Harvey publishing company bought the rights to all of the Famous characters and their old cartoons from Paramount Studios in 1957 and retitled them "Harveytoons." The characters were featured in both animated and comic book forms. See Charles Solomon, *Enchanted Drawings: The History of Animation* (New York: Wings Books, 1989), pp. 177–78. See also Leonard Maltin, *Of Mice and Magic: A History of American Animated Cartoons* (New York: New American Library, 1980); chapter 11, pp. 305–16, traces the history of Paramount/Famous Studios.

9 Solomon, *Enchanted Drawings,* p. 178.

10 Ibid., p. 177.

FROM THE SUBLIME TO THE UNCANNY: MIKE KELLEY IN CONVERSATION WITH THOMAS MCEVILLEY

JCW *This conversation on the relation between the sublime and the uncanny took place in the New York apartment of the art historian and critic Thomas McEvilley in December 1992. It was printed, in a slightly different form, in the catalogue for the exhibition* Sonsbeek 93 *(ed. Jan Brand, Catelijne de Muynck, and Valerie Smith [Arnhem, The Netherlands: Sonsbeek, 1993]) accompanied by letters from Kelley to curator Valerie Smith describing his plans for an exhibition within her exhibition on the theme of the uncanny. Ernst Jentsch's essay "On the Psychology of the Uncanny," referred to by McEvilley, was discussed by Freud and is cited by Kelley in "Playing with Dead Things: On the Uncanny" (his catalogue text for the exhibition he curated,* The Uncanny, *following in this volume); it is translated by Forbes Morlock in* Angelaki 2, no. 1 (1996). *Notes on some of the artists (John de Andrea, Duane Hanson) and issues discussed or alluded to here accompany "Playing with Dead Things."*

Thomas McEvilley *Sonsbeek* is usually an exhibition of site-specific work, yet you're not involved in that, are you?

Mike Kelley What I like about art is that it embraces falseness and allows for nonspecificity. So an art whose very definition is specificity is uninteresting to me. I prefer ambiguity. I won't say "art is false"—since art always engages reality, if you think about it in psychic terms. But I want to distance myself from the belief that art is about truth; and I've never liked public art anyway, because it forces an aesthetic onto people. I prefer people to engage with something because they choose to.

TM So you will use the museum?

MK Yes. The artwork I've proposed is to curate an exhibition for the museum.

TM Is it a museum intervention, in which an artist creates a show out of a museum's collection, usually turning the museum against itself in some way, having certain parts of the collection criticize others, and so on?

MK I'm just going to use the museum's exhibition space to show works borrowed from elsewhere.

TM What will determine the works that you will gather?

MK I'm after a certain feeling. I want to put together works that produce an effect like Freud describes as "the uncanny." All the works will be figurative.

TM Such as?

MK I want to include artworks ranging from verist sculptures like Duane Hanson's, to Han dynasty tomb sculptures, as well as non-artworks—things like mannequins and, hopefully, a mummy.

TM Your point in doing this is not, I gather, to survey different approaches to representing humanity.

MK Right. I'm proposing that art basically addresses death, it's about re-presentation, using doubling as a defense against the fear of death. And death strikes me as an important issue relative to postmodernism.

TM Yes, in its being supposedly art after the end of art, art after its own death.

MK Right, and also, the return of figuration seems to me to evoke the tradition of the artwork as a *memento mori*. Some works in the show will be documentary photos accompanied by appropriate quotations—passages from Freud, a section from the biography of Ed Gein describing his relationship to corpses, for example.[1]

TM I think I see where you're tending. In his essay "The Uncanny," Freud refers to an earlier essay by Jentsch who, he says, identified the uncanny as involving doubts "whether an apparently animate being is really alive or conversely whether a lifeless object might not be in fact animate."[2] Jentsch referred to the impression made by waxwork figures, artificial dolls, and automatons. Would that be the modality of the uncanny you're focusing on?

MK Yes. I think the currently embarrassing aspects of primitive or religious artworks—their supposed magical qualities, confusions about whether they're alive or dead, and so on—are still at play somehow in modernist works, though modernism tried hard to repress that.

TM In the expression theory of art, for instance, the idea that the artwork is expressing something fetishizes it by implying it has intentions and desires.

MK Freud states that these feelings are biological. They still operate even though one invents sublimatory rationales to deny that fact.

TM So the figures you choose will convey this feeling of uncanny uncertainty about the interface between life and death?

MK Right. And the effect is compounded by the fact that, until recently, academic art was forbidden, taboo, in the realm of fine art practice. So not only is there this strange feeling produced by the question of realistic art being alive or not alive, there's also the strange attraction/repulsion to something that's forbidden. Figurative art itself is like a corpse or mummy, and one wants to resuscitate this forbidden thing, bring it back to life. Because it's bad, one wants to make it good again—breathe life into it.

TM The project seems to introduce into sculpture some of the postmodern tendencies that appeared in painting about ten years ago but haven't been so prominent in sculpture yet. I mean the postmodernist subversion of the modernist idea of history by using formal concepts that are out of date or that reverse the flow of history, and the perverse iconicity of so-called "bad" art, as in the *"Bad" Painting* show of 1978.[3]

MK Of course, a kitsch sensibility is observable in an artist like Jeff Koons, for example.

TM Sure, but by and large sculpture hasn't confronted either the idea of the "bad" or postmodern archaizing as much as painting has.

MK I would agree. But the uncanny is not specifically a modern or postmodern phenomenon; it's a psychological experience.

TM So are you going to avoid specific emphasis on these postmodern traits of your project?

MK I'm hoping to avoid having the show understood as an exercise in kitsch. My work has often been described as glorifying kitsch—which I've always denied. The kitsch-loving sensibility usually implies the superiority of the viewer, who is in control and knows better than to show a real investment in something that is commonly held in contempt. In effect, kitsch can only

be embraced ironically. Now, the uncanny denies this: you are affected by these images beyond your control. Whether one feels superior to these objects or not is a moot point, because one is affected by them on an unconscious level.

TM Your focus on uncanny figuration is right in line with your remark that the fundamental subject of art is death, isn't it?

MK Death forces one to confront materiality. I want to focus on the material nature of art production, which I don't think painting can. This is why I have such a big disagreement with Greenbergian ideas about painting, because painting can never be truly material.

TM Because it represents, even if it only represents a void.

MK Yes.

TM Still, I think painting is sometimes purely material, though in a sense it become "sculptural" in this condition.

MK I would agree with that.

TM A painted canvas can be used as a sculpture.

MK It reminds me of Leo Steinberg's idea of the "flatbed" painting.[4] If Pollock had left his paintings on the floor, they would have been sculpture, but he didn't, he put them up on the wall. He made space out of them.

TM Yes, Greenbergian materiality always had a hidden spirituality in it. But then, in early works of minimal sculpture—say, [Carl Andre's] bricks on the floor—you got a frank confrontation with the material nature of it all.

MK There was a shift in the twentieth century in the meaning of materialism, away from realist depiction to an emphasis on matter itself. So in minimalism one is confronted with the base materials that make up daily life, like the base materials of the architecture one lives in presented in an unformed state. And what happens is, one becomes strangely body-conscious in this situation. The focus of the art experience shifts from experiencing an object to experiencing oneself in relation to the object, environmentally.

TM I see what you mean.

MK This self-conscious state is, I think, very close to the uncanny. One becomes aware that one is not, normally, self-aware.

TM Right at the beginning of his essay Freud says, "The uncanny belongs to all that is terrible, to all that arouses dread and creeping horror,"[5] which reminds us, quite directly, of the traditional eighteenth-century writings on the sublime.

MK That's right. It's very much like Edmund Burke.

TM And like Kant, who may have adopted many of Burke's views of the sublime, but extended them in an interesting way. For Burke the sublime was anything that is so vast and "other" that it seems by its very existence to threaten the annihilation of the observing subject. One is witnessing a thing whose inner meaning is one's own annihilation.

MK I think minimalism is sublime in that regard.

TM But Kant made an interesting shift by saying that any experience is sublime that involves the deliberate subordination of oneself to some force or category supposedly greater than oneself. You had four famous examples that I think were used first by Addison, then by Burke, then by Kant: mountain peaks, storms at sea, Milton's description of Hell, and infinity.[6]

MK I love Burke's compendium of sublime subjects.

TM But aside from that list of awesome, threatening, terrifying, and delightful experiences, Kant proposed that ethical acts are also sublime, because they also involved the denial of oneself in relation to some greater category.

MK Right. But you could say that that goes back to the original discussion of the sublime by . . .

TM Longinus?

MK Yes. His descriptions of the sublime relating to rhetorical concerns in public speech- making.

TM Except for his remark—which lies in the background of sublime paintings such as Turner's later works, or Géricault's *Raft of the Medusa*—that a picture of the sublime might show the entire world being torn apart. It's only a step from that to the abstract expressionist sublime—say Barnett Newman's—the portrayal of the void into which one's selfhood will supposedly dissolve. Which gets us right back to Jentsch's idea of the uncanny as the interface between life and death, or animate and inanimate.

MK Or the loss of self. I think Longinus is an interesting writer to think about propaganda through. Propaganda is sublime in that it causes one to accept ideas, that one wouldn't normally accept, as one's own. It's an interesting entry into discussions of fascism, for example.

TM The sublime does have that tendency, doesn't it? So the idea of the sublime, when extended in that way, goes very far.

MK Very far—into political considerations.

TM For example, the experience of beholding an artwork or literary work which one basically doesn't like, and making an effort to appreciate it by getting into an alien point of view, might be a sublime act on this Kantian model.

MK A loss of self in any way.

TM Any willing loss of self. I mean, the sublime in Burke . . .

MK Oh, but that's unwilling, in Burke it's unwilling.

TM Well, he talks about the delight of the storm at sea and so on, and one can imagine him climbing up to mountain peaks in search of the sublime experience, like they did so commonly a couple of generations later . . .

MK But wouldn't that be a kitsch sublime?

TM But that's how the sublime functions as a cultural presence—through this deliberation. I mean, one gets on a motorcycle and goes a hundred miles an hour at night to deliberately feel the terror and wonder of the sublime.

MK Right. But I don't know if that could really be considered sublime. I mean, that I would willingly take a risk, not to annihilate my ego—but to promote it, to prove my greatness, my strength.

TM Well, again I see what you mean, but I think that at a certain point in experiences like that there is just the sheer, hair-raising terror of the sublime, going beyond any mood of self-congratulation.

MK Well . . .

TM What I'm driving at is that, in terms of embodying it in artistic objects, the sublime has been approached primarily by way of trying to shadow forth the formless in art.

MK Like monochrome painting?

TM Yes. But by focusing on the uncanny rather than the sublime, you've reversed the direction. Rather than approaching the formless beyond, you propose to show that form from which life has just departed, or might be just about to depart, into that hypothetical beyond. So you're showing the small formed reality into which the sublime is ingressing.

MK Like I said, using an artistic form that itself is dead.

TM The resuscitation of the corpse. It's kind of like the sublime as the Golem.

MK Yes. Or Frankenstein.

TM Uh-huh.

MK I was reading some books recently from the early '70s, about the first verist sculptors, like John De Andrea and Hanson. Some really believed that their works were an extension of nineteenth-century realism. That's bullshit. That kind of realism was already impossible because of the irony and formal removal of pop art. I can only see their statues as depicting stock character types. In De Andrea's case, I see false idealism—false Greek sculpture—and in Hanson's case false social realism.

TM I think of Yves Klein as the first verist sculptor, for his body casts.

MK But, I'm avoiding anything connected with body art and the whole "art and life" movement. That gets into theater and questions of identity, which I don't want to get involved with. I want to keep away from any focus on the human person except for its sheer materiality.

TM Along with formlessness, the theme of the sublime in recent art involved a sense of the human individual possessing in a hidden way a potential for vast spiritual greatness. Newman is again the obvious example. But clearly you are approaching it differently.

MK Right. I have a big problem with that reading of the sublime. My reading is more Freudian, involved with notions of sublimation. I see the sublime as coming from the natural limitations of our knowledge; when we are confronted with something that's beyond our limits of acceptability, or that threatens to expose some repressed thing, then we have this feeling of the uncanny. So it's not about getting in touch with something greater than ourselves. It's about getting in touch with something we know and can't accept—something outside the boundaries of what we are willing to accept about ourselves.

TM You're not concerning yourself with what's on the other side of that limitation.

MK The limitation is us. I'm not interested in what's not us. But to keep talking about it in relation to the threat of physical annihilation separates the project too much from aesthetic discourse. And I want that also to be a part of it. It's about one's interaction with an object, not just one's interaction with one's self. The focus is on the object.

TM Still, the object and the self tend to merge in this case, since the sublime, as the uncanny, leads immediately to a contemplation of the death and decay of the body.

MK Well, of course. Why else would one want to make a mummy, or a statue, or any representation at all?

NOTES

1 On Ed Gein, see note 31 to Kelley's essay "Playing with Dead Things: On the Uncanny" (following in this volume).

2 Ernst Jentsch, cited by Sigmund Freud in "The 'Uncanny'" (1919), in *Sigmund Freud: Collected Papers,* vol. 4, trans. and ed. Joan Rivière (New York: Basic Books, 1959), p. 378.

3 *"Bad" Painting,* curated by Marcia Tucker, the New Museum of Contemporary Art, New York, January 14 to February 28, 1978.

4 Borrowing the term from "the flatbed printing press," Leo Steinberg develops his idea of "The Flatbed Picture Plane" in the final section of his essay "Other Criteria," in *Other Criteria: Confrontations with Twentieth-Century Art* (New York: Oxford University Press, 1972), pp. 82–91.

5 Freud, "The 'Uncanny'" (1919), p. 368.

6 The major discussions of the sublime alluded to in the exchange that follows can be found in W. Smith, *Longinus on the Sublime* (1739), introduction by W. B. Johnson (New York: Scholar's Facsimiles & Reprints, 1975); Edmund Burke, *A Philosophical Enquiry into the Origin of Our Ideas of the Sublime and Beautiful* (1757/59), ed. Adam Phillips (Oxford: Oxford University Press, 1990); Immanuel Kant, *Critique of Judgment* (1790), trans. Werner S. Pluhar (New York: Hackett Publishing Co., 1987), and *Groundwork of the Metaphysics of Morals,* translated and analyzed by H. J. Paton (New York: Harper & Row, 1964).

PLAYING WITH DEAD THINGS:
ON THE UNCANNY

MK *The* Uncanny *project grew out of a collaborative work with Paul McCarthy,* Heidi: Midlife Crisis
Trauma Center and Negative Media-Engram Abreaction Release Zone, *made for the* LAX *show at
the Krinzinger Galerie in Vienna (1992). In preparation for that installation/videotape, I began to
collect images of figurative sculptures that had qualities I was interested in duplicating in the
figures included in our project. When Valerie Smith invited me to propose a work for the sculp-
ture exhibition* Sonsbeek 93 *which she was curating in Arnhem, Holland, I suggested an "exhi-
bition within the exhibition" of figurative sculpture, curated by me, based on my collection of
images. The simple exercise of grouping resource materials together on a pin-up board became
the basis for the exhibition of sculpture, objects, and photographs titled* The Uncanny.*

 Traditionally a show of outdoor sculpture,* Sonsbeek 93 *had been updated to include
site-specific works situated throughout the area of Arnhem. I chose a different approach, to uti-
lize the Gemeentemuseum, the art museum of Arnhem. The project was a response to the preva-
lence of postmodern discourse in the art world at that time—specifically, issues of recuperation
of outmoded models of art production. Thus,* The Uncanny *was purposely designed to be an old-
fashioned, "conservative" museum exhibition in contrast to the many artworks in* Sonsbeek 93
that were installed in nontraditional sites. As such, the project was somewhat of a joke on site

specificity as a gesture of "resistance." However, I did not want the exhibition simply to understood as a parody. I took my role as art curator seriously, researching and writing a catalogue text, designing the installation, and laying out and overseeing the production of an exhibition catalogue that was completely separate from the main Sonsbeek 93 catalogue.

The theme of the exhibition centered on Sigmund Freud's essay "The 'Uncanny'" (1919), which I had found stimulating and helpful in relation to the "creepy" qualities of the images I had collected for the Heidi project. The exhibition itself consisted primarily of figurative sculptures, ranging from ancient to contemporary, which had an "uncanny" aura about them, but also included nonart objects that had a similar quality, such as medical models, taxidermy, preserved human parts, dolls, life masks, and film special-effects props. A large collection of historical photographs relative to the subject was also presented. The exhibition was laid out in a traditional manner, except that at the end of the show there was an anomalous gallery containing objects that seemed quite unrelated to the rest of the exhibition. This room contained fourteen separate collections of mine, ranging from my childhood rock collection to a contemporary collection of business cards. These collections were referred to as "harems," a term used to describe a fetishist's accumulation of fetish objects, which are generally like in character. This final "harem room" was meant to question the purpose of the exhibition. What had appeared, on the surface, to be a sensible presentation of objects organized thematically could then be viewed simply as another manifestation of the impulse to collect—an example of Freud's principle of a "repetition-compulsion" in the unconscious mind. It is the recognition, in the conscious mind, of this familiar but repressed compulsion that produces a feeling of the uncanny. I wanted this notion of the uncanny to be considered as well as the more familiar version related to depictions of the body, and the unease they instill in us because of how they make us conscious of our own mortality.

JCW This essay is a slightly modified version of that published in the catalogue for Kelley's exhibition The Uncanny (1993). Kelley placed a bibliography of sources after the essay, which I have incorporated, with additions, into more specific endnotes. A brief section from the essay discussing the "Ackermuseum" was published in Forest J. Ackerman, Daniel Faust, and Mike Kelley, "Monster Manse," Grand Street (New York), no. 49 (1994), pp. 224–33 (see note 17, below). Conceived

in the early 1990s, this piece is the culmination of the artist's long-standing interest in the iconography and social effects of mannequins, dolls, and other figurative forms usually considered marginal to the fine arts tradition. The central concerns of "Playing with Dead Things," and the reading of Freud's signature essay, "The 'Uncanny'" (1919), that it contains, relate Kelley's discussion to a number of similarly predicated writings published around the same time, including Anthony Vidler's The Architectural Uncanny: Essays in the Modern Unhomely *(Cambridge, Mass.: MIT Press, 1992), Hal Foster's* Compulsive Beauty *(Cambridge, Mass.: MIT Press, 1993), and Terry Castle's* The Female Thermometer: Eighteenth-Century Culture and the Invention of the Uncanny *(New York: Oxford University Press, 1995).*

––––––––––––––––––

Fetishes, idols, amulets, funeral images, dolls, waxworks, manikins, puppets, and, most dramatically, automata, all play their part in the vast substratum of figures which historians used to rank far below sculpture as a fine art. Many of these artifacts have a basis rooted, not in any Western concept of beauty, but in some very practical purpose. And only recently have the liberalizing tendencies of modern art and the discoveries of archaeology finally compelled historians to consider the aesthetic merits of these and an increasing range of other anthropomorphic forms. A "history of human images," free of what the art historian Wilenski refers to as "the Greek prejudice," has yet to be written.

Jack Burnham (1968)[1]

Puppets, mannequins, waxworks, automatons, dolls, painted scenery, plaster casts, dummies, secret clockworks, mimesis and illusion: all form a part of the fetishist's magic and artful universe. Lying between life and death, animated and mechanic, hybrid creatures and creatures to which hubris gave birth, they all may be liked to fetishes. And, as fetishes, they give us, for a while, the feeling that a world not ruled by our common laws does exist, a marvelous and uncanny world.

Janine Chasseguet-Smirgel (1984)[2]

It may be true that the uncanny is nothing else than a hidden, familiar thing that has undergone repression and then emerged from it.

Sigmund Freud (1919)[3]

What I'm after is a group of objects that, like the original collection of images I pinned to my wall, share an "uncanny" quality. What this quality is, precisely, and how it functions, are difficult to describe. The uncanny is apprehended as a physical sensation, like the one I have always associated with an "art" experience—especially when we interact with an object or a film. This sensation is tied to the act of remembering. I can still recall, as everyone can, certain strong, uncanny, aesthetic experiences I had as a child. Such past feelings (which recur even now in my recollection of them) seem to have been provoked by disturbing, *unrecallable* memories. They were provoked by a confrontation between "me" and an "it" that was highly charged, so much so that "me" and "it" become confused. The uncanny is a somewhat muted sense of horror: horror tinged with confusion. It produces "goose bumps" and is "spine tingling." It also seems related to déjà vu, the feeling of having experienced something before, the particulars of that previous experience being unrecallable, except as an atmosphere that was "creepy" or "weird." But if it was such a loaded situation, so important, why can the experience not be remembered? These feelings seem related to so-called out-of-body experiences, where you become so bodily aware that you have the sense of watching yourself from outside yourself. All of these feelings are provoked by an object, a dead object that has a life of its own, a life that is somehow dependent on *you,* and is intimately connected in some secret manner to your life.

In his essay "The 'Uncanny'" (1919), Freud writes that the uncanny is associated with the bringing to light of what was hidden and secret, distinguishing the uncanny from the simply fearful by defining it as "that class of the terrifying which leads us back to something long known to us, once very familiar."[4] In the same essay, Freud cites Ernst Jentsch, who located the uncanny in "doubts" about "whether an apparently animate being is really alive; or conversely, whether a lifeless object might not in fact be animate."[5] He also lists Jentsch's examples of things that produce uncanny feelings: these include, "wax-work figures, artificial dolls and automatons," as well as "epileptic seizures and the manifestations of insanity."[6] Freud's essay elaborates on, but also narrows, Jentsch's definition of the uncanny, and I will return to it later. When I first read this essay,

in the mid-1980s, I was struck by Jentsch's list and how much it corresponded to a recent sculptural trend—popularly referred to in art circles as mannequin art. Freud's influence on the surrealists is well known, and it is possible that his essay on the uncanny might have had something to do with the development of avant-garde interest in the mannequin, which reached its zenith in the 1930s.[7] But rather than attempt to document aspects of this history, I want to concentrate on mannequin art as a current phenomenon. My reasons for undertaking this exhibition were timely ones: I was interested in examining a current trend, jumping on the bandwagon, if you will. It seems that every ten years or so there is a "new figuration" exhibition of some kind,[8] the most recent being *Post Human* (1992).[9] Obviously, figurative sculpture is in the air, and there are enough artists committed to new considerations of the figure to devote an entire exhibition to contemporary manifestations of this theme. But what is particular to this current reevaluation of the figure? According to Jeffrey Deitch, curator of *Post Human,* "The Freudian model of the 'psychological person' is dissolving. . . . There is a new sense that one can simply construct the new self that one wants, freed of the constraints of one's past."[10] "New" is the primary adjective in Deitch's essay: the world "will soon be" and "is becoming."[11] It is a world where technological manipulation of body and mind is at our fingertips. This "distinct new model of behavior and a new organization of personality"[12] sounds very much like the model offered by early science fiction, or like the modernist version of a technological utopia. When I look at the work presented in *Post Human,* I don't find myself marveling at the newness of it, but wondering what *differentiates* the material it foregrounds from artworks of the past. For me, history is not denied here—it is evoked. Thus, I decided to not limit my exhibition to contemporary works alone, but to include a wide range of historical examples of figurative sculpture that have the quality I am interested in.

It's much easier to group together a selection of like objects than to describe why they are alike. Perhaps a good place to begin, then, is with what I excluded from the exhibition. These considerations noted, what constitutes these objects' similarities will hopefully become clearer.

Scale

It is important to me, first of all, that the objects displayed maintain their physical presence, that they hold their own power in relation to the viewer. I decided, therefore, to exclude miniatures—smaller than life-size statues, dolls, toys, figurines, and the like—from the exhibition. Generally, I believe that small figurative objects invite the viewer to project onto them. By this, I mean that the viewer gets lost in these objects, and that in the process of projecting mental scenarios onto them they lose sense of themselves physically. The experience of playing with dolls is a case in point. The doll becomes simply an object to provoke daydreams, and its objecthood fades into the background. Once the fantasy is operating, it could be replaced by any other object. On the other hand, I *am* interested in objects with which the viewer empathizes in a human way—though only as long as the viewer, and the object viewed, maintain their sense of being there physically.

There are, however, some less-than-life-size objects that have an uncanny quality, even though our perception of it differs depending on the age and experience of the viewer or participant. I would include stuffed animals, transitional objects, fetishes, and magical objects, such as Egyptian funerary sculpture, in this category. For the very young child, a stuffed animal is not simply a model of some agreeable object, a friendly animal or an object to weave fantasies around, like a doll. It is primarily a tactile object associated with great physical pleasure. It is *very* present. This is even more the case with the infant's transitional object, which has been called the child's first "Not-Me possession."[13] This object represents the mother in her totality, and its tactility and smell are of utmost importance, to the extent that if the transitional object is washed it ceases to be comforting. As figurative sculpture, transitional objects are especially interesting in that they do not *picture* the mother. They can take the form of a simple piece of cloth, for instance. Yet they function in a very real way as substitutes for the mother, and as extensions of the child itself. The same may be said of the pervert's fetish.[14] It is an object that does not picture what it symbolically stands for, yet it holds the same (often greater) power than that thing itself. The small, lifelike depictions of servants performing various tasks that were buried in the tombs of Egyptian royalty are magical objects. They were believed actually to carry out the functions depicted for the dead person who owned them in the afterlife. The literalness of the objects is revealed by the fact that sometimes the figures are jointed, allowing the limbs to move. In the case of magical objects, size is usually of

little importance (though there are some that equal the weight or size of the thing mimicked). For the Egyptian tomb sculptures, scale was probably determined by convenience, so that more figures could be fitted into the tomb.[15]

In photography, where size is indeterminate, the problem of scale is obliterated. My original pin-up board held images of objects of many different sizes. Yet on that board, they all read as one size: the general height of a human being. Because all of the objects were figurative, the human body became the primary referent for scale. Even though I am mostly interested in the relationship between the physical viewer and a three-dimensional object, I have included photographic documentation of objects in the exhibition. In part this is because many of the objects I wanted could not be borrowed or no longer exist. But once photography was a part of the exhibition, I decided to include "art" photography as well. In all cases I am treating photographs as documentation of figurative sculpture, including some for which this is not actually the case, such as Cindy Sherman's photographs of medical demonstration models arranged into figures. Despite visual clues to the contrary, Laurie Simmons's photographic tableaus of dolls invite a reading of the figures as human-size and as *alive*. For similar reasons, I have also included in the exhibition special effects objects produced for films. Film special effects models are designed specifically to be seen only through the medium of film, and are often destroyed after—or in the process of—being used. This "hidden" nature is part of their appeal as objects, for a lingering sense of their filmic reality lies behind their shabby or provisional appearance, soliciting our investment in the belief that they were once convincingly alive. A strange corpselike quality surrounds them. Like Egyptian funerary sculpture, their true size is inconsequential, eclipsed by their ritual relationship to filmic reality.

Willis O'Brien made a number of special effects objects for the 1933 film version of *King Kong*.[16] They ranged from small, doll-sized versions of the giant ape, animated through stop-frame photography, to full-sized hands, heads, and feet big enough actually to hold or step on a human being. The parts only formed a full figure once they were spliced together in film. In the same manner, filmic fragments spliced together in the editing process also configure the various Kong parts into a living being, the experiential equivalent of Frankenstein's monster: a being composed of dead body parts, sewn together. Divorced from the fictive entity for which they substitute, these FX parts definitely have an uncanny quality.

Forest J. Ackerman, former editor of *Famous Monsters of Filmland* magazine, has created the largest existing collection of horror and fantasy film special effects objects, which are displayed in his home in the Hollywood Hills. Touring it is like walking through a morgue.[17] Everywhere there are recognizable fragments of Hollywood film reality. But, unlike a normal museum where things are organized in a seemingly logical way, his collection is arranged like a child's bedroom—things are piled everywhere in a cacophony of film history. In one corner there is a rubber cast of Jane Fonda's breasts used in the filming of *Barbarella* (1968) and a wall of life-masks of actors (including those of Bela Lugosi and Vincent Price). In another, a faux black panther head from *The Most Dangerous Game* (1932), the head of an extraterrestrial from *Close Encounters of the Third Kind* (1977), and various other claws, body parts, and models from films long forgotten. On a shelf is a small clay animation figure by Ray Harryhausen,[18] experienced on the movie screen as a gigantic monster. Upstairs, in the living room, is a one-eyed blob from an episode of the science fiction television series *Outer Limits*. This prop is close to five feet high, yet I remember it as almost microscopic on the TV show. You realize that to experience the projected figures on the movie theater screen as life-size involves the reduction of your own body to the size of a doll, while with television, conversely, you must mentally blow yourself up to the size of a giant to account for the minuscule scale of the figures on the small screen. All of this hit home when I was confronted with Ackerman's collection of objects never meant to be seen in the light of day but only under the magic lantern of film-induced daydreams. Refusing to give up their dreamlike reality, his "statues" keep me detoured outside of consciousness. They were too familiar as intensely felt memory simply to become objects.

My response to Robert Graham's work raised some interesting problems regarding scale in relation to this exhibition. I had considered exhibiting one of Graham's works from the 1960s in the show, specifically, one of the Plexiglas cases housing minutely realistic wax female nudes.[19] I finally decided not to include one, for, in my view, their analogous relation to dolls and their submission to the criteria discussed above meant that the viewer's experience of this work was more mental than physical. Graham's objects provoke a voyeuristic mental scenario akin to looking through the walls of a bachelorette pad with "x-ray spex." To enjoy this fantasy fully, viewers must imagine themselves shrunk down to the scale of the figures, thus negating the true sculptural presence of the objects. The transparent doll house–like structure that encases the nudes is like the movie screen—an invisible barrier that allows dreams only if one gives up their sense of physical

presence and scale. Nevertheless, a certain amount of perverse presence is maintained in Graham's work. The fact that the Plexiglas cube is also an art-world signifier positing a relation to the then-current minimalist aesthetic makes it impossible to dismiss it outright. A similar double message is also present in Graham's later monochrome bronze work, life-size sculptures of almost classical female nudes or horses set atop simple geometrical forms which act as pedestals.[20] While the reference to Constantin Brancusi is obvious, the simplified figurative forms in his totemic sculptures are replaced by incredibly detailed ones—with the result that the figures are unmistakably portraits of actual young women. This shift from the general, or should I say "essential," to the specific is quite disturbing. The sculptures invite you to experience them formally, yet the sexual component is too strong for one's encounter to terminate on the surface. The women or horses are often raised just high enough that their genitals are right in your face.

This formalizing of the display of genitals reminds me of a bust of a man found in the ruins of Pompeii. This highly realistic portrait of a male head sits atop a simple geometrical pedestal of torso height that has no other adornment except, at the proper position on the pedestal, an equally realistically sculpted penis and patch of pubic hair. The pedestal becomes an obvious geometrical stand-in for the body, with all other features except head and penis removed.[21] Such a mixture of sexuality and order might have seemed natural in the classical period, but it provokes a more complex, dialectical reaction in the 1990s. Despite their formality and colorlessness, Graham's bronze figures demand to be experienced as flesh and blood, like the classical sculptures which, while time has washed them clean of their painted flesh tones, still retain their bodily sensuousness. Graham's bronze ballet dancer bodies have surrounding them a mental aura of color, the remembered color of sex, that denies their timeless monochrome facade.

Color

Historically, literalness has been considered the enemy of art. Along with material itself, color is one of the most loaded signs of the quotidian. The literal use of material is a non sequitur in art. No one would seriously consider the idea of sculpting a body out of actual flesh, or carving a rock out of stone. What would be the purpose of such a redundant exercise? Color is thus set at a difficult conjunction between sign and signified, a problem that is negated in painting because it operates in

two-dimensional mental space—which is why painting has been king of Western art history, with sculpture relegated to the role of its idiot cousin. Naturalistically colored dolls, mannequins, automata, and wax portrait figures are not included in the generally accepted version of Western art history, and polychrome religious statuary is on the lowest rung of the art hierarchy. Until recently, it would be difficult to come up with much of a list of polychrome figurative sculpture from the fine art of the last century. Even the realist movement produced almost nothing. I can think of no single nineteenth-century polychrome realist sculpture. The closest might be Degas's *The Little Dancer of Fourteen Years* (1880–81)—a slightly smaller than life-size bronze figure with painted clothes and a skirt made of real cloth.[22]

Because of its mix of sculptural convention and literalness, Degas's figure is still perversely interesting today. It truly looks like a statue that has been dressed in children's clothes. It is the only one of his sculptures that Degas exhibited during his lifetime, but it was very well received.[23] Joris-Karl Huysmans, the artist's contemporary, wrote that it was "the only really modern attempt of which I know in sculpture."[24] One wonders what influence, if any, mass-produced, commercial mannequins, a familiar part of urban life in the later nineteenth century, had on the work. Featured in the picture windows of many large stores, nineteenth-century mannequins were incredibly realistic, with naturalistic wax heads (outfitted with glass eyes and human hair) and extremities. And they were often displayed in elaborate window tableaus utilizing real furniture and props and painted backdrops. The erotic allure of the new mannequins was noted by both the antinaturalist writer Huysmans, who concentrated on the variety and naturalism of their breasts, taking classical Greek sculpture to task for the uniformity and monotony of its depiction of this part of the female anatomy, and the realist Emile Zola, who said that they had "the disconcerting lasciviousness of the cripple."[25]

Besides the Degas, there is little that could be said to have been influenced by these popular sculptural developments. Most realist sculpture of the period concentrated on social subject matter to evoke "realism," substituting members of the working classes or "great men" for the nobility that were the subject of previous heroic sculpture. Only the colored sculpture of the academic Jean-Léon Gérôme breaks with the monochrome trend. Gérôme's *The Ball Player* (1902) represents a female nude carved from marble, tinted naturalistically and covered with wax, giving the surface a skinlike quality.[26] Gérôme was an admirer of the painted figures unearthed at the Boeotian town of Tanagra, which had further upset the myth of pure white Greek sculpture. Appropriately

enough, another of Gérôme's tinted sculptures (though now bleached white) offers a version of the myth of Pygmalion and Galatea. Recounted by Ovid in the *Metamorphoses,* the story tells of a sculptor who falls in love with one of his statues, which is then brought to life by Venus.[27]

Not much more is to be found in the twentieth century either—and most of that can be seen as an extension of painting. I would say that the painted wooden sculpture of the German expressionists, the patchy archaism of Manuel Neri and Marino Marini, and the "Beat" collage works of Robert Rauschenberg, such as his famous *Monogram* (1959), which includes an expressionistically painted stuffed goat, all serve primarily to extend notions of painting—either by treating three-dimensional objects as analogous to the painting support, or by producing three-dimensional embodiments of painterly, gestural distortion.

By and large, modernist works continue on with the "Greek prejudice"—the neoclassical misconception that classical Greek sculpture was uncolored. Modernist essentialism understands this colorlessness as one of the "truth[s] to materials" it defended—the truth of archetypal, not specific, representation. Thus, a bronze or stone sculpture is left unadorned to reveal its "true" coloration. Or, if the female form is alluded to in a Hans Arp or Brancusi, for example, reference is not made to a specific body, but to the form of femininity in general. Truth arises from the base material, gives rise to archetypal meaning, and issues in timeless truths. The sign for the timeless is monochrome. It isn't until surrealism, and later pop art, that the truthfulness of an image is examined in relation to daily experience, either as a psychologically determined phenomenon, or simply as the by-product of culturally produced clichés. Truth is not a timeless given but a socially constructed fact.

Whilst others fish with craft for great opinion
I with great truth catch mere simplicity;
Whilst some with cunning gild their copper crowns,
With truth and plainness I do wear mine bare.

Troilus speaking to Cressida[28]

Citing this passage, psychoanalyst Janine Chasseguet-Smirgel suggests that "idealization is only a thin film disguising an unchanged material, a mechanism aiming at masking the self. It also shows that there are human beings that prefer truth to mendacity."[29] The context, here, is a discussion of fetishism and perversion, which are "connected with sham, counterfeit, forgery, fraudulence, deceit, cheating, trickery, and so on—in short with the world of semblance."[30] Perverts tend toward aestheticism, she maintains; they often have a love of art and beauty, and this is likened to the infant's wonder at the accessible parts of their own bodies, and their love of shiny and animate *external* objects—like dangling pieces of colored glass. Such external beauty is compared to the embalming of corpses, where makeup is applied to imitate life, and, in Egyptian funerary practice, this decorating impulse is continued with jewels and other precious materials until the dead body is sculpted into a god—that is, a fetish, an idealized substitution for something secret and shielded. This example recalls a recent account of the actions of the murderer and grave robber Ed Gein who, after his mother's death, dug up the graves of women roughly her age and brought pieces of them home.[31] Gein found solace in these body parts, which seemed to him like dolls, and in some cases he even wore them, becoming a surrogate for his mother's living being as he went about his daily life. Searching Gein's house, investigators found boxes of body parts, some dabbed with silver paint and decorated with bits of ribbon. Chasseguet-Smirgel's examples present surface decoration in this kind of pathological light, tying her aesthetic to modernism's stripped-down essentialism. Her moralism here strikes me as somewhat surprising, in that one would imagine that a psychoanalyst would have more sympathy for the complexities, and poetics, of the interrelationship between psychic and daily reality. In her account, color is false and pathological: it represents lies. This idea of color as misrepresentation is quite different from my own understanding of the tendency toward noncoloration in modernism, which I interpret as a sublimation of surface variance and complexity reaching for an idealized, though shadowy, essential reality.

On the social level, Chasseguet-Smirgel's moralistic take on coloration is beautifully illustrated by an occurrence in Beverly Hills, a wealthy city within the Los Angeles city limits. In the 1970s a mansion was purchased there by a rich Saudi Arabian sheik, Mohammed Al-Fassi. The sheik decorated his house in a thoroughly garish manner, including, for example, a row of copies of classical statuary painted naturalistically—right down to the pubic hair. These works initiated an ongoing battle between Al-Fassi, his neighbors, and city government that ended only when the house was burnt down by an arsonist.[32] Even though we now know that Greek statues were

painted when they were made, their present function as a popular sign of taste and order will not allow this fact to be recognized. The timeless order of the neoclassical conception is an appropriate symbol for the upper classes. Kitsch, outwardly characterized by gaudy colors, is a cheap and false version of the true, made for and consumed by the underclasses. What was most dangerous about Al Fassi's painted statuary was that it hinted at presentness, a here and now that always entertains the possibility of a loss of position and power. The sheik's sculptures were symbolically unsuitable objects for the decoration of a Beverly Hills mansion. No wonder, then, that aesthetic arguments can shift into violence when the politics of the sign are so loaded.

Certain contemporary works reexamine the tensions between the Platonism of modernism, as signified by monochrome coloration, and an unsettling sensation of the "real"—manifested especially through the evocation of self-conscious body awareness. The recent sculptures of Bruce Nauman, composed of wax casts of human heads in various single colors, and the paintings of Jasper Johns that incorporate cast wax or plaster fragments of body parts participate in this reassessment.[33] In both cases, it is the tactile quality of the material that supersedes the calming effect of monochrome. Wax is so fleshlike in consistency, and has such a long history of usage as a flesh substitute in popular sculpture, that notwithstanding the various formal tropes utilized in these works, it is impossible to experience them in a purely formal way. The fragmentary nature of the body parts, reinforced by the organic qualities of the wax, strongly suggests the disordering of the body. Indeed, it's difficult to imagine that any ordering principle applied to them could offset the uncanny feelings thus produced. I would say that Nauman's minimal organizing strategies make these feelings even stronger. When applied to body parts, basic compositional exercises, like up vs. down or in vs. out, come off as cruelly tongue-in-cheek. These simple organizing gestures cannot help but remind viewers of the actual morphology of the body—and of their *living* bodies in particular. Everyone knows how the body is organized and how many of each part he or she has; this is a given and is never thought about. To become aware of these particulars, one must imagine oneself unwhole, cut into parts—deformed or dead.

The Body Part and Wholeness

While studying the ancient sculptural ruins in Rome, Auguste Rodin made a statement that was obviously meant to apply to his own work as well. He said: "Beauty is like God; a fragment of beauty

is complete."[34] This thought links Rodin unconditionally to the cubist movement that followed him and confirms his position as a protomodernist. Each piece is a microcosm of the whole, and each piece is a whole itself. Part and parent body are linked together by some essential glue that makes them a unit, a Platonic whole. This essentialism prevents the modernist work from degenerating into an image of chaos, and, instead, makes it complete. The various fracturing strategies of the cubists and futurists, the close-ups and severe croppings of modernist photography, the reductive principles of early abstraction, and the pinpoint material focus of minimalism and monochrome painting all rely on the benevolent metaphysics of essentialism to prevent their aesthetics of exclusion from being seen as cruel.

Herbert Read distinguishes Honoré Daumier's sculpture from Rodin's by claiming that Daumier was not modern because he was a caricaturist.[35] He states that the deformations of the caricaturist have nothing in common with the formal conceptions of Rodin. What is the difference? I would say the main difference is whether cruelty is openly addressed or not. In Daumier, the figurative deformations are conscious attacks on specific physiognomies; in Rodin, the cruelty of his deformations has been sublimated into aesthetic and metaphysical discourse. You can argue with Rodin's success in his endeavors, but you are not allowed to question his motives. Henri Matisse, for example, takes Rodin to task for sacrificing the body's completeness to the sum of its parts; his work is not "whole" enough. Matisse, I would assume, felt that Rodin's work was not optically simple enough: it could not be taken in in one glance. In Rodin's terms, however, this would be a moot point. If each fragment is really a whole, then the reorganization of parts back into a greater whole, fragmentary or provisional as it may seem, cannot diminish their wholeness. This way of conceptualizing allows Rodin to play quite nasty formal games while still allowing him to keep his noble status. Not that Rodin wasn't criticized for his work. A cartoon published in *Le Charivari* in November 1913, headed "The Balkan Atrocities," shows a commission of inquiry examining a group of mutilated torsos and body parts in a war-torn landscape, accompanied by the caption: "Oh! What fine models for Rodin!"[36] Writing in 1925, Fred Wellington Ruckstull alludes to Rodin's practice of making full figures in clay which would then often be cut apart and rearranged, with some parts ending up on different figures or exhibited singly. "But why any man," he wrote, "should, today, *deliberately model* a human body and then *mutilate it* and then *hack it,* and exhibit it, except as a revelation of his sadistic soul, passes our

comprehension."[37] He goes on to denounce Rodin's statue as a "cadaver." As Rodin's reputation firmed, these criticisms were considered philistine; the true viewer saw no sadism, and such views were not worthy of critical discussion. At that moment in the art world, there was no place for the fragment *as* fragment.

The Part and Lack (The Organs without Body)

In recent art, the modernist notion of the fragment as a microcosm has given way to a willingness to let fragments be fragments, to allow partiality to exist. As in the case of Nauman's uncomfortably dysfunctional formalism, wholeness is something that can only be played with, and the image of wholeness only a pathetic comment on the lost utopianism of modernism. It is comparable to a kind of acting out of socially expected norms, the presentation of a false "true self," long after the notion of a unified psychological mind has given way to the schizophrenic model as the normative one.[38] Now, "sham," "falseness," and all the other terms that once were pejorative have become appropriate to contemporary notions of the function of art. Surrealism offers some of the earliest examples. Salvador Dalí wrote in 1930 that "It has to be said once for all to art critics, artists, &c., that they need expect nothing from the new surrealist images but disappointment, distaste and repulsion. Quite apart from plastic investigation and other buncombe, the new images of surrealism must come more and more to take the forms and colors of demoralization and confusion."[39] Dalí's inspirations ("masturbation, exhibitionism, crime, love")[40] and surrealism's basic motivating factor, desire, all point toward lack as the focus of art. Art is creation in response to lack. Quite different from a stand-in for the archetype, which must be there, somewhere, the art object is a kind of fetish, a replacement for some *real* thing that is missing.

The surrealist artist Hans Bellmer constructed a life-size figure of a young girl in the early 1930s. This figure was fully jointed and came apart in pieces in such a way that it could be put back together in innumerable ways. He also made extra pieces that could be added so that the figure could have, if desired, multiples of some parts. Bellmer's playful dismantlings and reorganizations of this figure were documented in a series of photographs, most hand-tinted in the pastel shades of popular postcards. The "doll" is a perfect illustration of Bellmer's notion of the *body as anagram:* the body as a kind of sentence that can be scrambled again and again to produce new meanings

every time.[41] "The starting-point of desire, with respect to the intensity of images," Bellmer wrote, "is not in a perceptible whole but in the detail. . . . The essential point to retain from the monstrous dictionary of analogies/antagonisms which constitute the dictionary of the image is that a given detail such as a leg is perceptible, accessible to memory and available, in short is *real,* only if desire does not take it fatally for a leg. An object that is identical with itself is without reality."[42] The sentence of experience is recalled through the syntax of remembered moments. For Bellmer, the shifting of attention during the sex act from one body part to the next is presented in terms of a kind of futurist simultaneity—all at once rather than one after the other. This flow of physical recollection is further intensified by the crossover of one body part into another, as one part becomes associated with or a stand-in for a different part. Freud calls this "anatomical transgression," a situation in which "certain parts of the body . . . lay claim as it were, to be considered and treated as genitals."[43] This is even a part of "normal" sexual practice; the polymorphous perversity of infantile sexuality has found its way into a canon of socially acceptable genital substitutes. "Partiality" to the lips, breasts, or the ass is not seen as strange at all.[44] In fact, a number of years ago in *Penthouse* magazine there was a very popular series of letters supposedly documenting the interest of various men in female amputees, obsessions that were often explained by the fact that their mothers were amputees. Here, the fetish is not a part that can be objectified, but a missing part— an absence. The castration reference is inescapable.

The Readymade and the Double

When Bellmer says that "an object that is identical with itself is without reality,"[45] I immediately think of Marcel Duchamp's readymades. Without doubt, these objects constitute the most important sculptural production of the twentieth century, precisely because, in the simplest and most concrete package, they present reality as impossible to concretize. Duchamp achieves exactly what I presented before as an impossibility: he sculpts an object in its true material. He performs the sin of literalism and demands that it *is* art. The problems these pieces raise are so numerous that it is difficult to know where to begin to talk about them. On one hand, they react against the accepted notion of art as a facade, preoccupied with representation, by presenting a "real" object as art. On the other hand, they reduce the modernist idea of art as materially self-referential to an absurdity,

for it is impossible for these "real" objects, once presented in the context of art, to maintain their "real" status. As "art," they dematerialize; they refuse to stay themselves and become their own doppelgangers. The categorical confusions raised by the readymade make them the father of all the time-based work that followed, the progenitor of everything that traversed the slippery dividing line between sculpture and theater, between what is *in* time and what is *out of* time. One need only think of Piero Manzoni's—obviously Duchampian—act of signing live nude models as artworks in 1961.[46] Here the problem raised by Duchamp is made evident. If real objects are going to be art, what are the rules and limits of this as defined *in time?* Duchamp's readymades do stick to one historical convention of art-making: they are in permanent materials; he can be credited with inventing sculptural still-life. Yet, their status as real objects problematizes this reality; one wonders *when* they are a real object, and *when* are they an illusion. It is not a difficult jump, then, to shift to the use of organic materials that have a limited life—they die, they rot. Were Manzoni's nudes still art when they put their clothes on? Were they art when they were no longer young? Are they still art, and if so, how, after they are dead and gone?

Statues and Death

The issues raised by time-based and body art are too complex to deal with in this short essay. I have decided to limit myself here—and in the *Uncanny* exhibition—to the representation of the inanimate human figure. The long history of figurative sculpture has normalized representations of the body, taking the edge off of our experience of such objects and preventing us from having the same ambivalent relationship with them that we have with Duchamp's readymades. This has not always been the case. The history of Western art is also the history of Christian thought, and this is a history where image making, and especially statue making, is fraught with controversy.

Thou shalt not make to thyself a graven thing nor the likeness of anything that is in heaven above, or in the earth beneath, nor of those things that are in the waters under the earth. (Exodus 20:4)

Interestingly, during the Middle Ages it was believed that sculpture was a more recent artistic development than painting, a reversal of the opinion commonly held today.[47] Technical advances in art were equated with an accelerating evil, probably because they were seen as being at a further distance from the simplicity of Eden. All sculpture was dangerous and linked to idolatry; it was seen as a proud attempt to compete with God's creation of man in His own image. The Eastern church believed there should be no sculpture in the round at all, so that flat or slightly raised icons were the only appropriate religious images. The test of acceptability was to see if you could grasp the figure's nose.[48] All sculpture was perceived in religious terms. Crusaders ritually knocked the heads, arms, and legs off of pagan "idols," which were often, in actuality, secular sculptures. Many classical and Roman portrait sculptures were probably destroyed in the belief that they were images of unknown gods. Nevertheless, colored sculpture was employed as a way of teaching the book of God to those who could not read.[49] Various pagan beliefs and customs were absorbed and tolerated by the church as a way of attracting pagan converts; the adoration of statues of Christian figures as idols was bound to happen, despite the fervent attempts of Christian iconoclasts to stop it. As late as the early nineteenth century, an archbishop ordered the destruction of a "palm ass" (a realistic statue of Christ, elaborately dressed in rich attire and seated atop a statue of a donkey on wheels, which allowed it to be rolled in Palm Sunday processions) despite the protests of the people.[50] The attention and riches heaped upon these basic figures were embarrassing to a church whose main tenet is the denial of the physical world and body. The power of statues that performed miracles or healings—which could not be denied, for God is capable of such things—was often explained as the work of devils, beings who had totally surrendered to the illusions of earthly desire. But the Catholic Church was not willing to give up the use of statues, for they were crucial tools for reaching and educating the public. Yet their usage could not be policed. Those physical things that were designed to *recall* the immaterial God and the dead saints became idolized themselves. The desire for God in material form is too great to repress.

Because of their construction in permanent material, statues, as with the readymades, constantly evoke in viewers their own mortality. Indeed, this could be said to be the main point of Christian statuary: to rub people's noses in their own mortality so that their minds were forever focused on the afterlife. And this is probably why, in the modern era, figurative sculpture is held in such low esteem, for this primitive fear cannot be erased from it. The aura of death surrounds statues. The origin of sculpture is said to be in the grave; the first corpse was the first statue. And early

statues were the first *objects* to which the aura of life clung. Unwilling to accept the notion of himself as a material being with a limited life span, "Man" had to represent himself symbolically as eternal, in materials more permanent than flesh. It is supposed that our early ancestors believed themselves to be surrounded by the ghosts of the angry dead, angry because the pleasures of the body were denied them.[51] To ward off such ghosts, early societies believed that the corpse had to be recreated in permanent material form, or the body itself had to be kept from rotting through mummification. These surrogate bodies then had to be given the things that people need: food, at the very least, and in the case of important people, all of the pleasures they had come to expect in life. I have already mentioned how statues were left in Egyptian tombs to work for their masters in the afterlife. An example of this on a grand scale is found in the life-size terra cotta figures of soldiers, servants, and horses, over 7,000 statues in all, discovered buried in the tomb of the Chinese emperor Ch'in Shih Huang Ti, who reigned from 221 to 210 B.C.[52] This emperor is credited with ending the practice of sacrificing servants in China and substituting statues for them. Still, the importance of these figures as actual replacements is proven by the fact that each figure is different, leading some to believe that the figures were made from life casts of the soldiers themselves.

The Statue as Stand-in

This ending of the socially destructive practices of human and animal sacrifice and the burial of precious goods by replacing them with sculptural stand-ins probably came from necessity, yet it established the idea of sympathetic magic, that the image of something could function analogously to the thing itself. Beyond that (this is the germ of the concept of kitsch), a less precious thing could be substituted for a more valuable one. The image was a tool, useful but dispensable, a kind of labor-saving device. The Egyptian dead, their bodies mummified to ensure their physical presence in the afterlife, had psychically to split themselves in order to deal with this fact—a premonition, perhaps, of the current notion of a nonpathological, schizophrenic psychology.[53] Physical presence in the afterlife also meant that physical labor was expected. Image magic was used to escape this commitment. A small statue called an *ushabti* figure was buried with the dead.[54] The purpose of this figure was to do your labor for you; when you were called upon to work, the *ushabti* answered. A kind of double was created, a shadow of yourself bound to perpetual slavery. All popular sculp-

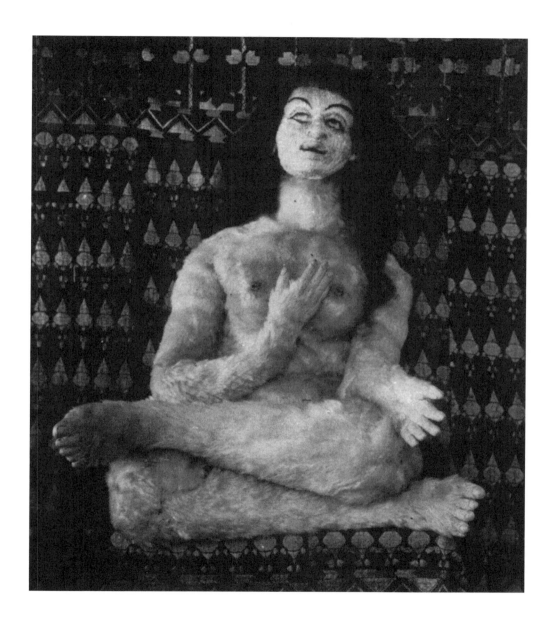

Hermine Moos, life-size fetish doll of Alma Mahler commissioned by artist Oskar Kokoschka (1919). Courtesy Graphische Sammlung Albertina, Vienna.

ture—from votive sculpture, which is a representation of the person making sacrifice before a god, to the most mundane worker replacement like the scarecrow or shop-window mannequin—has this plebeian quality.[55] Votive sculpture, ranging from life-size wax figures to small depictions of afflicted body parts that a person wants healed, could be said symbolically to represent devotees *themselves* as sacrificial offerings to the gods. Although these replacements are sometimes highly charged emotionally, and this throwaway quality is repressed, they still have one foot in the garbage dump. In the fourteenth century it was not uncommon for the wealthy to have a life-size, wax votive image of themselves set up in a church perpetually to mourn a dead loved one or to show reverence to a religious image. Churches became so crowded with these figures that they had to be hung from the rafters. Of course, this trash heap of simulated devotees was eventually just tossed out.[56]

The disposability of the venerated substitute has modern correlatives. We know, for example, that the life-size doll Oskar Kokoschka commissioned to be modeled after the object of his erotic obsessions, Alma Mahler, was simply torn apart by revelers at a drunken party after his desire waned.[57] The focus of his thoughts for years, this fetish object became as dispensable as an inflatable sex doll available at the corner sex shop. Then there are whole classes of figures designed specifically to be destroyed in use: car-crash test dummies, the effigies of hated political figures hung and burned at demonstrations, the mannequins that people the perimeters of nuclear test sites, and the electrified human decoys recently used in India to shock man-eating tigers into losing their taste for human flesh.[58] In a way, all these figures ask to be mistreated. The iconoclast, the one who feels compelled to destroy images, knows: statues invite violence. Like the vampire, they desire a violent death to relieve them of the viewer-projected pathos of their pseudo-life.

In a series of famous psychological experiments performed in the early 1960s by Albert Bandura to study the effects of televised violence on preschool children, young subjects were shown films of adults manhandling large punching-bag dolls.[59] Of course, the children proceeded to beat the dolls themselves, ostensibly proving that the image of violence engenders violence. The experiment actually seems like a study of sympathetic magic in reverse, where the actions of real people become stand-ins for a media image. Couldn't the true purpose of the experiment have been to set up a situation that allowed the adults the pleasure of beating statues (using the tried and true excuse that it helps children in some way)? In the roughly contemporaneous experiments

by Harry F. Harlow that explored mother-child bonding, infant monkeys were given a surrogate dead and a surrogate living mother.[60] The experiments were so popular that they were re-presented at the 1962 World's Fair held in Seattle. Whatever their scientific importance, the experiments found favor with the public by suggesting that the attraction to statues is "natural." It was proved that these young monkeys, our uncivilized cousins, love stuffed animals too. Clement of Alexandria's early Christian moral example, offered as an attack on pagan idolatry, is thus reversed: "Those who keep apes are always amazed that these animals are never deceived by clay or wax figures (they do not mistake them for living things). Now if you cling to those statues and paintings you will be even lower than the ape."[61]

Aping the Mirror of Nature

J. J. Pollitt suggests that the Greek artists of the early classical period were able to see their own style in historical perspective, an ability characteristic of very self-conscious ages, like our own.[62] He goes on to note that one symptom of this historical perspective and self-consciousness is archaism, the interest in reviving and reorganizing earlier types. One example he cites relates to the statue of Apollo, the central figure on the west pediment at Olympia.[63] The Apollo was sculpted in an older style than the figures it is grouped with, leading some to surmise that it is not a representation of Apollo at all, but a representation of a *statue* of Apollo: it is a statue of a statue. What is the "self-consciousness" that Pollitt describes? It could be a kind of period mindset within which the magical power, and perceived efficacy, of the image is at low ebb. Writing about caricature in the 1930s, psychoanalyst Ernst Kris pointed out that the existence of such a transgressive aesthetic presupposes the general belief that images *do not* spur action[64] (though he goes on to claim that the aggressiveness of such images precludes their being accepted as art).[65] In the years before World War II, caricature was still "lively" enough to lie outside the realm of aesthetics. It would seem that modernism, then, is not one of these self-conscious periods (based on its iconoclasm, its stark fear of the image), at least not as it is now generally defined. Unless, that is, the term is broadened to include a figure like Salvador Dalí, who historically participated in modernism, but whose aesthetic has more in common with what has been called postmodernism. With its adoption of "bourgeois" realist painting techniques, the work of Dalí and René Magritte in the 1920s and 1930s was in

direct opposition to prevailing modernist tenets, according to which realism was associated with truth to materials.[66] The style of Dalí and Magritte was also antithetical to that of other surrealist painters, like André Masson or Joan Miró, whose paintings, in the 1920s at least, could be said to operate expressively in an attempt to transcend language and the sign. Dalí and Magritte, on the other hand, revel in the cliché. Their embrace of an "outmoded technique" is willfully perverse. What was to the modernists a despicable world of conventional, academic imagery became an open field of taboos and dead signs that could be rearranged at will.

With the work of these stylistically dissident surrealists in mind, it seems improper to speak of modernism and postmodernism as historical movements following one after the other.[67] Perhaps it makes more sense to distinguish between modernist aesthetics and the aesthetics of a surrealist such as Dalí with the terms "high modernism" and "low modernism."[68] This divide is mediated by the belief in, or regulation of, a kind of inherent meaning. From the high modernist standpoint, all antiessentialist work, concerned as it is only with facades, is branded as kitsch. In this regard, high modernism is almost Christian in its moralistic flight from the temporal. Here we have two opposing versions of realism: one based on pure material presence divorced of association, and the other on an empty conventionality. Pop art tried to ride the line between the two, substituting the ubiquitous—hence meaningless—images of everyday life for the geometries of high modernism. The so-called new realism of the late 1960s was often presented as a continuation of nineteenth-century realism.[69] But, even if this *was* its intent, such continuity was impossible. By the 1960s, the making of realist artworks could be viewed only as a kind of archaism equivalent to making a statue, not of another statue, this time, but of a photograph.

Famous for his superrealist statues of female nudes, John de Andrea made several black-and-white works: one was based on the famous newspaper photograph of a student shot at Kent State University, and another represented the artist casting a model in plaster. Even though these works are drained of color, the use of monochrome couldn't be further removed from the conventional, timeless colorlessness of heroic sculpture. The "realism" of black-and-white documentary photography is the obvious referent. This photographic sense of truth captured in the moment is beautifully undermined here, simply through the process of literalization. When the photo is actualized in sculptural form, truth is dispensed with. The photographic "essence" of the moment takes on the cheesy pseudohistorical feel of every cheap roadside museum. De Andrea and Duane

Hanson were some of the first contemporary sculptors willing to make works that evoked the banality of the wax museum.[70] The literalness of the wax figures found at Madame Tussaud's empties them of their magic. These figures, obviously a secular outgrowth of the magical/religious votive figure, are no longer in sympathetic vibration with the souls of their models; they are as dead as the corpses they portray. Many artists could now be said to be working with a kind of formalism of conventions. The sense of these formalist strategies having any real base in fixed laws of order has vanished. Rather, they are dysfunctional mirrors of random cultural conventions. In Jeff Koons's polychrome statues, for example, we are presented with a set of historical tropes, now overtly kitsch, that, by virtue of their placement in the art world—instead of on the knick-knack shelf—as well as their huge price tag, demand to be taken seriously. Yet we all know they only ask for, but do not expect, this respect. They only toy with self-importance. If Koons's works are kitsch, it is not the kitsch defined by high modernism, the kitsch of those who subscribe to cultural hierarchy, whose laughter at or hatred of kitsch presupposes a feeling of superiority: they are better than it.[71] I get the sense that most artists now do not think this way. They know all too well that the lowest and most despicable cultural products can control you, despite what you think of them. You *are* them, whether you like it or not. Cindy Sherman's photographs are a case in point. Rather than photographic odes to pop culture, they are self-portraits of a psychology that cannot disentangle itself from the kaleidoscope of clichés of identity that surrounds it. And one convention is as good as the next. The only test of quality is how well we recognize the failure of the cliché to function as given.

In Charles Ray's *Male Mannequin,* we are presented with exactly what the title announces: a standard, store-bought, nude male mannequin.[72] Yet the normally neutered figure has been completed with a superrealist cast of male genitals. The genitals prove, quite literally, the figure's "maleness," which had been determined previously by other outward signs, such as physique, hairstyle, and, in normal usage, the clothing it would be dressed in. By this simple addition, Ray's piece raises a plethora of questions. The realism of the genitals throws the stylization of the mannequin into question, and although we know that mannequins do not *need* genitals—they can't be seen anyway when the mannequin is performing its proper function of displaying clothes—this somehow doesn't seem reason enough to leave them off. We cannot help but see the mannequin as being castrated, a ludicrous idea to apply to something that never *had* genitals. Expectation

is the key here: we expect certain things of the male human form; we expect certain things of a mannequin; and we are presented here with something that doesn't meet our expectations. It is problematic. It really doesn't matter that the *Male Mannequin* represents a human body, for it represents a convention, and, as an artwork, it functions similarly to other works Ray has made with nonfigurative objects. There is nothing "humanist" about Ray's work. Morals are revealed as determined by the convention. I am reminded of a very controversial work from 1980 by the artist John Duncan called *Blind Date*. The work consisted of Duncan having sex with a human corpse, and was presented in the form of an audiotape as a kind of concrete music. Duncan said of the experience, "One of the things this piece showed me was that people don't accept death. Until the body is completely dust, people can't accept the fact that someone is dead. To me the corpse was like solid matter that had nothing do with the person who was occupying it."[73] To those who hold onto an essential notion of the human body, the corpse is inseparable from the life force that once occupied it; to those that do not, the corpse is simply another material.

The Uncanny

This current tendency of artworks to use as their subject the conventional and the cliché returns us to Freud's conception of the uncanny. Earlier definitions of the uncanny had described it as a fear caused by intellectual uncertainty—precisely what the decontextualizing strategies used by the various artists I have just described are meant to produce (one of the prime examples given being the confusion as to whether something is alive or dead).

 I have already offered a list of objects said to produce an uncanny reaction—these include waxwork figures, artificial dolls, and automatons, but also the body itself as a puppet, seemingly under the control of an outside force, which is the impression given by epileptic seizures and manifestations of insanity. Freud's contribution was to link the uncanny to the familiar. He defines the uncanny as the class of the terrifying which leads us back to something long known and once very familiar, yet now concealed and kept out of sight. It is the unfamiliar familiar, the conventional made suspect. This once-familiar thing is the infantile primary narcissism that holds sway in the mind of the child and is still harbored unconsciously in the adult. The narcissistic personality projects its thoughts onto others; others are its double. The alien self can be substituted for its own,

by doubling, dividing, and interchanging itself. The transitional object is a locus of such ideas. This object is a combination of itself, child, and mother, and the psychic doubling that results is an assurance against the destruction of the ego. But when the infantile stage terminates, the double takes on a different aspect. It mutates from an assurance of immortality into a sign of egolessness—death. Freud equates this change of meaning to a fall from grace: "after the fall of their religion the gods took on demonic shapes."[74] The uncanny is located in the uncomfortable regression to a time when the ego was not yet sharply differentiated from the external world and from other persons. When something happens to us in the "real" world that seems to support our old, discarded psychic world, we get a feeling of the uncanny. The uncanny is an anxiety for *that which recurs* and is symptomatic of a psychology based on the compulsion to repeat. Freud also claims that, in addition to its more primitive use as a protector of the ego, doubling acts as a safeguard against castration anxieties.[75] Multiplication insures that the loss of one part is not *total* loss. Castration anxiety lends the idea of losing organs other than the penis, and the notion of the body as made up of parts, their intense coloring. The fetish, an exaggerated replacement for something that is repressed from consciousness, is subject to these same kinds of doubling procedures (according to Freudian theorists, the fetish is a symbolic replacement for the Mother's missing penis). The compulsion to repeat results in the fetish being collected and hoarded. This kind of collection has been called the fetishist's "harem."[76] Whether or not we accept castration theory, Freud's ideas still deserve attention for the light they shed on the aesthetics of lack. It cannot be denied that collecting is based on lack, and that this sense of lack is not satisfied by one replacement only. In fact it is not quenched by any number of replacements. No amount is ever enough. Perhaps this unquenchable lack stands for our loss of faith in the essential. We stand now in front of idols that are the empty husks of dead clichés to feel the tinge of infantile belief. There is a sublime pleasure in this. And this pleasure has to suffice. No accumulation of mere matter can ever replace the loss of the archetype.

Now, in the role of Sunday curator, I present this exhibition, my harem, *The Uncanny.*

NOTES

1 Jack Burnham, *Beyond Modern Sculpture: The Effects of Science and Technology on the Sculpture of This Century* (New York: Braziller, 1968), p. 185.

2 Janine Chasseguet-Smirgel, *Creativity and Perversion* (New York: Norton, 1984), p. 88.

3 Sigmund Freud, "The 'Uncanny'" (1919), in *Sigmund Freud: Collected Papers,* vol. 4, trans. and ed. Joan Rivière (New York: Basic Books, 1959), p. 399.

4 Ibid, pp. 369–70.

5 Ibid, p. 378.

6 Ibid.

7 See Benjamin Péret, "Au paradis des fantômes," *Minotaure* (Paris, December 5, 1934), pp. 29–35; and the *Exposition Internationale du Surréalisme* (Galerie Beaux-Arts, Paris, January to February 1938), in which surrealist artists including André Masson, Kurt Seligmann, Max Ernst, and others dressed and interfered with found mannequins arranged along a "surrealist street" and in the galleries.

8 One sequence might begin with the New York Museum of Modern Art's *New Images of Man,* curated by Peter Selz in 1959, and Robert Doty's *Human Concern/Personal Torment* at the Whitney Museum of American Art, New York, 1969.

9 Jeffrey Deitch, catalogue for *Post Human* (FAE Musée d'Art Contemporain, Pully/Lausanne, 1992). The exhibition traveled to Turin, Athens, and Hamburg, 1992 to 1993.

10 Ibid, p. 27.

11 Ibid, pp. 29, 41.

12 Ibid, p. 38.

13 D. W. Winnicott, "Transitional Objects and Transitional Phenomena" (1951), in *Through Paediactrics to Psycho-Analysis* (New York: Basic Books, 1958), p. 229.

14 Sigmund Freud notes that "the substitute for the sexual object is generally a part of the body but little adapted for sexual purposes, such as the foot or hair or some intimate object (fragments of clothing, underwear), which has some demonstrable relation to the sexual person. . . . The substitute is not unjustly compared with the fetich in which the savage sees the embodiment of his god"; see "The Sexual Aberrations," in "Three Contributions to the Theory of Sex," *The Basic Writings of Sigmund Freud,* trans. and ed. A. A. Brill (New York: Modern Library, 1978), p. 566. See also Wilhelm Stekel, *Sexual Aberrations: The Phenomena of Fetishism in Relation to Sex,* trans. Samual Parker (New York: Liveright, 1971), p. 34.

15 This is Kelley's suggestion; on scale in Roman funerary monuments, see e.g. Max von Boehn, *Dolls and Puppets* (New York: Cooper Square, 1966), p. 39.

16 Willis O'Brien (1886–1965) began his career creating animated dinosaur models for films—first for the 1917 short *The Dinosaur and the Missing Link* and then for *The Lost World* (1925), based on Sir Arthur Conan Doyle's novel. He was awarded a special Oscar in 1950 for his work on *Mighty Joe Young,* though he is most famous for his creation of the giant ape in *King Kong* (1933).

17 Beginning in 1958, Forest J. Ackerman (born 1917) was editor of *Famous Monsters of Filmland* for 190 issues. Open by appointment for almost half a century, the "Ackermuseum" houses some 300,000 horror, sci-fi, and special effects items.

18 Ray Harryhausen was O'Brien's collaborator on *Mighty Joe Young.* He went on to become a leader in stop-motion animation in the 1960s in such films as *Jason and the Argonauts* (1963).

19 See *Robert Graham: Works 1963–1969* (Cologne: Buchhandlung Walther König, 1970).

20 Graham's bronze sculpture *Stephanie and Spy* (1980–81) was on the cover of *Artforum* 21, no. 7 (March 1983), with a special project on pp. 56–57.

21 This is the bronze bust of L. Caecilius Jucundus, a Roman work from the first century A.D., reproduced as figure 264 in Germain Bazin, *The History of World Sculpture,* trans. Madeline Joy (Greenwich, Conn.: New York Graphic Society, 1968), p. 176.

22 See Linda Nochlin, *Realism* (Harmondsworth, U.K.: Penguin, 1971), note 134, p. 269.

23 Joris-Karl Huysmans, review in *L'Art Moderne* (Paris), 1883, 1902; cited in Herbert Read, *A Concise History of Modern Sculpture* (New York: Praeger, 1964), p. 32.

24 Joris-Karl Huysmans, *Croquis parisiens* (Paris: L. Vanier, 1886), p. 36; cited in Nicole Parrot, *Mannequins* (London: Academy Editions, 1982), p. 39.

25 Emile Zola, *Au bonheur des dames* (Paris: E. Fasquelle, 1906), p. 41; cited in Parrot, *Mannequins,* p. 41.

26 Gerald Ackerman in Peter Fusco and H. W. Janson, *From the Romantics to Rodin: French Nineteenth-Century Sculpture from North American Collections* (Los Angeles/New York: L. A. County Museum of Art/Braziller, 1980), pp. 289–91.

27 The story of Pygmalion is in Ovid, *Metamorphoses,* trans. A. D. Melville (New York: Oxford University Press, 1988), pp. 232–34.

28 William Shakespeare, *Troilus and Cressida,* Act IV, Scene 4; cited in Chasseguet-Smirgel, *Creativity and Perversion,* p. 100.

29 Chasseguet-Smirgel, *Creativity and Perversion,* p. 100.

30 Ibid, p. 81.

31 See Robert H. Gollmar, *Edward Gein* (New York: Pinnacle Books, 1981). Gollmar was the judge in the Gein case.

32 For further details, see Scott Harris, "Sheik, Prattle, and Dough: On the Trail of the Elusive Saudi," *Los Angeles Times,* May 6, 1989, section 2, p. 1.

33 On Nauman's colored wax heads, see John C. Welchman, "Peeping over the Wall," in *Narcissism: Artists Reflect Themselves* (Escondido: California Center for the Arts Museum, 1996), pp. 19–20; reprinted as chapter 5, "Peeping over the Wall: Narcissism in the 1990s," in Welchman, *Art after Appropriation: Essays on Art in the 1990s* (Amsterdam: G+B Arts International, 2001); on Nauman's later sculpture, see Jörg Zutter, *Bruce Nauman: Skulpturen und Installationen 1985–1990* (Cologne: DuMont Buchverlag, 1990). On Johns, see e.g. Richard Francis, *Jasper Johns* (New York: Abbeville, 1984).

34 Auguste Rodin, cited in Albert E. Elsen, *Rodin* (New York: Museum of Modern Art, 1976), p. 167.

35 Read, *A Concise History of Modern Sculpture,* pp. 32–34.

36 The cartoon is reproduced in George Melly and J. R. Glaves-Smith, *A Child of Six Could Do It!: Cartoons about Modern Art* (London: Tate Gallery, 1973), p. 24.

37 Cited in Elsen, *Rodin,* p.180. Ruckstull was organizer of the National Sculpture Society in the United States.

38 See e.g. R. D. Laing, *The Politics of Experience* (New York: Ballantine, 1967/68). Gilles Deleuze and Félix Guattari, *L'Anti-Oedipe: Capitalisme et schizophrénie* (Paris: Minuit, 1972), is perhaps the most influential text in recent critical theory appealing to the schizophrenic model; it was translated by Robert Hurley, Mark Seem, and Helen R. Lane as *Anti-Oedipus: Capitalism and Schizophrenia* (New York: Viking, 1977; Minneapolis: University of Minnesota Press, 1983).

39 Salvador Dalí, "The Stinking Ass," trans. J. Bronowski, *This Quarter* 5, no. 1 (September 1932); reprinted in Lucy Lippard, ed., *Surrealists on Art* (Englewood Cliffs, N.J.: Prentice-Hall, 1970), p. 97.

40 Ibid.

41 Hans Bellmer, interview with Peter Webb, in Peter Webb with Robert Short, *Hans Bellmer* (London: Quartet Books, 1985): "the body is like a sentence that invites us to reimagine it, so that its real meaning becomes clear through an endless series of anagrams" (p. 38).

42 Hans Bellmer, *L'Anatomie de l'image* (Paris: Terrain Vague, 1977), p. 38; cited and translated in Webb and Short, *Hans Bellmer,* p. 102.

43 Freud, "The Sexual Aberrations," p. 566.

44 Stekel discusses "the field of 'partialisms'" in *Sexual Aberrations,* pp. 38f.

45 Bellmer, *L'Anatomie de l'image,* p. 38; cited and translated in Webb and Short, *Hans Bellmer,* p. 103.

46 Among other activities during his brief life, Piero Manzoni (1933–1963) made a series of textured abstract paintings, the *Achromes,* and collected, signed, and put up for sale ninety sealed cans of his excrement (*merda d'artista*), to be sold at the price per gram of gold.

47 See Michael Camille, *The Gothic Idol: Ideology and Image-Making in Medieval Art* (Cambridge: Cambridge University Press, 1989), p. 42.

48 Ibid.

49 Ibid., p. 219.

50 Von Boehn, *Dolls and Puppets,* p. 102.

51 Ibid., p. 37.

52 See Audrey Topping, "Clay Soldiers: The Army of Emperor Ch'in," *Horizon* 19, no. 1 (January 1977), pp. 4–13.

53 Von Boehn, *Dolls and Puppets,* p. 78.

54 Ibid., p. 80.

55 On the scarecrow, see James Giblin and Fale Ferguson, *The Scarecrow Book* (New York: Crown, 1980). On the mannequin, see Parrot, *Mannequins.*

56 Von Boehn, *Dolls and Puppets,* p. 72.

57 See Klaus Gallwitz, *Oskar Kokoschka und Alma Mahler: Die Puppe, Epilog einer Passion* (Frankfurt am Main: Städtische Galerie im Stadel, 1992); and Frank Whitford, *Oskar Kokoschka, a Life* (New York: Atheneum, 1986), esp. pp. 124–25 (chapter 11 discusses Kokoschka's doll).

58 See "A Shocking Tale about Dummies That Smart," *Discover* (July 1986), p. 7 (unsigned).

59 See Albert Bandura, "What TV Violence Can Do to Your Child," *Look* (October 22, 1963), pp. 46–48; and *Psychological Modeling: Conflicting Theories* (Chicago: Aldine; New York: Atherton, 1971).

60 See chapter 1, "Love," in Harry F. Harlow, *Learning to Love* (San Francisco: Albion, 1971), which discusses the affectional systems, maternal love, and infant love.

61 Clement of Alexandria, cited in Camille, *The Gothic Idol*, pp. 14–15.

62 J. J. Pollitt, *Art and Experience in Classical Greece* (Cambridge: Cambridge University Press, 1972), pp. 60–61.

63 Ibid., p. 63.

64 Ernst Kris (written in collaboration with E. H. Gombrich), "The Principles of Caricature," in *Psychoanalytic Explorations in Art* (New York: Schocken Books, 1964), pp. 201–02.

65 Ibid., p. 192.

66 For a note on what Dalí termed his "retrograde technique," see e.g. Lucy R. Lippard, ed., *Surrealists on Art* (Englewood Cliffs, N.J.: Prentice-Hall, 1970), p. 96.

67 In *Five Faces of Modernity* (Durham: Duke University Press, 1987), Matei Calinescu argues for a similar recalibration between modern and postmodern.

68 Despite my discomfort with such overused hierarchical terms as "high" and "low," in this case they seem appropriate since I am adopting them from the dominant standpoint of modernist history. [Kelley's comment appeared in the body of the text in its first appearance.—JCW.]

69 Udo Kultermann, *New Realism* (Greenwich, Conn.: New York Graphic Society, 1972), chapter 6, "The New Tradition," discusses the continuities of neorealism with various traditions of realism, including "experiments with colored wax sculptures" in the seventeenth and eighteenth centuries (p. 24).

70 See Dennis Adrian, *John De Andrea/Duane Hanson: The Real and the Ideal in Figurative Sculpture* (Chicago: Museum of Contemporary Art, 1974).

71 For the classic statement on the antithesis between avant-garde art and kitsch, see Clement Greenberg, "Avant-garde and Kitsch" (first published in *Partisan Review* 6, no. 5 [Fall 1939]), in Greenberg, *The Collected Essays and Criticism*, ed. John O'Brian, vol. 1: *Perceptions and Judgments, 1939–1944* (Chicago: University of Chicago Press, 1986), pp. 5–22.

72 See *Charles Ray*, curated by Paul Schimmel (Los Angeles: Museum of Contemporary Art, 1998). *Male Mannequin* (1990) is reproduced on p. 25.

73 Lewis MacAdams, "Sex with the Dead: Is John Duncan's Latest Performance Art or Atrocity?" *Wet* (Santa Monica), no. 6 (March/April 1981), p. 60.

74 Freud, "The 'Uncanny,'" p. 389. He rephrases this statement in note 1 to chapter 4 of *Civilization and Its Discontents*, trans. and ed. James Strachey (New York: Norton: 1961), p. 51; first published 1930.

75 Ibid., p. 387.

76 Stekel, *Sexual Aberrations*: "There is in all cases of fetishism a tendency to the formation of series and a sort of harem" (p. 33).

CROSS-GENDER/CROSS-GENRE

MK *This paper was originally presented on September 26, 1999, in Graz, Austria, at the Steirischer Herbst festival as part of "Re-Make/Re-Model: Secret Histories of Art, Pop, Life, and the Avant-garde"—a series of panel discussions sponsored by the Berlin Group and the Steirischer Herbst focusing on the politics of queer aesthetics. I also mounted a video installation at the Palais Attems titled "Unisex Love Nest," which included a feature-length videotape compilation composed of selections of period cross-gender-related films and documentation, as well as contemporary interviews with some of the artists.*

JCW *A slightly different version of this text, without notes, appeared in* PAJ: A Journal of Performance and Art *(Johns Hopkins University Press), no. 64 [vol. 22, no. 1] (January 2000), pp. 1–9.*

———————————

My intention here is to present some thoughts on the aesthetics of the period from the mid-1960s to the mid-1970s in relation to images of gender confusion. This decade, which, for want of a better term, I call the "psychedelic" period, is rife with such images. I will attempt to explain why I believe this is so, and to describe some of the avant-garde clusters and pop genealogies associated with this cross-gender phenomenon.

Jack Smith, still from unidentified performance (1965). Courtesy of Plaster Foundation.

It's best to begin by explaining where I come from and thus why this theme is important to me. Born in 1954, I came of age at the tail end of the 1960s, a period of immense social change and unrest in America. I was fourteen in 1968, conscious enough to feel a part of the general social turmoil, too young to be a real hippie, but just old enough to be eligible for the Vietnam draft. However, my worldview was very much a by-product of the countercultural movement. As a result, I had nothing in common with my older siblings. They were "postwar"; I was part of the TV generation. I was mediated . . . I was "Pop." I didn't feel connected in any way to my family, to my country, or to reality for that matter: the world seemed to me a media facade, and all history a fiction—a pack of lies. I was experiencing, I think, what has come to be known as the postmodern condition, a form of alienation quite different from postwar existentialism because it lacks any historical sense—there is no notion of a truth that has been lost. It is characterized by the feeling that there is a general evenness of meaning. To borrow a phrase from Richard Hell, I was part of the "blank generation."[1]

I was, however, sufficiently caught up in the '60s ethos to involve myself in radical politics, at least as a spectator. In Detroit, Michigan, the city where I grew up, the local version was the White Panther Party[2]—supposedly a white spin-off of the revolutionary Black Panther Party. In reality it had more in common with the Yippies,[3] the mostly white, hedonist, anarchist group whose politics consisted primarily of "acting out"—making one's life into a kind of radical street theater. The purpose of this exercise was to render oneself unfit to function in normal society, and thus to prevent oneself from participating in and prolonging it. As the logic went, if one consumed enough drugs, one simply could not work in the military-industrial complex.[4] White Panther activity was centered in the college town of Ann Arbor, and my interest in it drew me to related avant-garde music, theater, film, and political events. This is what led me to become an artist, which is quite remarkable, since I come from a working-class background and had little or no exposure to the fine arts as a child.

This psychedelic culture[5] completely altered my worldview. When I first heard psychedelic music,[6] it was as if I had discovered myself. I had never cared much for music before I heard bands like the MC5, the Stooges, the Mothers of Invention, and Jimi Hendrix. Their fractured music made sense to me—it mirrored the nature of the world as I understood it, and that of my own psyche. Of course, as every educated person knows, this was all old hat in relation to modernism—the

avant-gardes at the beginning of the century: cubism, futurism, dada, and surrealism. But I was encountering a phenomenon of mass culture, not high art. One of the most interesting things about the late '60s is that the historical avant-gardes were picked up and inserted into popular culture under the guise of radical youth culture. In one swoop, surrealism became teenybopper culture. This was possible because the artists working in this crossover period still considered themselves *avant-garde,* a notion still conceivable in those years. "Progressive" psychedelic music emerged, formally, in concert with notions of progressive social change, a liaison that, while it quickly fell apart (as evidenced in the irony of the camp aesthetic),[7] was still operable at that moment. There are several strains within this progressive aesthetic, almost all sharing a link to the notion of the feminine.

The popular appeal of '60s radical youth culture in America was very much a by-product of the anti-Vietnam War movement. For the first time, complacent white youths were delivered into political consciousness by the threat of military conscription. The model for social protest was the black civil rights movement; the pacifist tendencies of Martin Luther King worked well with an antiwar message. It was this coincidental encounter between two very different constituencies that provoked, I believe, white male youths' profound empathic connection to "otherness" in general. But the greatest "other" was woman. If America's problems were the result of being militaristic and patriarchal, the antidote would be the embrace of the prototypically feminine.[8] And contemporary radical culture was dominated by displays of femininity (pacifism, long hair, flowery clothes) presented as signs of resistance.[9] But not only femininity, male homosexuality as well, for the two were conflated in the popular mind.[10] If the female is other, then the homosexual is doubly other since he was supposed by straight culture to be "unnatural." In a sense, the Vietnam War itself promoted this posture, since one way to escape the draft was to play gay, a masquerade that may be one motivating factor for the coming decade of popular homosexual posturing that finds its apex in glam rock.[11]

Hippie and flower child cultures are the "natural" versions of this dyad of the feminine and the homosexual, and camp is its unnatural cousin. Despite the fact that they are both generally "progressive" and "leftist" and share many surface similarities, they are aesthetically opposed. Jack Smith, godfather of the New York '60s avant-garde theater and film scene, exemplifies the difference.[12] Smith was a major influence on diverse New York trends (he was important, amazingly

enough, to both the minimalist and maximalist camps); Warhol's narrative films and the theater of Robert Wilson would almost be inconceivable without him, as would the junk sensibility of the East Village aesthetic. Yet Smith achieved his greatest notoriety by making the first avant-garde transvestite film, *Flaming Creatures* (1962–63)—a kind of structuralist parody of Orientalist Hollywood films of the 1940s. Smith's embrace of the phoniness of these films is central to the camp aesthetic—and its politics. The camp aesthetic itself is suspect, for you are never sure whether its joys are real or ironic. It is an arcane aesthetic. Like Smith, hippie culture also embraced non-Western cultures, mixing them together in a psychedelic stew. But the hippie aesthetic invested in a "truth" located in the "other," who becomes our savior. While there is little room for irony in this essentialist position, it too is suspect, for the other in hippie culture is generally presented through exotic clichés—media-derived stereotypes of the Native American, the Indian mystic, and so on. The hippie aesthetic now seems kitsch, even if that was not the intention. Hippie has become camp by default.

The primary signifier of psychedelic culture, the pastiche aesthetic, promotes confusion while at the same time postulating equality—all its chaotic parts are considered equal. This effect can be understood as either very democratic or profoundly nihilistic. We could describe the difference as set between a "utopian" and a "black" version of camp. The Cockettes—and the films of Steven Arnold—illustrate this difference.[13] The Cockettes were a San Francisco-based troupe that produced a kind of campy and parodistic transvestite theater that, unlike traditional transvestite shows, reveled in the exhibition of the incomplete pose. Though they wore extravagant costumes that mimicked 1930s Hollywood notions of glamour, their feminine masquerade was deliberately provisional and half-accomplished. The "queens" often had beards—a definite no-no in transvestite acts where "passing" as a woman is the sign of quality.[14] The Cockettes included women, yet these did not usually cross-dress as men. The aesthetic of the group was organized around a redefinition of glamour—an "alien" glamour, if you will, but one still rooted in a feminine pose. Such was the group's debt to hippie culture: they represent a true crossover between hippie communalism and a later, more overtly defined, "queer" aesthetic.

In the films of John Waters, by contrast, while no vestige of hippie remains, there is a similar play with gender slippage in the figure of the grotesque "drag queen" Divine, who could never be mistaken for a woman.[15] Waters celebrates "queerness" for its abject nature relative to

Production still, The Cockettes in *Luminous Procuress* (dir. Steven Arnold, 1971). Photo: Scott Runyon. Courtesy Sebastian.

dominant American society. One need not search for an outside aesthetic in his films, because "you," the supposedly empathic film viewer, already represent the other.[16] The negative connotations of being "artistic"[17]—that is, pathological—are presented in Waters's films in a completely unsublimated manner. The freakish characters in his films were not designed just to be laughed at; they are, in a sense, role models. His are low comedies with no ascendant intentions and no redeeming social value—they are post avant-garde and proto-punk.

The Mothers of Invention have an abject aesthetic similar in some ways to Waters's, but more traditionally avant-garde. The Mothers were a rock band formed in the mid-1960s by white R&B musician Frank Zappa,[18] who combined dissonance with his R&B roots under the influence of new music composer Edgard Varèse.[19] The Mothers' music exemplifies the psychedelic aesthetic in its use of pastiche structures, combining elements of pop, rock, free jazz, new music, electronic music, and comedy. The effect is akin to a live reenactment of a tape collage work by John Cage. The band was also overtly theatrical, adopting transgressive stage techniques (such as audience baiting and performative discontinuity)[20] derived from such modernist, post-Brechtian forms as the Happening. Their visual aesthetic was neodada: abject, "junk," and ugly. The Mothers were part of a larger community of musicians and artists in the Los Angeles area, centered primarily around Zappa, called the Freak Scene, which openly positioned itself against the hippie aesthetic of the natural.[21] This scene included the avant-garde rock groups Captain Beefheart, Alice Cooper, and the GTOs, the latter an all-female band composed of groupies.[22] All of these acts employed drag elements from time to time.[23]

As with the Cockettes, the Mothers' version of drag was incomplete. But there are differences, for, despite their ridiculous image, the Cockettes had a playful, positive quality absent from the Mothers—whose use of drag has more in common with the traditional comedic adoption of female garb by the male, and is in that sense an abject usage. In Western culture, men who dress in female clothes are considered funny, while the opposite is generally not the case: a woman dressed in male clothes has little comedic value. The sexism underlying this difference is obvious, for why else should the adoption of feminine characteristics by a man be abject?[24] This is not to deny that the Mothers were a politically conscious band—in fact, they were one of the most politically aware musical groups of the period. In a sense, though, they were a realist band ridiculing the romantic utopianism and exoticism of hippie psychedelia. Their satiric ugliness was meant to be a distorted mirroring of the values of dominant culture.

Film still, Divine in *Pink Flamingos* (dir. John Waters, 1972). Courtesy John Waters and New Line Cinema.

The Alice Cooper band is somewhat similar, but more pop: their aesthetic is more flat and their intentions are less clear.[25] Like Zappa's, early Alice Cooper records mix rock and roll with noise elements influenced by avant-garde music. Both share that anti-hippie reveling in the aesthetics of the ugly, though for Alice Cooper it's a blend of transvestism and cheap horror-film theatrics. Their "decadent" mixture of horrific and homosexual signification was designed for a much more general audience than Zappa's. Like Waters, they were unapologetic in their embrace of the low. It could be said that they were the first truly popular camp band—with two separate audiences. Alice Cooper was a very commercially successful pop band, putting out a string of top ten hits including ironic saccharine ballads that some of their audience read as parodies, while others embraced them as genuinely emotional.[26] Similarly, one part of their audience empathized with their freakish, decadent personas, while another simply perceived such roles as comedic. By virtue of their use of camp strategies, Alice Cooper could be said to have "outed" the spectacular aspects of pop music.

Pop music in America has long embraced the "glamorous," a.k.a. the homosexual, in closeted terms. Liberace's campy stage act was never discussed openly in relation to his homosexuality. The performer himself foreclosed such considerations, once winning a lawsuit against a British gossip columnist who merely intimated that he was a homosexual.[27] Somewhat ironically, considering the purported "sexual" nature of the musical form, such sublimation pervades the history of rock and roll. Elvis's appearance was repellent at first to his primarily country music audience because of his use of makeup;[28] but as he became more and more of a popular figure, this aspect of his stage act became invisible—naturalized. The so-called British invasion bands of the mid-1960s, like the Rolling Stones, picked up on this "glamorous" posturing, filtering it through English visual tropes of foppish "decadence."[29] Mick Jagger's stage movements were at once "black" and "gay," which made him twice evil—and doubly sexualized—in the eyes of his teenybopper fans. Such posing signals a major change in the pop arena, for its open flirtation with "evil" is something that Elvis, with his desire to be a mainstream pop star, could never have entertained. It was only within the framework of the '60s counterculture that such a "transgressive" aesthetic could find acceptance as "popular" music.

From Jagger on, a whole string of figures raise the stakes in decadence and danger. The two most important are probably Jim Morrison of the Doors[30] and Iggy Pop of the Stooges.[31] Morrison is rumored to have lifted his leather boy look from the rough trade posturings of the Warhol

Eleanor Antin, *Portrait of the King* (1972). Black and white photograph. 10 x 14 ins.
Courtesy Ronald Feldman Fine Arts, New York.

scene,[32] and his confrontational stage act from the methods of the Living Theatre.[33] Iggy Pop's vile and self-destructive stage persona became the model for the later punk rock performers of the '70s. In American culture at least, much of the aesthetics of "homosexual evil" can be traced back to the work of filmmaker Kenneth Anger,[34] whose book *Hollywood Babylon,* focusing on the dark and degraded subhistory of Hollywood glamour, is the bible of camp.[35] Anger's films detailing various American subcultures seen through a homosexual gaze set the standard for much pop art following in the Warholian tradition. It is through Kenneth Anger that the leather-clad 1950s juvenile delinquent, with his emotion-laden pop songs, finds his way into the camp pantheon,[36] enters the Velvet Underground, and finally comes to rest in the leather uniform of punk. His influence also helped convert the macho posturings of the biker thug into a sign of the alienated and sensitive artist—witness Patti Smith's image mix of leather boy and romantic poet. Likewise, it is through Anger, whose interest in popular subcultural ritual led him to ritual magic, that Satanism—as another sign of decadence—enters the pop music world[37] (primarily through the Rolling Stones in their psychedelic period, when they adopted Anger's look lock, stock, and barrel).[38]

What becomes of this "outing" of the abject nature of the feminine, consensually precipitated in music and avant-garde cultures?[39] As "transvestite" counterculture leaves the utopianism of the 1960s behind and enters the economically harsher social climate of the 1970s, two major trends emerge: feminism and punk. In the context of all this female posturing, it only makes sense that female artists would finally demand to play a role. Even though there were female members of such "transvestite-oriented" groups as the Cockettes—and the various versions of the Ridiculous Theater in New York[40]—the outward signs of most of the costuming were female-coded. Some of the female artists involved with these theater companies describe their experiences as a kind of self-exploration in relation to conventions of glamour.[41] As participants in the antipatriarchal tenor of the period, they were not particularly interested in experimenting with the adoption of male gender stereotypes. With her overtly S&M persona as the whip dancer with the Velvet Underground, her "butch" roles in Warhol's films, and her masculine portrayals in John Vaccaro's plays, Mary Woronov is the exception here.[42] More commonly, the female participants were primarily concerned with their own relationship to female stereotypes. The GTOs, for example, invented a look that was a trash version of the female Hollywood stars of the 1920s and 1930s.[43] Like the Warhol "star system," this was meant as a retooling, or redefinition, of that beauty, yet was still tied to it through the inversions of camp.[44] Several female artists in the early 1970s began to

experiment with shifting roles and identities in relation to issues of glamour and gender. Eleanor Antin, for example, made a work titled *Representational Painting* (1971), for which she sat in front of a mirror applying makeup, removing it, and applying it again in a constant state of "pictorial" self-definition.[45] She later adopted a series of overtly theatrical personas, including a king, a nurse, and a ballerina.[46] This kind of play reached its zenith in Judy Chicago's feminist workshop programs in the Los Angeles area in the early 1970s.[47] Here, female artists collectively explored their relationship to various female stereotypes in a much more critical and politically conscious environment than had previously been possible. Their performances used such stereotypes as the cheerleader, bride, waitress, beauty queen, and drag queen as a way of exploring and destabilizing female stereotypes.

The rise of glam rock was concurrent with this movement. In America at least, Alice Cooper is a key transitional figure, in that he leaves psychedelia behind and fully embraces the frameworks of pop—trying, that is, to balance irony and popular appeal. Glam rock was a music that fully understood the commercial music world and accepted it as an arena of facade and emptiness, using the image of the drag queen as a sign of this status. David Bowie is crucial here.[48] He adopts personas, throws them away at whim, and constantly reinvents himself for the market. He mirrors our culture of planned obsolescence. For consumer culture, it has been suggested, the constantly changing, chameleon persona *represents* empowerment. Certain feminist critics have read Madonna's activities in this way, though I have serious misgivings about this interpretation of her practice—or of Bowie's.[49] Madonna becomes the sign of a spectacular female producer, in contrast to the traditional image of the passive female consumer. I might add that this is how the GTOs thought of themselves: as consumers—groupies—who became producers—rock stars themselves.[50] The spectacular is engaged head-on through pure emulation.

Punk was the immediate response to this fixation with spectacular consumer culture; it replaced the spectacular with the pathetic.[51] Punk was the last gasp of avant-gardism in pop, played out with the most extreme signs of decadent nihilism. As a symbol of this end state, the gender significations of the previous avant-garde were reversed: maleness became the general referent. The punk uniform is the macho rough trade look of Kenneth Anger's camp leather boy—for men and women alike. Androgyny remains a factor here, but whether the punk "unisex" image was a vestige of some connection to the utopian, feminine androgyny of the psychedelic period, or is simply consistent with the capitalist cult of youth culture, is open to argument. But that's another story.

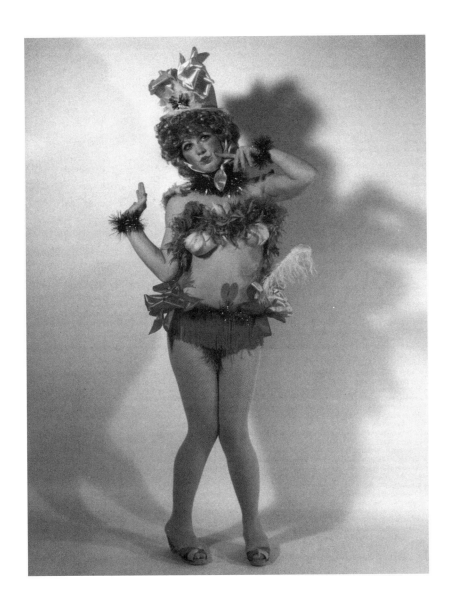

Nancy Youdelman, *Kewpie Doll* (1970). Costume designed by Nancy Youdelman and modeled by Cheryl Zurilgen. Photo: Dori Atlantis. Feminist Art Program, Fresno State College. Courtesy Nancy Youdelman.

New York Dolls, promotional still for Mercury Records press kit, 1973.

NOTES

1 The poet and punk rock musician Richard Hell recorded *Blank Generation* in 1976 (Ork Records). His intentions, signaled in the song's title, differed from its general reception: "People misread what I meant by 'Blank Generation.' To me, 'blank' is a line where you can fill anything in. It's positive. It's the idea that you have the option of making yourself anything you want, filling in the blank. And that's something that provides a uniquely powerful sense to this generation. It's saying, 'I entirely reject your standards for judging my behavior.'" Cited in Clinton Heylin, *From the Velvets to the Voidoids: A Pre-Punk History for a Post-Punk World* (New York: Penguin Books, 1993), p. 123.

2 The core White Panther texts are collected in John Sinclair, *Guitar Army: Street Writings/Prison Writings* (New York: Douglas Book Corporation, 1972).

3 Key Yippie publications include: Abbie Hoffman, *Revolution for the Hell of It* (written under the pseudonym Free) (New York: Dial Press, 1968); Abbie Hoffman, *Woodstock Nation: A Talk-Rock Album* (New York: Vintage Books, 1969); Jerry Rubin, *Do It* (New York: Simon and Schuster, 1970); and Jerry Rubin, *We Are Everywhere* (New York: Harper and Row, 1971).

4 "The whole push of the industrial world is to enslave people. The corporations are just modern versions of the old feudal system—in fact they call the factories 'plants,' which is short for 'plantation,'—you dig? . . . Take LSD a few times and you become physically incapable of having anything to do with it." John Sinclair, cited in "The Penitentiary Ain't Shit to Be Afraid Of: Interview with Peter Steinberger" (1972), in Sinclair, *Guitar Army,* p. 182.

5 For a history of the rise of American psychedelic culture, see Martin A. Lee and Bruce Shlain, *Acid Dreams: The CIA, LSD, and the Sixties Rebellion* (New York: Grove Press, 1985).

6 On psychedelic music, see Vernon Johnson, *The Acid Trip: A Complete Guide to Psychedelic Music* (Todmorden, Lancashire: Babylon Books, 1984); Gene Sculatti and Davin Seay, *San Francisco Nights: The Psychedelic Music Trip 1965–1968* (New York: St. Martin's Press, 1985); Jim DeRogatis, *Kaleidoscope Eyes: Psychedelic Rock from the '60s to the '90s* (Secaucus, N.J.: Citadel Press, 1996).

7 On camp, see Susan Sontag's seminal essay "Notes on Camp" (1964), in *Against Interpretation and Other Essays* (New York: Farrar, Straus and Giroux, 1966), pp. 277–93; on Kenneth Anger, Jack Smith, and Andy Warhol, see Phillip Monk, "Beat Brando, Camp Brando," in *American Playhouse: The Theatre of Self-Presentation* (Toronto: The Power Plant, 1998), pp. 15–27; see also Kim Michasiw, "Camp, Masculinity, Masquerade," in Elizabeth Weed and Naomi Schor, eds., *Feminism Meets Queer Theory* (Bloomington: Indiana University Press, 1997), pp. 157–86.

8 "A new consciousness is rising out of the morass of a declining society that has bent too far toward rationalism, toward technology and toward the acquisition of power through unbridled competition. . . . The new consciousness takes note that our society has become overbalanced in favor of the so-called 'masculine' qualities of character. The new orientation that is gaining influence may be characterized as emphasizing 'feminine' values, or values that in the past, at least, have been associated more with the feminine than with the

masculine. Among these values is a preference for cooperation rather than competition, for a team approach to problems rather than a strictly individualistic approach, for giving credit to intuition at times over and above a deliberate thinking process, and for emphasizing sexuality and relationship over and above power and violence." June Singer, *Androgyny: Toward a New Theory of Sexuality* (Garden City, N.Y.: Anchor Books, 1977), p. 15.

9 "The pig police are the shock troops of cultural repression and as such are extremely interested in snuffing out even the external manifestations of our culture. They pretend they are 'only doing their job,' but they follow our cultural developments very closely and get their weird sexual kicks by arresting and beating freeks and other new people. They can't just fuck, they have to try to stop other people from fucking (which will never work) and from even *saying* 'fuck.' They seem to have no other sex life. . . . They get their rocks off by arresting us for getting ours off however naturally we can, and by any means necessary. They are sick, insane, perverted PIGS who can't stand to see us having a good time even as we struggle for our freedom. They hate us and everything we do or stand for. They want to cut our hair off because it shows them that we are free from the honkie work ruse and the perverted standards of 'manliness' and 'femininity' they use to keep people trapped in inhuman sexual roles." John Sinclair, "Our Culture Is a Revolutionary Culture" (1969), in Sinclair, *Guitar Army,* pp. 148–49.

10 "It is because it is not too far removed from the binarism of phallic power that becoming-woman can play this intermediary role, this role as mediator vis-à-vis other sexed becomings. In order to understand the homosexual, we tell ourselves that it is sort of 'like a woman.'" Félix Guattari, "Becoming-Woman," in François Peraldi, ed., "Polysexuality," *Semiotext(e)* 10 (Autonomedia, 1981), p. 87.

11 For an overview of glam rock, see Barney Hoskyns, *Glam!: Bowie, Bolan, and the Glitter Rock Generation* (New York: Pocket Books, 1998).

12 On Jack Smith, see J. Hoberman, "The Theatre of Jack Smith," *The Drama Review,* no. 81, pp. 3–12; Stefan Brecht, *Queer Theatre* (New York and London: Methuen, 1986), pp. 10–27 and pp. 157–77; Edward Leffingwell et al., *Flaming Creature: Jack Smith, His Amazing Life and Times* (London: Serpent's Tail, 1997). Smith's writings are collected in *Wait for Me at the Bottom of the Pool: The Writings of Jack Smith,* ed. J. Hoberman and Edward Leffingwell (New York: High Risk, 1997).

13 The Cockettes appear in performance in the underground films *Palace* (1971), dir. Scott Runyon and Syd Dutton, which documents the Cockettes' first Halloween show, *Les Ghouls,* at the Palace Theatre in San Francisco; *Tricia's Wedding* (1971), dir. Sebastian; and *Luminous Procuress* (1971), dir. Steven Arnold. Other films by Arnold include *Messages, Messages* (1972) and *Flesh Garden* (1974). A biographical sketch is provided in Peter Weiermair, *Steven Arnold: 'Exotic Tableaux'* (Kilchberg/Zurich: Stemmle, 1996), pp. 9–13. See also the recent documentary *The Cockettes* (dir. David Weissman and Bill Weber, 2001), GranDelusion Productions.

14 The following exchange is from an interview by Mike Kelley with Sebastian, conducted in 1999.

> Mike Kelley: Can you say a little bit about how the Cockettes developed their cross-dressing aesthetic? They are interesting in that their look seems to be a mix of drag and hippie cultures.
>
> Sebastian: Exactly. That was really them. I don't know how they came up with it, but it was certainly original at the time. The only drag that you saw in San Francisco then was the typical drag

show where they would pull off the wig at the end, and the Cockettes were totally different from that. A lot of them had beards. It was like a sketch; a sketch doesn't always tell the full story, but it gives you the idea. And this idea was in itself somewhat revolutionary. And, also, they weren't just men dressing as women—there were plenty of women in the group too. Sometimes they played men's roles, but quite often they didn't. They liked to call themselves "The Theatre of Sexual Role Confusion." I always liked that term a lot. It's much better than "gender-bender."

15 On John Waters, see Brecht, *Queer Theatre,* pp. 137–56. Also John Waters, *Crackpot: The Obsessions of John Waters* (New York: Random House, 1987) and *Shock Value: A Tasteful Book about Bad Taste* (New York: Dell, 1981).

16 "Unlike kitsch-attribution, then, camp-recognition doesn't ask, 'What kind of debased creature could possibly be the right audience for this spectacle?' Instead, it says *what if:* What if the right audience for this were exactly *me*? What if, for instance, the resistant, oblique, tangential investments of attention and attraction that I am able to bring to this spectacle are actually uncannily responsive to the resistant, oblique, tangential investments of the person, or of some of the people, who created it? And what if, furthermore, others whom I don't even know or recognize can see it from the same 'perverse' angle?" Eve Kosofsky Sedgwick, *Epistemology of the Closet* (Berkeley: University of California Press, 1990), p. 156.

17 For a discussion of gender readings and the social role of the artist, see chapter 2, "Women and Artists, Students and Teachers," in Howard Singerman, *Art Subjects: Making Artists in the American University* (Berkeley: University of California Press, 1999), pp. 41–66.

18 On Frank Zappa and the Mothers of Invention, see Michael Grey, *Mother! The Story of Frank Zappa* (London: Plexus, 1993); Frank Zappa with Peter Occhiogrosso, *The Real Frank Zappa Book* (New York: Poseidon Press, 1989); and Ben Watson, *Frank Zappa: The Negative Dialectics of Poodle Play* (London: Quartet, 1993).

19 On the relationship of Zappa's music to Varèse, see Watson, *Frank Zappa,* pp. 4–8, 46–61.

20 For a description of Mothers of Invention shows at the Garrick Theatre, New York, in 1966, see ibid., pp. 87–88; for the bigger concerts of the late 1960s, see Grey, *Mother!,* pp. 88–89.

21 For the views of Zappa (and others) on the Freak Scene, which Pamela Des Barres describes as "postbop, pre-pop," see Watson, *Frank Zappa,* pp. 33–35.

22 In 1967 and 1968 Zappa started two record labels, Bizarre and Straight, and released albums by Alice Cooper, Captain Beefheart, the GTOs, Lenny Bruce, Lord Buckley, and the street musician Wild Man Fischer, among others.

23 On the cover of the album *We're Only in It for the Money* (1968), the Mothers pose, in drag, in a tableau that parodies the cover of the Beatles' *Sergeant Pepper's Lonely Hearts Club Band*. Members of Captain Beefheart's Magic Band wear women's clothes in photos on the cover of the album *Trout Mask Replica* (1969).

24 In *Vested Interests: Cross-Dressing and Cultural Anxiety* (New York: Routledge, 1992), Marjorie Garber puts it like this: "If 'woman' is culturally constructed, and if female impersonators are *conscious* constructors of artificial and artifactual femininity, how does a 'female impersonator' differ from a 'woman'? The question

seems both ludicrous and offensive, but its theoretical and social implications are large and important. Female impersonators are often accused of misogyny (and regularly deny the charge), but in the female impersonator, the feminist debate about essentialism versus constructedness finds an unexpected, parodic, and unwelcome test" (pp. 354–55).

25 See Alice Cooper and Steven S. Gaines, *Me Alice: The Autobiography of Alice Cooper* (New York: Putnam, 1976).

26 Alice Cooper's hit singles in the 1970s include "I'm Eighteen" (1971), "School's Out" (1972), "Elected" (1973), "No More Mr. Nice Guy" (1973), and "Only Women Bleed" (1975).

27 Liberace writes about his lawsuit against the London *Daily Mirror* gossip columnist "Cassandra" in his book *Liberace: An Autobiography* (New York: Putnam, 1973).

28 Garber, again (*Vested Interests,* p. 367): "Elvis's appearance at the Grand Ole Opry, at the very beginning of his career, provoked a double scandal. His music was too black, and he was wearing eyeshadow. He was not asked back. For Chet Atkins, soon to become organizer of Elvis's recording sessions in Nashville, the one lingering memory of Elvis at the Opry was his eye-makeup. 'I couldn't get over that eye shadow he was wearing. It was like seein' a couple of guys kissin' in Key West.'"

29 "If Mick Jagger and Brian Jones used camp principally to underscore their basic machismo, when the Stones dressed in drag for their 'Have You Seen Your Mother, Baby, Standing in the Shadow' promo film, they were merely ridiculing female stereotypes—they none the less created a climate in which boys could flirt with homosexuality as a mode, a pose. Jagger's wiry androgyny was a potent rejection of 'straight' masculinity, heavily inspired by the foppish bisexual aristocrats with whom the Stones were consorting." Hoskyns, *Glam!,* p. 12.

30 On Jim Morrison and the Doors, see Jerry Hopkins and Daniel Sugerman, *No One Here Gets Out Alive* (New York: Warner Books, 1980).

31 See Iggy Pop, *I Need More* (Los Angeles: Thirteen Sixty-one, 1996); chapter 3, "Energy Freak-Out Freeform (1968–71)," in Heylin, *From the Velvets to the Voidoids,* pp. 32–43. The best source for information on the Stooges is probably "I Wanna Be Your Dog: 1967–1971," in Legs McNeil and Gillian McCain, *Please Kill Me: The Uncensored Oral History of Punk* (New York: Grove Press, 1996), pp. 27–86.

32 Poet, photographer, and assistant to Andy Warhol in the Factory, Gerard Malanga performed as a bullwhip dancer (along with Mary Woronov and Ronnie Cutrone) with the Velvet Underground as part of Warhol's multimedia show "The Exploding Plastic Inevitable." Malanga's trademark at the time was his leather pants. "Jim Morrison came to see us at the Trip, because he was a film student in LA at the time. That's when, as the theory goes, Jim Morrison adopted my look—the black leather pants—from seeing me dancing on stage at the Trip." Gerard Malanga cited in McNeil and McCain, *Please Kill Me,* p. 17.

33 Jim Morrison was charged with indecent exposure and other crimes after a concert with the Doors in Miami in 1969. He had been to a performance of *Paradise Now* by the Living Theatre shortly before this concert; see Hopkins and Sugerman, *No One Here,* pp. 222–23.

34 On Anger, see Bill Landis, *Anger: The Unauthorized Biography of Kenneth Anger* (New York: Harper Collins, 1995).

35 Kenneth Anger's *Hollywood Babylon* (San Francisco: Straight Arrow Books, 1975) was originally published in France by J. J. Pauvert, Paris, in 1959.

36 In *Scorpio Rising* (1964), Kenneth Anger's ironic, sentimental portrait of rebel biker culture, the soundtrack is composed of such then-current pop songs as "Fools Rush In" by Ricky Nelson and "Blue Velvet" by Bobby Vinton.

37 "Anger's use of Brando (in film snips from *The Wild One* in *Scorpio Rising*) allowed the filmmaker to continue his Luciferian themes of disobedience in a more recognizable image of delinquency, now pop cultural rather than esoteric. Satanism having become pop cultural by the late 1960s, the theme would resurface without disguise in Anger's *Invocation of My Demon Brother* in 1969." Monk, "Beat Brando," p. 24.

38 In their promo film for *Jumping Jack Flash* and on the cover of the album *Their Satanic Majesties Request,* the Stones' look is overtly Angeresque. "The Stones own 'flirtation' with evil continued when Mick Jagger, Keith Richards and Marianne Faithful became involved with Kenneth Anger's infamous *Lucifer Rising,* eventually released with a prison-recorded soundtrack by Manson acolyte Bobby Beausoleil. Jagger was supposed to play Lucifer to Richard's Beelzebub but—in Anger's own words—'backed away from being identified with him.' 'Kenneth had a very conscious influence over the Stones,' Marianne Faithful told Mick Brown. 'I think he thought Mick and the rest of the group could embody his vision.'" Barney Hoskyns, *Waiting for the Sun: Strange Days, Weird Scenes and the Sound of Los Angeles* (New York: Penguin, 1996), p. 175.

39 "I do not want to simply equate abjection with the feminine, but rather to acknowledge how patriarchal notions of femininity have been adopted for transgressive means. For, as Kristeva asks, 'does not the combat against the phallic sign and against an entire monological culture finally sink into the substantial cult of woman?' Here one must remark, however, that what connotes the 'cult of woman' (or the 'feminine') may have absolutely nothing to do with women; within a patriarchal society it connotes, rather, that which is not man. (For example, the 'feminine' connotes the body, nature, passivity, amorphousness versus man's mind, culture, activity, form.) If one accepts, then, the transgressive to be feminine and strives for a situation where 'everyone and everything becomes Woman—as a culture obsessively turns itself inside out—where does that leave women?' The privileging of the feminine in a transgressive discourse by no means guarantees liberation." Leslie C. Jones, "Transgressive Femininity: Art and Gender in the Sixties and Seventies," in *Abject Art: Repulsion and Desire in American Art* (New York: Whitney Museum of American Art/D. A. P., 1993), p. 34.

40 The term "Ridiculous Theater" has been used generically to describe the theater works of Charles Ludlum, Ronald Tavel, and John Vaccaro; see Brecht, *Queer Theatre,* and Bonnie Marranca and Gautam Dasgupta, *Theatre of the Ridiculous* (Baltimore: Johns Hopkins University Press, 1998).

41 Interviewed by Kelley in 1999, the performance artist Jacki Apple notes: "So the question was, could power exist within the same framework as beauty as defined by the culture at large—as glamour? So we decided to experiment with this. And of course the place that we had to look wasn't in the images of the '60s à la Twiggy, which is an androgynous kind of image and did not represent power but more of a kind of adoles-

cent—and all of fashion in the '60s sort of remade woman in a girl image, you know, with Mary Jane shoes and little puff-sleeve dresses. So the place we had to go back to for that coalition, that merging, of power and beauty was basically to the films of the '40s—to the powerful, glamorous movie stars of the '40s."

42 Woronov's most famous roles are Hanoi Hanna in Andy Warhol's *Chelsea Girls* (1966) and Tamburlaine in John Vaccaro's production of Charles Ludlum's *Conquest of the Universe* (1967). For Woronov's own account of her years in the Warhol scene, see Mary Woronov, *Swimming Underground: My Years in the Warhol Factory* (Boston: Journey Editions, 1995). Stefan Brecht enthuses about Woronov in Brecht, *Queer Theatre*, pp. 56–59.

43 On the GTOs, see Pamela Des Barres, *I'm with the Band: Confessions of a Groupie* (New York: Morrow, 1987).

44 "Warhol's second-period films, all in sound, were vehicles that he specially tailored for a new phenomenon— the underground superstar. Sensing the avant-garde cinema needed its counterparts to Hollywood's legendary stars, Warhol began to establish a stable of performers comparable to that of the old studio system. Between the final weeks of 1964 and the early months of 1965, he ushered in a new era of cinematic glamour with films constructed around the personalities of two underground movie queens: Mario Montez, a female impersonator, and Edie Sedgwick, a scintillating young socialite. Montez, representing a perverse inversion of movie-star attractiveness, contributed a new element of absurdity to Warhol's already controversial reputation, while Sedgwick gave him a chic respectability among the socially prominent." David Bourbon, *Warhol* (New York: Abrams, 1989), p. 196.

Jackie Curtis, another Warhol transvestite superstar, talks about his/her relationship with Hollywood glamour in Blair Sabol and Lucian K. Truscott IV, "The Politics of the Costume," *Esquire*, no. 75 (May 1971), p. 133: "The costume for Jackie is a critical part of her lifelong desire to be a star. In the facing photograph, she is sporting the bodice worn by Lana Turner in *The Prodigal* and feathers which once belonged to Marlene Dietrich. The setting is Ruby Shoes Day, a Village shop featuring properties acquired at last year's M-G-M auction. [Jackie Curtis said,] 'Being a star occupies every moment of my existence. Imagine how it feels to look like Rita Hayworth and feel like the reincarnation of James Dean. Hell—that's what. When you feel that way there's nothing left for you to do *but* go out there and star.'"

45 Eleanor Antin, Adrian Piper, Martha Wilson, and Jacki Apple all made work involved with role playing; see Lucy R. Lippard, "Making Up: Role Playing and Transformation in Women's Art" (1973), in *From the Center: Feminist Essays on Women's Art* (New York: E. P. Dutton, 1976), pp. 101–08.

46 A major retrospective, *Eleanor Antin,* curated by Howard Fox, was put on at the Los Angeles County Museum of Art in 1999.

47 See Faith Wilding, *By Our Own Hands: The History of the Women Artist's Movement, Southern California 1970–1976* (Los Angeles: Double X, 1977). See also Moira Roth, *The Amazing Decade: Women and Performance Art in America 1970–1980* (Los Angeles: Astro Artz, 1983); and Norma Broude and Mary D. Garrard, *The Power of Feminist Art: The American Movement of the 1970s, History and Impact* (New York: Abrams, 1994).

48 See Henry Edwards and Tony Zanetta, *Stardust: The David Bowie Story* (New York: McGraw-Hill, 1986).

49 This is Garber (*Vested Interests,* pp. 126–27) on Madonna: "But the moment (at a performance on a video awards show) that scandalized critics was a moment of sheer quotation from Michael Jackson, when Madonna danced toward the audience and squeezed her crotch. Now, in video and live dance performance Michael Jackson often makes this kind of theatrical gesture, and no one ever complains—quite the contrary. But Madonna, squeezing what she hadn't got (or had she?), emblematized the Lacanian triad of having, being, and seeming. Squeezing the crotch of her pants became for her, onstage, the moment of the claim to *empowered transvestism,* to seem rather than merely to have or to be—*not* (and this distinction is important) just a claim to empowered womanhood. In this moment, and in the very fact that she chose the cross-dressed costume from her longer video to present at the opening of the awards show, Madonna became transvestism itself, the more so since she was, apparently, so deliberately troping off Michael Jackson."

50 "Not too long ago, the GTOs arrived at the A&M Records studios for a photo session. They looked about the way they usually look: full freak. And on this day there seemed to be a sartorial leaning toward the 1940s in style and cut. . . . What the GTOs have going for them is, really, a dream come true. Now they're a group! Now they're making records! Now they're appearing in public. Now they're being interviewed and written about and photographed. It's as if they'd become the stars they'd so long worshiped." John Burks and Jerry Hopkins, *Groupies and Other Girls* (New York: Bantam, 1970), pp. 78–79.

51 In 1970, Lester Bangs had already anticipated the rise of the pathetic rock movement that came to be called punk. This is from a review of the Stooges, the godfathers of punk: "What we need are more rock 'stars' willing to make fools of themselves, absolutely jump off the deep end and make the audience embarrassed for them if necessary, so long as they have not one shred of dignity or mythic corona left. Because then the whole damn pompous edifice of this supremely ridiculous rock n' roll industry, set up to grab bucks by conning youth and encouraging fantasies of puissant 'youth culture,' would collapse, and with it would collapse the careers of the hyped talent-less nonentities who breed off of it." Lester Bangs, "Of Pop and Pies and Fun: A Program for Mass Liberation in the Form of a Stooges Review, or Who's the Fool?" (1970), in Lester Bangs, *Psychotic Reactions and Carburetor Dung* (New York: Alfred A. Knopf, 1987), p. 34.

SECTION II

MEKANÏK DESTRUKTÏW̄ KOMMANDÖH: SURVIVAL RESEARCH LABORATORIES AND POPULAR SPECTACLE

JCW *Commissioned for the journal* Parkett *(Zurich, Berlin, New York; no. 21, 1989, pp. 122–40), Kelley's essay on Survival Research Laboratories attempts to read the work of the San Francisco-based group less in relation to the punk subcultures in which they were most often situated than across wider contexts in art and popular visual culture. The text here returns to Kelley's original manuscript and is substantially longer than the piece that first appeared over a decade ago. Some of the editorial changes made by* Parkett *to the first two-thirds of the essay have been retained.*

—I got up and danced
the disasters—
Gongs of violence and how—
show you something—Berserk
machine—"Shift cut tangle
word lines—Word falling—
Photo falling—"

William Burroughs[2]

Survival Research Laboratories is the name of an artist's collective based in the San Francisco area that produces, in their own words, "Spectacular Mechanical Presentations." The main members of the group, which is constantly augmented by shifting numbers of volunteers, are Mark Pauline, the founder and artistic director, Matthew Heckart, and Eric Werner (though it has recently been reported that SRL has split apart, leaving Pauline in control). The group began staging their events in the late '70s, roughly coinciding with the explosion in the United States of the punk movement, with which SRL is often associated. The name "Survival Research Laboratories" was taken from a survivalist organization that placed a one-time advertisement in the mercenary magazine *Soldier of Fortune.*[3] The name recalls those of many ultraradical fringe political groups, military organizations, and cults that camouflage their extremist positions behind titles that read, on the surface, as cool, business-like, normative—the false fronts behind which hide the secret and harmful societies that are the mainstay of paranoid conspiracy theory. The public image that SRL has cultivated also ironizes corporate rhetoric through the use of titles for their activities that mimic the wordy and technical-sounding language of big business: "AN EPIDEMIC OF FEAR: THE RELIEF OF MASS HYS-TERIA THROUGH EXPRESSION OF SENSELESS JUNGLE HATE," "DELIBERATELY FALSE STATEMENTS: A COMBINATION OF TRICKS AND ILLUSIONS GUARANTEED TO EXPOSE SHREWD MANIPULA-TIONS OF FACT," "EXTREMELY CRUEL PRACTICES: A SERIES OF EVENTS DESIGNED TO INSTRUCT THOSE INTERESTED IN POLICIES THAT CORRECT OR PUNISH," "FAILURE TO DISCRIMINATE: DE-TERMINING THE DEGREE TO WHICH ATTRACTIVE DELUSIONS CAN OPERATE AS A SUBSTITUTE FOR CONFIRMATION BY EVIDENCE," "A PLAN FOR SOCIAL IMPROVEMENT BASED ON ACHIEV-ING COMPLETE FREEDOM FROM THE CONSTRAINTS OF CIVILIZATION."[4]

SRL's aesthetic appropriates the styles of the military-industrial complex yet subverts it by foregrounding its destructive purpose. Besides adopting the language of the corporation, they have also taken on its outward signs: the representative logo and standardized graphic style. Survival Research Laboratories' two-part symbol is an image of this unmasking of the destructive impulse: one part shows a male head framed in a circle containing a triangle that carries the SRL initials; the second part replaces the head with a skull—the death's head.

SRL's mechanical presentations, usually held outdoors, are demonstrations of homemade weaponry and robots. The machines are very much the stars of the show; like those black-draped figures in traditional Japanese theater, the artists are reduced to nearly invisible caretakers. SRL's

machines and devices are amazingly varied and quite spectacular: *Shock Wave Cannon* focuses the blast from a half stick of dynamite into a coherent shock wave; *Fluorescent Tube Gun* fires illuminated tubes at 200 mph from eight barrels; *Stairway to Hell* is an escalator that carries objects up only to drop them to the pavement; the spider-like *Walking Machine,* which spits fire, is controlled by an on-board guinea pig; *Mechanical Hand* is contained in its own vat of oil; *Mechanical Mummy Dogs* are a carousel of mechanically activated dead dogs; *Sprinkler from Hell* sprays burning gasoline; *Big Man,* a giant robot with a spinning Manson-like head, has flamethrower arms. Other devices include bomb-tossing catapults, mechanical biting metal skulls, hopping machines, machines that propel themselves on giant screws, reanimated cow carcasses, and machines that shoot explosive darts or blow off shotgun blasts. These devices fight with each other, tear apart animal corpses, or destroy symbols of human order such as the *SRL Shantytown,* a mobile suburban house, or the *Tower of Babel,* a mammoth windmill with spinning blades. Like grotesquely expanded children's war games endowed with real destructive potential, the shows provoke in the audience a mixture of delight and fear.

Each year SRL's presentations become larger and more complex. Developing from small-scale, stable, motorized-junk contraptions like *Assured Destructive Capability* (1979)—a machine that, among other things, defaced photos of Soviet premier Leonid Brezhnev (tape documentation was banned by the governments of East Germany and Czechoslovakia)—the events have swelled to grand theatrical spectacles involving numerous radio-controlled mobile robots and set pieces. With the aid of an expanded audience of technical-specialist fans, the collective's technology has become more elaborate and sophisticated. Current projects include experiments with computer-programmed robots and military-style lasers. At the same time, the group has begun to tour more frequently; in 1988 SRL made their first European tour.

In line with SRL's association with subcultures, they have chosen to operate through popular forms of media, such as magazines and video, rather than in galleries or other art-world venues. And their performances, often staged in out-of-the-way industrial areas to small audiences (though the size is growing), have begun to attract a wider public through video documentaries. Directed by Jonathan Reiss,[5] their tapes combine highlights of the machine shows with behind-the-scenes action footage and interviews with group members. Reiss is currently attempting to get the tapes stocked in home-video rental stores, a few of which already carry them in their "cult" sec-

tions. The tapes are distributed and sold through the mail by the alternative culture journal *Re/Search* (an outgrowth of the old punk magazine *Search and Destroy*) which often does features on SRL. In addition, the group appears in the pages of other underground publications, like independent music magazines, where they are usually the only "artists" included. By virtue of these diverse outlets, SRL has acquired a mixed audience that extends far beyond the "high culture" arena of the art world. However, despite the fact that SRL has had relatively little exposure in the art world proper, it is quite well known there. (It has even been suggested that Bruce Nauman's recent mechanical animal-carcass sculptures owe more than a little to SRL's notorious mix of machine part and beast flesh.)[6]

This subcultural popularity has recently started to filter upward, usually into the cracks in the mass media reserved for oddities. SRL has been profiled on television news programs and on magazine format shows like *Believe It or Not*.[7] They have also created machines for Hollywood films and an artist's segment for MTV. The MTV commission they cleverly turned to their own advantage (such segments usually only function as filler between rock videos) by designing it in the form of a television commercial for themselves. SRL's attitude toward the coopting power of dominant media recalls that of the Yippies, who saw the mass media simply as another public forum, like the street, which could be used to communicate one's message. If the material is radical enough, they believed, it would filter through the homogenizing and moralizing intent of media containment.

SRL appears, of course, at the tail end of modernism's long history of fascination with the machine. In avant-garde theater, that history commenced at the turn of the century with the symbolists' antinaturalism, which exhibited its distaste for merely human actors by replacing them with puppets—or, as Gordon Craig famously termed them, "übermarionettes."[8] The modernist tendency to mechanize theater appears in Russian constructivism, futurism, dada, and the Bauhaus, all of which furnish examples of pseudorobot, puppet, and/or abstract-mechanical, actorless theater. The division between the symbolist and modernist use of the machine is usually situated along the difference between the puppet, or automaton, and the robot—a difference Jean Baudrillard defines as being "between a simulacrum of the first order and one on the second."[9] The "second order," Baudrillard suggests, is opposed to theatrical illusion: "no more resemblance or lack of resemblance, . . . but an imminent logic of the operational principle."[10] The automaton mimics the human; the robot is true to mechanical efficiency. The latter is exemplified in

"Biomechanics," an actors' training system developed by the Russian director Vsevolod Meyerhold which attempted to apply Taylorist principles of industrial work efficiency to the theater.[11]

However, SRL has little in common with this sort of technological utopianism. If anything, they are the flower borne by the antitechnological, nihilistic seed of dada. In fact, SRL's activities are often compared to those of various artists of the late 1950s and early 1960s referred to as neo-dadaists. This group included the artists associated with DIAS, the Destruction In Art Symposium, held in London in 1966,[12] and with the machine sculptor Jean Tinguely.[13] Tinguely's machine events, like *Homage to New York,* the self-destructing machine built in the garden of the Museum of Modern Art in 1960, and *Study for the End of the World No. 2,* the large-scale mechanical spectacle utilizing explosives done in the Nevada desert in 1962, have been cited as precursors to SRL. But what separates SRL from Tinguely is the fact that Tinguely's work (like that of many of the '60s Happenings artists) was created as a reaction to the issues and techniques of abstract expressionism. Many of Tinguely's early mechanisms were designed specifically to produce abstract gestural paintings, and the machines themselves recall this type of painting both compositionally and in their manner of execution. The work of Gustave Metzger, organizer of the DIAS events and the author of a number of manifestos on "Auto-Destructive Art," can also be seen as a response to abstract expressionism.[14] His *Demonstration of Acid Nylon Technique* (1960)[15] replaces the "creative" layering of Pollock with "destructive" subtraction by substituting acid for paint, thereby erasing part of the support with each gestural stroke. Vestiges of painterly practice can be found in the technological action collages of Wolf Vostell, and even in the blood rituals of the Austrian Hermann Nitsch,[16] two contemporary artists whose works have also engaged with overt destruction.

Ultimately, SRL's aesthetic is closest to some of the lesser-known DIAS artists whose work seems informed by the political street theater popular in the 1960s. These artists replaced the Jungian timelessness of abstract expressionism with an emphatic topicality, the sign of which is the mass media photograph. Ivor Davies's *Robert Mitchum Destruction/Explosion Event* (September 13, 1966) and Werner Schreib's *Spiral of Crisis* (1966), in which a photo of a public figure is burned,[17] clearly update and extend the time-honored political gesture of burning public figures in effigy. But now the effigies do not stand in for the public figures themselves but for their media representations. Many of SRL's machines also incorporate photographic elements, but theirs are reminiscent of the picture displays found in historical or science museums—except that they replace the order

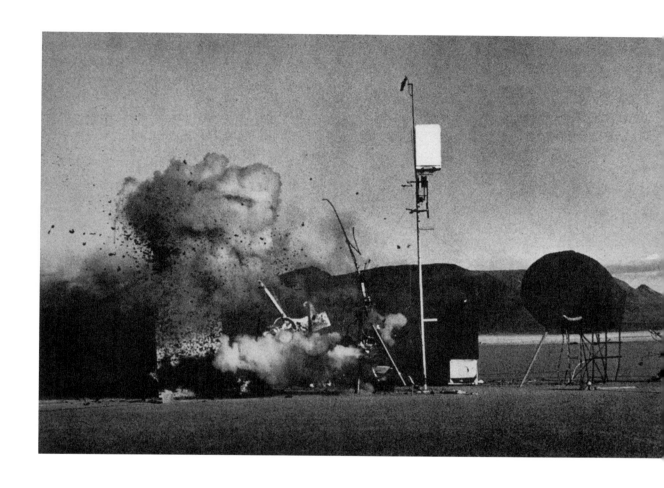

Jean Tinguely, *Study for the End of the World No. 2* (live machine event utilizing explosives in Nevada desert, 1962). Courtesy Allan Grant/Time Pix.

of history and the logic of science with the disorder of riot and disaster. *Spinning Picture Display* features photographs of this kind: an oversize "flip book" repeatedly presents three scenes of doom; a giant photograph depicting the 1960 assassination of the Socialist prime minister of Japan includes a ringing bell, a stabbing arm, and a blood pump; and the massive, shuffling architectural photo-collage, *Wave Attack* consists of walls of glass coated with images of mayhem—as it moves forward missiles are shot through it. Theatricalized violence counters images of violence.

SRL is also a generation removed from the agitprop directness of the neodadaists. Though SRL's work is obviously political, it refuses to reveal any clear position, focusing instead on the negative, coercive aspects of political rhetoric. In one performance, leaflet bombs exploding overhead rained down a shower of tracts on the audience: "RADIATE INFLUENCES OF DESPAIR AND DEFEAT WHEREVER YOU GO; DO ANYTHING WRONG TO GET PUBLIC APPROVAL; CALL THE TRUTH AN INSULT TO AVOID ACCEPTING IT AS FACT," etc.[18] Like Jenny Holzer's "Truisms,"[19] these directives adopt the syntax of "plain truth," but they are only empty rhetoric, designed to produce knee-jerk emotional responses.

SRL's relationship to the media imagery they use is also quite different from that of earlier artists. SRL knowingly operates within the mediated world, rather than adopting a separatist stance and pointing out how one is acted on by it. Current art-world strategies call for a more organic relationship between the artist and the media—after being suitably deformed, material taken from the mass media must be reinserted back into it. In this regard, Pauline connects to the generation of art students–turned–rock stars chronicled in Simon Frith's and Howard Horne's *Art into Pop,* which addresses the British scene.[20] Taught by media-conscious pop artists, British art students took the logical next step, abandoning the art world to enter the popular arena. Avant-garde experimentation and radical postures were packaged for popular consumption. Pete Townsend credits Metzger as an influence on the infamous end-of-concert instrument-smashing episodes of the Who.[21] And it should be remembered that Metzger's DIAS companion Ralph Ortiz was well known at the time for demolishing pianos and other objects with a sledgehammer. These actions, featured in a contemporary *Life* magazine cover story,[22] were later parodied on the *Monkees* television show with Liberace substituting for Ortiz as the piano-smasher. Young artists coming into prominence now are much more likely to have been influenced by such mass media spectacles than by artists working strictly within the realm of the fine arts.

Much of SRL's mystique relates to such theatrics and the packaging of rock rebellious-ness—despite Pauline's displeasure at the comparison. Heavy metal bands like Blue Öyster Cult also adopted the corporate logo, overlaying on it a poetics of death. And for SRL, as with these media-conscious bands whose image precedes their presence, going on tour augments the already fa-miliar product. This fact produces an interesting schism between expectation and experience, for there is quite a difference between SRL live and on tape. The editing of their video documentaries leaves the impression that SRL's events are highly choreographed, nonstop tableaus of destruction. In fact, if SRL owes anything to its Happenings forefathers, it is in the Cagean randomness and dy-namic evenness of their performances. Despite all the shocking imagery, noise, and destruction, the events are quite boring. The shows begin when the machines are turned on and end when they break down. Though there is some attempt at dynamics in the shows, the gradual introduction of the machines and the buildup of tension before key machines engage in combat (for example), the general effect is one of chaos, accentuated by blaring tape-collage soundtracks. There is much dead time, and many technical failures and accidents, all of which add to the feeling of designed anticontrol. At the same time, there is constant evidence of the recording process: the ever-present lights and camera operators. As in sports events in which media presence is similarly integrated into the action, all the boring subevents and preparation time are made up for in one moment of per-fection, designed to be captured in freeze frame.

There are other obvious comparisons to be drawn between SRL and such lower-class spectacles as fire and brimstone, special effects–oriented heavy metal arena concerts, and auto-mobile stunt shows like demolition derbies, truck pulls, big-wheeler events, and rocket car racing. Truck pulls originated in farm-related competitions of tractor strength, but have developed into ma-chine circuses where the competition is a supplanted spectacle—much like professional wrestling, which has become a scripted burlesque of competitive sport, fetishizing violence. Big wheelers—altered pickup trucks fitted with massive oversize tires, individually styled and named—run over and crush rows of cars. One particularly popular truck, named Bigfoot, has even been personified and made into the hero of a children's cartoon show.[23] Rocket cars are, essentially, rocket engines mounted on wheels, producing an unsteerable—and unbrakable—vehicle. One demonstration of them, called a meltdown, consists of placing a junked car or bus in the rocket exhaust flames. The

rocket car, fixed in position, torches the junker, sending sparks into the air. This is especially beautiful at night when the shooting sparks resemble fireworks.

Georges Bataille wrote that there is "the necessity of a division between the economic and political organization of society on one hand, and on the other, an antireligious and asocial organization having as its goal orgiastic participation in different forms of destruction, in other words, the collective satisfaction of needs that correspond to the necessity of provoking the violent excitation that results from the expulsion of heterogeneous elements."[24] SRL aligns itself with this second category as it exists in American culture. In contrast to culture-affirming, nationalistic, middle-class spectacles such as holiday parades, football halftime shows, and the Olympic Games festivities and the Statue of Liberty celebration (two massive public theatrical productions staged by David Wolper[25]—the Albert Speer of the 1980s), there are those other events that mirror the joys of conspicuous accumulation with those of mass destruction. Paul Virilio suggests that "next to the Hall of Machines they put a Hall of Accidents."[26] SRL seems to have responded by creating an industrial machine show of mistakes infused with the negative images associated with rock music and horror film—the images of death, destruction, riot, crime, and war so loved by the masses (yet denied by official culture). They have created a circus that struggles against becoming an opiate.

SRL's similarity to these low spectacles, and their use of kitsch, automatically raises questions of class conflict: SRL could be said to employ a form of class primitivism. But unlike modernist primitivism, organized around the lure of the exotic and the new (witness the cubist interest in African sculpture, and dada's love of jazz), SRL is drawn to the familiar and worn-out. In this they seem to exhibit a "camp" aesthetic—an aesthetic that implies the superiority of the viewer, as in the "knowing" snideness of Jeff Koons, for example. But SRL's work doesn't have this effect. There is no sense of superiority; on the contrary, we experience an all-over quality of degradation. The "happy" exotica and Muzak played before the shows acts as soundtrack music for the videotapes and a foil to heighten the "horror" of the machine show proper (though each comes off as equally dull). Happiness and the horrible are represented by tired clichés. There is a certain pathos in the very failure of these signs to mean as expected. But pathos is denied by the interjection of humor—and even this is qualified, for the humor is one of cruelty, a black humor.

Pauline once suggested that his decision to use machines instead of actors was based on the notion that people respond more to a mechanical presence than a human one. This also ex-

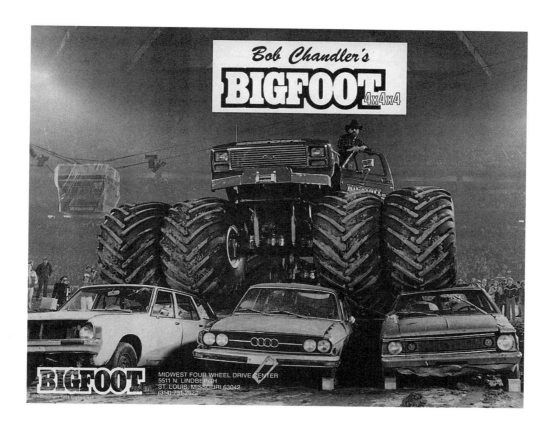

Bigfoot, promotional still (1984). Courtesy Bob Chandler and Bigfoot 4x4, Inc.

plains SRL's use of animal corpses and body parts, for the machine and the animal are man's most riveting "others"—those things that challenge our superiority by their very similarity to us; that provoke an uncanny sense of familiarity—yet are so alien. Indeed, we constantly try to force machines and animals into being non-alien by dressing them up in human garb and personifying them. Television cartoon shows reveal the power that these images exert on the popular imagination, for the majority of them concern either the personified machine—the robot—or the talking animal. The truth of Pauline's observation that people identify themselves more closely with the nonhuman is revealed by the response SRL receives to their use of dead animals. For, of all the disturbing material that they employ, this draws the biggest howls of protest. Disturbing photos taken from animal rights pamphlets are exploited by SRL in their own graphics, furthering the controversy. Like everyone else, SRL buys its meat from the butcher. All the group does is to present this flesh in public—and a flood of collective guilt ensues. The food industry, like the military, operates in secret; meat products bear little resemblance to animals. Yet when recognizable animal flesh is set in a theatrical context, especially when contrasted with the blind activity of machinery, waves of black fantasies are drawn out—the satanist, the sadist, the inhuman, the "animal" nature of man, are the obvious culprits. Not us—we are indignant.

SRL's most direct use of personification is in their only nondocumentary videotape, *A Bitter Message of Hopeless Grief* (1988), a production that differs from the others in its narrative form and adoption of the conventions of filmic reality. No more than a series of tableaus, the story depicts a day in the life of some cave-dwelling machine/animal/monsters whose activities consist entirely of fighting, hunting, and destroying—a puppet show version of survival of the fittest. In the tape, the machines lose their mechanical identity almost entirely and take on an animal projection. It reminds me very much of a Disney-type nature docudrama, the kind where personified animals goodheartedly suffer through the trials of the natural world. SRL offers a cruel parody of these kinds of films: obvious allegories of the expected behavior of John Q. Public. Recalling popular depictions of dinosaurs, those behemoths of chaos that fought in prehistoric landscapes of fire and lava before the arrival of man and reason, the protagonists, the symbols of "nature"—of "us"—are blind engines of destruction posed in phony sets.

SRL's machines are dinosaurs in a number of ways, not only in size and shape but also in their failure. Dinosaurs are the exemplary metaphors of failure: they are extinct. The pathos evoked

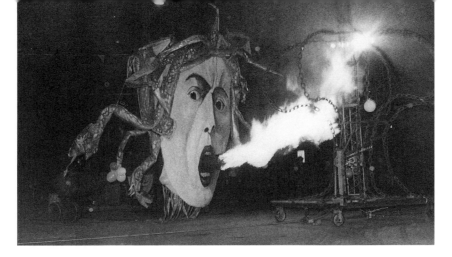

Survival Research Laboratories, *Carnival of Misplaced Devotion*
(performance in Seattle, June 23, 1990). Courtesy Sixth Street Studio.

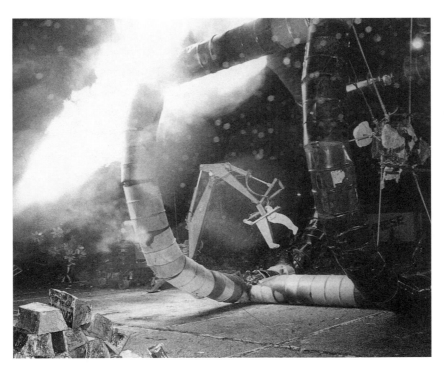

Survival Research Laboratories, *Misfortune of Desire Acted Out at an Imaginary Location
Symbolizing Everything Worth Having* (performance at Shea Stadium, New York, in connection
with The Kitchen, Creative Time, and The New Museum, New York, May 17, 1988). Courtesy
Sixth Street Studio.

in SRL's shows by the breakdown of the machinery and mechanical disorder is heightened by the fact that the machines offer a nostalgic representation of dinosaur technology, composed as they are of parts picked from the industrial graveyard. SRL's use of collected trash also links them to the West Coast Beat tradition of junk assemblage.[27] The use of refuse in Beat assemblage is very different from that of its dada models. In dada assemblage the junk functions in a "timely" manner; it pictures a current state. But in Beat assemblage the junk has come to represent timelessness. Like a memento mori these objects position man in sublime relation to eternity. Viewing them provokes an undefined sense of loss.

The current wave of "postindustrial" romanticism evident in popular entertainment is manifested in many forms: in cyberpunk science fiction literature; in films like *Alien* (dir. Ridley Scott, 1979) which picture the future by imaging not sleek space rockets but rather hulking and rusted space tugboats; in David Lynch's films, such as *Eraserhead* (1977), set in surreal, crumbling industrial wastelands; and in industrial music, a romanticized, and thus no longer concrete, form of "concrete music"—tone poems painting the industrial landscape, our version of the Gothic castle falling into ruin. It is interesting to compare SRL's use of the ruins of industry to the work of Robert Smithson. Smithson was a self-defined classicist whose roots were in the Beat movement. He was fixated on the timeless quality of the rotting industrial landscape—which reminded him, simultaneously, of both the long past and distant future. His equation: cave man equals space man. Touring the industrial sites of Passaic, New Jersey, he called the decaying industrial structures he found there "monuments."[28] Smithson reveled in seeing the "tools of technology become a part of the Earth's geology as they sink back into their original state." "Machines like dinosaurs," he continued, "must turn to dust or rust."[29] Like SRL, Smithson was a fan of the low: of the poetry of technical language, and of science fiction—that allegorical literature that illustrates the present in terms of the past or future. It is in his choice of science fiction that the difference between Smithson and the later artists is most clearly revealed. Smithson was drawn to the utopianism of science fiction imagery, to the primal forms and crystalline structures of future architecture. He searched after the timeless, the quotidian extended into geological duration. His interest in the image of decay was that it stopped time. Industrial ruins, he said, rise into decay rather than fall; they are like films run backwards.

SRL, on the other hand, is interested in decay that maintains its presentness. They are overtly dystopian, drawn to images of intensity, conflict, and corruption. If they are interested in

timelessness, it is the timelessness of the struggle for power, which always exhibits itself in particulars: the particular people, places, and things that power covets. The romantic, pathetic, and the spectacular are merely hooks to draw the viewer in. It sets up expectations that are never fulfilled. The work is full of contradictions, populist but confrontational, antiart yet avant-garde, spectacular but boring, nihilistic yet utopian. Pauline has said that he hopes to draw off the talent that normally would go into the military and product research. He believes that, if offered the choice, many engineers and scientists would rather work for an organization like Survival Research Laboratories, would rather engage in useless destruction than "useful" destruction. Looking at it in terms of these conflicts, dysfunction is an integral part of their aesthetic.

> we creatures of steel
> were ordered to carry the fat ones,
> > running on tires,
> were ordered to work in their factories.
> Shaft on shaft,
> for ages our flywheels
> and driving belts tore you apart.
> Shout, you motors!
> A great joy is ours!
> The fat ones are beaten.
> From now on, we're free!
>
> Vladimir Mayakovsky[30]

NOTES

1 The title is taken from the third record album by Magma (A&M Records, 1973). Magma's records were chapters of a continuing science fiction rock opera that follows the exploits of a group of space travelers. At one point they engage in battle with the people of ORK, who are described as being "made of indescribable matter which to the machines is what the machines are to man." The songs are sung in a language invented by the group.

2 William Burroughs, *The Soft Machine* (New York: Ballantine Books, 1961), p. 163.

3 Interview with Mark Pauline in *Industrial Culture Handbook, RE/search* (San Francisco), no. 6/7 (1983), p. 39.

4 Kelley complied these titles and the descriptions that follow mainly from the catalogue *Survival Research Laboratories* (Berlin: Vogelsang, 1988).

5 Jonathan Reiss also directs music videos, and recently completed a film on rave culture, *Better Living through Circuitry* (Cleopatra Pictures, 1999).

6 See e.g. *Hanging Carousel (George Skins a Fox)* (1988), reproduced in Jörg Zutter, *Bruce Nauman: Skulpturen und Installationen 1985–1990* (Cologne: DuMont, 1990), plate 4.

7 Named for cartoonist and author Robert L. Ripley (1893–1949), *Ripley's Believe It or Not* comic panel (first published in the *New York Globe* in 1918) was reinvented in a broadcast TV magazine format between 1982 and 1986, and has recently been revived.

8 On Edward Gordon Craig (1872–1966), see E. Gordon Craig, *On the Art of the Theatre* (London: William Heinemann, 1911); and his essay, "The Actor and the 'Übermarionette,'" written for *The Mask* (1: 3b–16b) in 1908.

9 Jean Baudrillard, *Simulations* (New York: Semiotext(e), 1983), p. 93.

10 Ibid, p. 95.

11 For an account of Vsevolod Meyerhold's (1874–1940) theory of biomechanics, see Edward Braun, trans. and ed., *Meyerhold on Theatre* (London: Methuen, 1969; revised ed. 1991), which includes "The Actor of the Future and Biomechanics," the report of a lecture Meyerhold delivered in Moscow in 1922.

12 On DIAS, see Kristine Stiles, "Synopsis of the Destruction in Art Symposium and Its Theoretical Significance," *The Act* (New York) 1, no. 2 (1987); and Barry Farrell, "The Other Culture," *Life* 62, no. 7 (February 17, 1967).

13 On Tinguely, see Pontus Hultén, *Jean Tinguely: A Magic Stronger Than Death* (New York: Abbeville, 1987).

14 "Auto-Destructive Art—Demonstration by G. Metzger" (South Bank, London, July 3, 1961, 11.45 a.m.–12.15 p.m.) is one of three manifestos written between 1959 and 1961 reproduced in facsimile in Udo Kultermann, *Art and Life* (New York: Praeger, 1971), p. 58.

15 The work is reproduced in Adrian Henri, *Total Art: Environments, Happenings, and Performance* (New York: Praeger, 1974), p. 167.

16 Wolf Vostel (b. 1932) organized a series of *Décoll/age happenings* in Germany, New York, and elsewhere, beginning in 1958. Herman Nitsch (b. 1938) first developed the ideas for his "Orgien-Mysterien-Theater" in 1957, and participated in Viennese actionism from around 1960.

17 Schreib's *Spiral of Crisis* (1966) is reproduced in "The Other Culture" (p. 86) with the caption: "Ludwig Erhard's picture covered with glue and gunpowder."

18 These phrases are cited mainly from *Survival Research Laboratories* (Berlin: Vogelsang, 1988).

19 On Jenny Holzer, see "David Askevold: The California Years," in this volume, note 12.

20 Simon Frith and Howard Horne, *Art into Pop* (London: Methuen, 1987).

21 Ibid., p. 100.

22 "The Other Culture" (see note 12, above); a photograph of Ortiz's demolition of a piano with Paul Pierrot is reproduced on pp. 94–95. See also the exhibition catalogue *Rafael Montañez Ortiz: Years of the Warrior, Years of the Psyche* (El Museo del Barrio, New York, March 26 to May 22, 1988).

23 On Bigfoot, see Kelley's "Urban Gothic," in this volume, note 18.

24 Georges Bataille, "The Use Value of D. A. F. de Sade" (1930), in Bataille, *Visions of Excess: Selected Writings, 1927–1939,* ed. Allan Stoekl (Minneapolis: University of Minnesota Press, 1985), p. 101.

25 Veteran film and TV producer David Wolper organized the opening and closing ceremonies for the 1984 Los Angeles Olympic Games with a reported budget of $5 million; he also staged the Statue of Liberty Rededication in 1986.

26 Paul Virilio and Sylvère Lotringer, *Pure War* (New York: Semiotext(e), 1983), p. 33.

27 See *Lost and Found in California: Four Decades of Assemblage Art,* curated by Sandra Leonard Starr (James Corcoran, Shoshana Wayne, and Pence Galleries, Santa Monica, California, July 16 to September 7, 1988); and *Forty Years of California Assemblage* (Wight Art Gallery, University of California, Los Angeles, April 4 to May 21, 1989).

28 Robert Smithson, "A Tour of the Monuments of Passaic, New Jersey" (first published as "The Monuments of Passaic," *Artforum* [December 1967]), in *The Writings of Robert Smithson,* ed. Nancy Holt (New York: New York University Press, 1979), pp. 52–57.

29 Robert Smithson, "A Sedimentation of the Mind: Earth Projects" (1968), in ibid., p. 85.

30 Vladimir Mayakovsky, "Mystery-Bouffe" (1921) in *The Complete Plays of Vladimir Mayakovsky,* trans. Guy Daniels (New York: Simon and Schuster, 1968), p. 133.

DEATH AND TRANSFIGURATION

JCW *Originally published with the subtitle "A Letter from America," Kelley's essay on Paul Thek was commissioned by Daniel Buchholz for the catalogue of the first major exhibition of Thek's work after his death in 1976 (Paul Thek, Turin, Castello di Rivara, September 1992, pp. 15–20). The catalogue also featured essays by Jean-Christophe Ammann and Gregorio Magnani. A German translation of Kelley's text was published in Texte zur Kunst (Cologne), December 1992, pp. 43–49.*

———————————

Nothing can prevent me from recognizing the frequent presence of images in the example of the multiple image, even when one of its forms has the appearance of a stinking ass and, more, that ass is actually and horribly putrefied, covered with thousands of flies and ants; and, since in this case no meaning is attachable to the distinct forms of the image apart from the notion of time, nothing can convince me that this foul putrefaction of the ass is other than the hard and blinding flash of new gems.

Nor can we tell if the three great images—excrement, blood and putrefaction—are not precisely concealing the wished for "Treasure Island."

Being connoisseurs of images, we have long since learned to recognize the image of

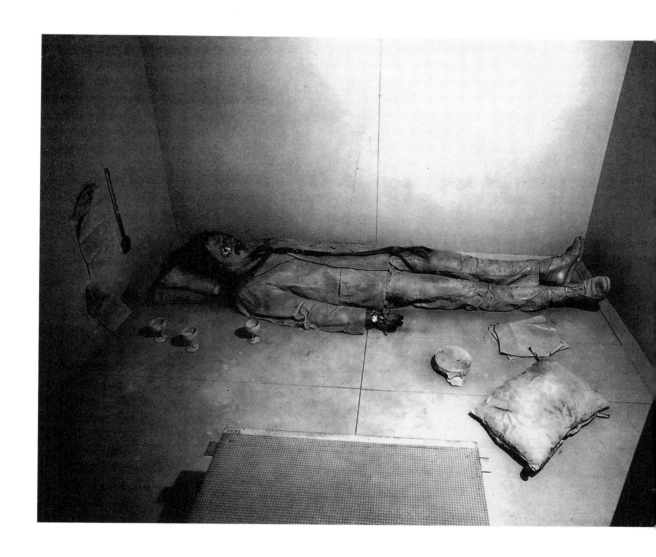

Paul Thek, *The Tomb—Death of a Hippie* (1967). Wax figure in wooden structure. 101 x 125 x 125 ins. Installation view at Stable Gallery, New York, 1967. Photo: John D. Schiff. Courtesy Estate of George Paul Thek and Alexander and Bonin, New York.

desire in images of terror, and even the new dawn of the "Golden Age" in the shameful scatol-
ogous images.

Salvador Dalí, "The Stinking Ass" (1932)[1]

Looking at Paul Thek's bio, it's interesting to discover that he had been showing consistently in art museums and galleries, and had been written about regularly in the art press, from the mid-1960s.[2] This came as a surprise, since I had always thought of Thek as an "artist's artist"—one of those shadowy figures who seem to exist only by word of mouth and are known to makers of art but not to those who respond to or record it. Why then, if Thek was always so present in the art world, has he passed so completely out of its history? He is not in any major United States museum collections, there is only one monograph on his work, now long out of print, and he is rarely included in the anthologies that purport to chronicle American art of the 1960s.[3] One example of Thek's marginal-ization can be found in Gregory Battcock's influential anthology *Minimal Art,* in which he is repre-sented by a single photograph (of one of his most reduced "technological reliquary" sculptures).[4] Neither this piece, nor Thek's work as a whole, is mentioned anywhere in the anthology; and the caption accompanying the single reproduction gives the reader no clue that the pristine Plexiglas structure houses a realistic wax depiction of meat—information that is crucial if Thek's work is to be differentiated from the abstract sculptures grouped around it in the book. One has the feeling that art history has purposely misrepresented Thek—or left him out entirely.

Though always quite well received when he was actively making art, for some reason Thek's work was seldom viewed as an appropriate representation of that time. Now, all of a sud-den, he is being written back into history. Why? One obvious reason is that so much recent art *looks like* Thek's. Perverse takes on minimalism, "body art," and "scatter art" dominate the New York galleries at the moment. And the critics seem to have been caught with their pants down, surprised and unable to account for such developments.[5] The works of Robert Gober, Kiki Smith, Charles Ray, Cady Noland, John Miller, Paul McCarthy, and many others need a lineage to explain them. Paul Thek is the man . . . maybe. The problem with digging up influences previously thought to be unim-portant is that it makes the revisionist look stupid for not seeing their importance all along. The way to remedy this unpleasant situation is to label the precursor as aberrant, as a freak of history. This

is the strategy that produces "visionary" artists, ones who can only be discussed in terms of later artistic discourses, not their own. Thek has been transformed into a visionary to explain and give credence to this later generation of artists. Yet discussion of Thek should obviously be grounded in his contexts in the 1960s and 1970s, not in 1990s art, and to label him as aberrant is willfully to forget a whole group of other artists (Lucas Samaras, Tetsumi Kudo, Ed Kienholz, Yayoi Kusama, Peter Saul, and others) whose work doesn't match our current understanding of 1960s art. All these artists approached the trash heap of 1960s counterculture a little too closely, which is the real reason for their exclusion from art history, and the reason they are labeled as aberrant. They were made to disappear, dealt a critical death blow. Unfortunately, Thek is literally deceased. He's not around to argue his place in history, to set records straight.

Fortunately, Thek's work short-circuits any sort of easy rescue job. For every aspect of it that is currently "acceptable," there are just as many that are gravely embarrassing to us now. Ironically, the overriding theme of many of his works is death and rebirth. So much so that Thek seems to point an accusatory finger at us and call out, *"fate has decreed that I would return."* And so he has, but it is a return fraught with problems. We are made to feel guilty when faced with it.

America's problem with Thek mirrors our culture's problem with the 1960s as a whole. It's amazing how different the art world's depiction of the decade is from the current political administration's treatment of the same period. To the art world, the 1960s was a glorious, almost classical, epoch. Art was cool, reasonable, and in touch with the national identity. The '60s was the last golden age of modernism, before the fall orchestrated by postmodernism. Compare this to the tale told by the Reagan/Bush clan. For them the 1960s was the *L* decade (for those unfamiliar with American political terminology, the *L* word is "liberal," the initial-only usage punning with the unmentionable *F* word): the out-of-control period directly responsible for America's economic and social decline. It was a period of dirt, mysticism, drugs, and anarchy: America's Dark Ages. This is Paul Thek's 1960s—which is why he is so hard to reconcile with the official versions of recent art history now emerging.

Contemporary American art history is spookily aligned with Reagan/Bush ideology. By excising artworks from the 1960s that mirror the social and political upheavals and countercultural activities of the period, or focusing on works primarily in the formalist tradition, an unspoken alliance is forged with the conservatives: both agree that these unsavory issues are not appropriate

for art, and thus for society. According to this narrative, Andy Warhol is the prototypical 1960s artist, and his silkscreen paintings are the apotheosis of the American art of that era. Drenched in user-friendly rationalism, they are formalism in populist drag. I simplify, of course. But it is in these terms that the work has reached its position of critical ascendancy. Eliminated from discussion, or demeaned as minor dalliances, are whole areas of Warhol's output that contradict his "high" status. I'm thinking especially of his films, which, by the very nature of their themes, "actors," and duration so perfectly reveal an audience at odds with museum culture. For the most part his paintings, by contrast, stick to traditional bourgeois themes: court portraiture and the still life denoting wealth. I often ask myself why Warhol did not bring the crummy street-world of his films into his paintings. Why, for example, did he never produce a portrait of Charles Manson,[6] who seems such an obvious and correct choice? What other figure so perfectly embodies the cultural conflict of the period? The answer is that there was no room in *art* for such a figure. To drag such base material into the hushed world of painting would run the risk of having Warhol's whole enterprise cast in a dangerous, "low" light: Andy's "factory" could become a doppelganger for Manson's "family."

Interestingly, Paul Thek and Andy Warhol made one collaborative work, *Meat Piece with Warhol Brillo Box* (1965), in which Warhol's sculpture becomes the vitrine that holds Thek's wax meat slab. At first it seems an unlikely pairing—the cool with the sexual, the hip with the foolish, the uninflected with the grotesque, the clean with the dirty. But then you realize that the connection lies in a kind of symmetrical perversity, in the strange parasitic relationship both of them have to the hard-edge aesthetic prevalent at the time. Thek's Plexiglas boxes reduce the minimalist aesthetic to display cases, while Warhol's boxes reduce it to commodities. In the collaborative piece, Warhol adopts the submissive role, becoming the surrogate defiled object, the stand-in for the derided primal form. In the current climate of art-world "outing," one is tempted to ponder their "collaboration" further, along the lines of the fantasies some weave around the relationship between Robert Rauschenberg and Jasper Johns.[7] This object is the only child of their union, however. Thek's work after the technological reliquaries goes in a direction completely incompatible with Warhol's aesthetic.

Death of a Hippie (1967) is the signpost for this change as well as, in my estimation, Thek's masterwork. Here, Thek tackles head-on the very material that Warhol shuns in his gallery work. The entombed hippie corpse (the "tripping corpse," to borrow a phrase from Raymond Pettibon)[8]

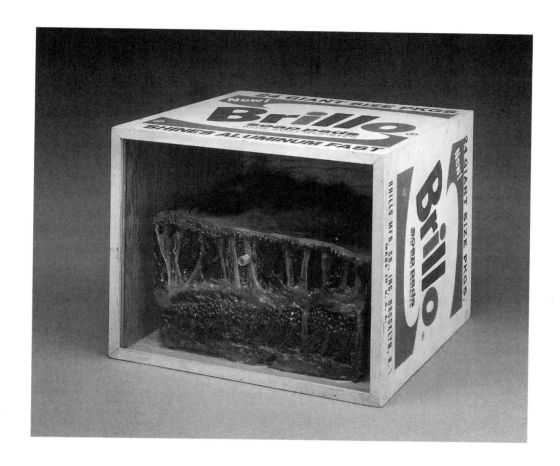

Paul Thek and Andy Warhol, *Meat Piece with Warhol Brillo Box* (1965). From the series *Technological Reliquaries.* Beeswax, painted wood, and Plexiglas. 14 x 17 x 17 ins. Photo: Graydon Wood. Courtesy Philadelphia Museum of Art: Purchased with Funds Contributed by the Daniel W. Dietrich Foundation.

is Manson, *is* the Altamont Hell's Angel:[9] the degraded end of hippie utopianism and the beginning of the notion of hippie as criminal burnout. Perhaps the direct result of his being shot by Valerie Solanis in 1968,[10] Warhol is the saintly JFK of the 1960s art world and the Factory his Camelot. The shooting was both his artistic assassination and his rise to glory. It signals the end of his association with street culture and ushers him fully into the pantheon of serious artists. It saves him from the bitter fate of being a "period" artist—the fate that awaited Paul Thek. Thek's complex allegory of the murder of the counterculture is meaningless in an art world that denies that hippies ever existed. Death of a hippie? How can something die that was born dead?

Official art culture is much more effective in its control of history than Republican strategists, for it knows that the best way to treat contradictory material is not to rail against it, but simply to pretend it didn't happen. Punk's reactionary anthems shouting "Kill the hippies!"[11] carried within them the seeds of the current neo-hippie revival. Such a return was so inevitable that the punk slogans are revealed as ironic—simply adolescent Oedipal backlash rather than truly ideological. If the punks had really hated hippies, they should have kept their mouths shut. Museum culture lets time do its work for it. Long repressed and forgotten material is reintroduced as clichés corresponding to present trends. Hippies are now ahistorical archetypes. Few know what led to their rise, or the particulars of their various styles and beliefs. Ideology has been drained from hippiedom, producing a stock character type—a cartoon of American otherness. Americans can only attach themselves to rebellion in this way—as a unitary sign stripped of conflict, its complexity neutered. If hippie aesthetics has found its way into the halls of cultural history, it is only in this way, in the form of works like the paintings of Philip Taaffe with their snide, winking allusions to 1960s op art and hallucinatory drug culture.

A good lesson can be learned by looking at how American critics have responded to the recent upsurge of interest in the French situationists. Major shows of situationist works have been mounted by the Institutes of Contemporary Art in London and Boston and elsewhere, and another show of works by supposedly situationist-inspired punk entrepreneur Malcolm McLaren was at the New Museum in New York.[12] These have been accompanied by a spate of catalogues, books, and essays on the subject—the most popular and grandiose of which is Greil Marcus's *Lipstick Traces*.[13] This romantic homage to the Sex Pistols traces punk's roots back through situationism to dada. But it is very careful never to stray too far from the path of sanctioned—entirely European—art history.

These are *serious* artists within a lineage of *high* art. Marcus shoves under the rug all rock history related to grassroots culture, and almost all reference to American counterculture. For me, the Sex Pistols make no sense unless they are seen in relation to this lost history. Marcus has constructed a story of rock for those outside of it, tailoring it to *their* art museum history. The result is cultural history flavored with tasteful old world spices. You can almost hear the longing in these critics' voices. "Why can't we have a serious, intellectual underground culture?" they whine. But we do—it's just that they wouldn't touch it with a ten-foot pole. There's nothing to be gained by it. It's not *important*.

How does the relationship of the French situationists to their culture compare to the Yippies' relationship to American culture? What's the difference between Malcolm McLaren's hip capitalism and Frank Zappa's "selling out" jokes?[14] How does the Clash's role as a "political" band compare to that of the MC5?[15] You'll never know. Because all the Americans I've just mentioned are categorized as hippies, not artists. They don't count. Radicalism and art are a contradiction of terms to American museum culture (academic Puritan agitprop of the Hans Haacke variety notwithstanding). It will be a cold day in Hell when you see a major American museum mount a show of the cultural production of the Weather Underground or Black Panthers. The situationists are OK; they're French.

Paul Thek's *Death of a Hippie* is a great work of art. It is a shrine to anti-Americanism, to the antipatriarchal. Yet it speaks in an American language, a low and dirty language. It must, because it's speaking to those who are frightened of the low and dirty, who are its enemies. They are the ones who have positioned *you* as the low and dirty. The dead hippie is a sign of America's disgust with and hatred of cultural otherness. It is the image of its fear of death, the erotic, gender confusion, and visual opulence—its fear of anti-institutional art, the kind of "art" you see captured in Larry Clark's photos of crash pads: installations for incorrect living, churches of cultural decay, garbage pits of existence.[16] The dead hippie is a statue of creative resistance, murdered. The fingers, the artist's generative organs, have been chopped off and placed in a bag around the figure's neck—souvenirs of the slaughter—like the kill tokens taken by soldiers in Vietnam who fashioned necklaces of human fingers, like the genitals hacked off and stuffed into the mouths of lynched blacks.

This corpse is pink. It is pretty decay, and prettiness is a weapon for Thek. He admits that one of the inspirations for his technological reliquaries was the work of Larry Bell, one of those critically hated "decorative" minimalists.[17] John McCracken did a series of simple planks in lipstick

shades that rested against the wall.[18] It was sissy minimalism. Pink is *the* hippie color. It's fairydust color, gender-bender color, anti-I-beam-sculpture color, the color of the New Man, *the hermaphrodite color.* In *A Procession in Honor of Aesthetic Progress,* Thek exhibited sculptures damaged during shipping in a gallery where they were bathed in pink light. He repaired them in this light, and when they were fixed, moved them into a room lit with white light. They were reborn. They moved from the womb into the world.[19]

 This contrary prettiness, which has been called his "decadent aestheticism,"[20] continues to be the most disturbing element of Paul Thek's work. The early works, the technological reliquaries, are the works that are now in vogue. Their faux coolness, their meanness, their reactionary attitude is what endears them to modern eyes, mine included. But his later works—the cosmic junk piles, the precious little paintings and sculptures—are a harder pill to swallow. They are truly embarrassing, calling to mind crafts more than art. Bunnies, Bambi, Bo Jangles, stomach-churning, sweet hippie *and* middle-American kitsch are combined in sometimes horribly melodramatic situations. Why is this material so hard to reconcile as art? Perhaps because it *is* our culture, and art is not culture—it is some ritual activity paralleling culture. American culture is best exemplified by Walt Disney (or his current reincarnation, Steven Spielberg). Disney's is the official culture, the one that has a name, is in secret dalliance with the low forms that remain anonymous: the unwashed mass of nameless producers of porn, horror, romance, and exploitation genres. He is the sweetness-and-light shielding us from the dark clouds. Disney is our God. He lies in state: frozen, ready someday to rise from the dead and walk hand in hand with Christ and Andy Warhol's audio-animatron.[21] Next to his frozen body, Paul Thek has placed an amazing wax effigy of himself: a stinking hippie in permanent fixed decay—a pink raspberry shitsicle in answer to Walt's porcelain-white vanilla bar.

NOTES

1. `Salvador Dalí, "The Stinking Ass," trans. J. Bronowski, *This Quarter* 5, no. 1 (September 1932); reprinted in Lucy Lippard, ed., *Surrealists on Art* (Englewood Cliffs, N.J.: Prentice-Hall, 1970), p. 97. Originally published in the first issue of *Le Surréalisme au Service de la Révolution* (July 1930). Kelley prefers this translation; but see also "The Rotting Donkey," trans. Yvonne Shafir, in Salvador Dalí, *Oui, the Paranoid-Critical Revolution: Writings 1927–1933,* ed. Robert Descharnes (Boston: Exact Change, 1998), pp. 115–19; and note on pp. 174–75.

2. Articles, reviews, or interviews about Thek's work appeared, for example, in *Art News* in April 1966, May 1969, March 1977, and February 1983; in *Art in America* in May 1977, June 1985, March 1986, and June 1990; and in *Artforum* in May 1980 and October 1981 (this list is selective).

3. Thek's work was absent from most major U.S. museums and public collections in the early 1990s. By the end of the decade, however, several acquisitions had been made. In 1998, for example, a Judith Rothschild Foundation grant for the purchase of work by Thek (one of "20 projects involving underrecognized, recently deceased artists") was awarded to the Museum of Modern Art in New York; two years before, the same foundation assisted the Los Angeles County Museum of Art with the acquisition and display of the sculpture *Untitled 1965,* "the first work of the artist to be exhibited in a major public collection in the Los Angeles area" (website of the Judith Rothschild Foundation). The out-of-print monograph is *Paul Thek: Processions,* published by the Institute of Contemporary Art, Philadelphia, on the occasion of the Thek exhibition, October 30 to December 4, 1977.

4. Gregory Battcock, ed., *Mimimal Art: A Critical Anthology* (New York: Dutton, 1968). Thek's work is *Untitled 1966* (illus. no. 443).

5. There were few cogent attempts in criticism or exhibitions to account for the various returns to the body in sculpture, installation, and video art at the end of the 1980s. An exception—significantly, seen only outside the U.S.—is Jeffrey Deitch's survey show *Post Human* (FAE Musée d'Art Contemporain, Pully/Lausanne, 1992).

6. Along with members of his "family," Charles Manson was convicted of the Tate and LaBianca murders in a trial that began in mid-June 1971 and lasted nine and a half months, the longest and most expensive murder trial in U.S. legal history.

7. For a discussion of the relationship between Robert Rauschenberg and Jasper Johns, see Jonathan Katz, "The Art of Code: Jasper Johns and Robert Rauschenberg," in Whitney Chadwick and Isabelle de Courtivron, eds., *Significant Others: Creativity and Intimate Partnership* (New York: Thames and Hudson, 1993), pp. 88–207. Katz delivered lectures on this subject on the West Coast in 1990 and at the College Art Association conference in 1991.

8. First issued in 1981, *Tripping Corpse* is the title of a series of self-published zines with drawings about the degraded end of the hippie era, drug culture, Charles Manson, etc., by Raymond Pettibon. For a partial compendium of Pettibon's books and zines see Roberto Ohrt, ed., *Raymond Pettibon: The Books, 1978–1998* (New York: DAP, 2000).

9 Kelley is referring to a Rolling Stones concert at Altamont Raceway, California, in November 1969 during which one of the Hell's Angels recruited to provide security knifed and killed black concertgoer Meredith Hunter. The event has often been interpreted as a kind of symbolic death of the 1960s.

10 Born in 1936, Valerie Solanis acted in several Andy Warhol films, authored the "SCUM [Society for Cutting Up Men] Manifesto" (1968), and was the would-be assassin of Warhol in June of the same year, shooting him three times in the chest. After three years in jail, she spent the rest of her life in and out of mental hospitals, before she died in 1988.

11 "Kill the Hippies" was released by the Deadbeats on Dangerhouse Records in 1978; "Kill the hippies" is a phrase attributed to Johnny Rotten of the Sex Pistols.

12 Recent exhibitions include *On the Passage of a Few People through a Rather Brief Period of Time* (Musée National d'Art Moderne, Centre Georges Pompidou, and the Institutes of Contemporary Art in London and Boston, 1989–90); and *Situacionistes: arte politica, urbanisme* (Barcelona: Museu d'Art Contemporani de Barcelona, 1996). On McLaren, see Paul Taylor, ed., *Impresario: Malcolm McLaren and the British New Wave* (Cambridge, Mass.: MIT Press, 1988).

13 Greil Marcus, *Lipstick Traces: Secret History of the Twentieth Century* (Cambridge, Mass.: Harvard University Press, 1989).

14 Most of the tracks on *We're Only in It for the Money* (as well as its cover satirizing the Beatles' *Sergeant Pepper*), released by Frank Zappa and the Mothers of Invention in February 1968, lambast hippiedom and the counterculture.

15 Managed by radical poet John Sinclair, the MC5 (Rob Tyner, vocals; Wayne Kramer and Fred "Sonic" Smith, guitars; Michael Davis, bass; and Dennis Thompson, drums) functioned as the mouthpiece for the Detroit/Ann Arbor-based anarchist White Panther Party. Their first album, *Kick Out the Jams,* was released in 1969. The band's live sets featured political rants patterned after those of the Black Panthers. The MC5 was one of the few bands to play during the disturbances at the Democratic National Convention in 1968. The "political" dimension of the Clash (formed in London in 1976 with Joe Strummer and Mick Jones on guitars, Paul Simenon on bass, and Topper Headon on drums) is quite different. As their first albums, *The Clash* (1977) and *London Calling* (1980), reveal, "the Clash have been understood," Greil Marcus suggests, "as 'political' for the right reasons: because more directly than other bands, they saw in punk proof that apparently trivial questions of music and style profoundly threatened those who ran their society." Greil Marcus, "The Clash" (1978), in *Ranters & Crowd Pleasers: Punk in Pop Music, 1977–92* (New York: Doubleday, 1993), p. 29.

16 *Tulsa* (1971) and *Teenage Lust* (1983) were self-published by Larry Clark in New York.

17 Thek noted quite specifically that "I was much influenced by Larry Bell"; cited in Richard Flood, "Paul Thek: Real Misunderstanding," *Artforum* (October 1981), p. 49.

18 The titles of some of John McCracken's plank pieces, such as *The Case for Fakery in Beauty* (1967) ("light lavender plank") and *Think Pink* (1967) ("Plank"), referring to pink and associated colors, are longer and more metaphoric than others in the series (e.g. *Black Plank* [1968]), suggesting a special investment in these chromatic signs. In a recent conversation with Kelley, the artist noted that these and some related titles were

taken from women's fashion magazines. See also Thomas Kellein, catalogue for *McCracken* (Kunsthalle, Basel, September 24 to November 12, 1995).

19 An account of the damaged work and the pink light is found in *Paul Thek: Processions,* p. 10. The pink tones of *Death of a Hippie* were noted by several critics, including Adrian Henri: "The life-size figure, its pyramid tomb, and all its enigmatic trappings, are colored a uniform shade of pastel pink" (*Total Art: Environments, Happenings, and Performance* [New York: Praeger, 1974], p. 56).

20 Henri, *Total Art,* p. 56.

21 The "urban legend" of Walt Disney's body being kept in cryogenic storage is alluded to on a Disney website; see http://www.snopes2.com/disney/disney.htm. Warhol's audio-animatron was designed as a stand-in for the artist for a theatrical work in which the robot was intended to expound Warhol's philosophy. Arising from a proposal by Broadway producer Lewis Allen, the figure was constructed but never completed due to technical problems. The genesis of the project is outlined in Pat Hackett, ed., *The Andy Warhol Diaries* (New York: Warner Books, 1989), pp. 254, 257, 339–40, 347–48, 517–18. The unfinished audio-animatron is pictured under the caption "Andy's No-Man Show" in *Life* (December 1984), p. 176.

DYSPEPTIC UNIVERSE: CODY HYUN CHOI'S PEPTO-BISMOL PAINTINGS

JCW *Kelley wrote this brief essay on Cody Choi shortly after the Korean-American artist completed his degree in fine arts at Art Center College of Design, Pasadena. It was first published in* Cody, Dip the Pink *(Seoul, Korea: Ya-Jung, 1992), and reprinted in* Cody Choi: XX Century *(New York: Deitch Projects, 1999). A couple of years after the appearance of this piece, Choi redirected his interest in Pepto-Bismol from painting to sculpture in a series of pedestal-mounted statues modeled on* The Thinker *of Auguste Rodin, made with toilet tissue papier-mâché drenched in the pink medium (see John C. Welchman, "Culture/Cuts: Post-Appropriation in the Work of Cody Hyun Choi," chapter 8 of* Art after Appropriation: Essays on Art in the 1990s *(Amsterdam: G + B Arts International, 2001).*

In the United States there is a medicine for stomach cramps and diarrhea called Pepto-Bismol.[1] The medicine is a bright pink liquid familiar to everyone—so familiar, in fact, that an American traveling to another country is shocked to find no equivalent for it there. It is sufficiently ubiquitous in the

United States that we've come to mistake it for a "natural" product: there *must* be some, interior, reason for its color. The pinkness itself *must* have some soothing quality; its pinkness *must* be a by-product of an element integral to its curative powers. Nonpink medicines are lacking this special something. Standing in some foreign airport examining the row of stomach medicines—all of them pinkless—is a revelatory experience: you have your first conscious thought that Pepto-Bismol might be pink because it has been dyed with food coloring. That's when art comes to mind. "Art," be-cause you've been duped. The facade of the pink remedy was so seductive it made you believe that something merely decorative was actually essential.

Cody Choi is a cultural emissary to America, seeing things as exotic that Americans take for granted. Arriving from Korea, where pink has different connotations, he is in America to reveal our cultural biases, to make us see the normal and familiar as strange and discomforting. His paint-ings are overtly decorative, but only to point out the fact that decoration is physically effective. Would Pepto-Bismol work as well as it does if it were not pink? No, it wouldn't. It couldn't.

I can think of only one other artwork that actually incorpoates Pepto-Bismol: Charles Ray's *Marble Box Filled with Pepto-Bismol* (1988). A large open-top, white marble cube filled to the brim with Pepto-Bismol, Ray's piece takes as given the medicinal associations of its featured liquid. The box seems to conflate minimalist sculpture and the vomitoriums of ancient Roman arenas. To those versed in Western art history, the mix is an unsettling one, producing a feeling of stability-gone-sour. Pepto-Bismol aside, it's even hard to recall many artworks that are colored pink. For some reason pink has been deemed an unsuitable color for art. Perhaps it's art's "noble" stature that occasions this relegation. For, when pink is used, it is generally seen as perverse, as something purposefully wrong. John McCracken's plank sculptures from the 1960s are a case in point.[2] Done at the same time as the minimalist work of Donald Judd and Carl Andre, these hot-colored versions of min-imalism could not be understood as anything other than contradictory. They seemed to be cari-catures of minimalism because their color was so unserious, so inappropriate to the sculpture's simplicity of form. Generally, pink is used in fine art as a weapon, deployed deliberately because of its inappropriateness. It is a color too loaded with cultural associations from outside the art context to sit comfortably within it. What, then, are these associations?

Well, the primary cultural reference of the color pink is its association with young girls. Pink is the color of little girl's rooms, dresses, and playthings. Measured against this scene of identification,

its "inappropriateness" to art unmasks the masculine orientation of the art world. In the art context, pink things come off as effeminate. Pink is also thought of as a "decorative" color, and decoration bears similar gendered connotations. It is frilly and useless: it dwells in the home and not in culture; it's about facade, not truth. A government building would never be heavily decorated, or pink—either of which would make it seem untrustworthy. But perhaps it is this feminine aura that has made Pepto-Bismol such a popular product. When one is sick, one wants to be mothered. One wants to adopt a submissive "feminine" role and be cared for. Pepto-Bismol appears as an image of soothing mother's milk to the adult infant suffering from colic. Symbolically, that is everyone.

All of these images—with their associations of sickness and organic, perhaps pathological, decoration—are summoned up when we look at Cody Choi's Pepto-Bismol paintings. My biggest question is: How will these paintings be understood in Korea? Are their associations too American to translate? Will the paintings be viewed, simply, in the lineage of abstract expressionism—and thus exude a kind of cultural exoticism to their Korean viewers? The problem of intercultural translation is addressed in the paintings themselves, however, by the fact that some of them are painted on American army blankets. As a child, Choi was profoundly influenced by growing up surrounded by the castoffs of the Korean War. The intrusion of American culture was ever present, and perhaps unwelcome. If the pink shapes are the figures in his paintings, the army blankets act as the grounds.

Many abstract expressionist paintings adopted from surrealism the notion that visual space is analogous to bodily space. The amorphous space occupied by the abstract shapes and painterly gestures is the inner space of the human body: the dark space of the body cavity or the more mysterious space of the unconscious mind. With the demise of abstract expressionism and the rise of less psychologically oriented (and more concrete) painting, such as color field, this idea of painted space slowly waned, and then itself become concretized. Gerome Kamrowski, a painting teacher of mine and an automatist of the Pollock generation, once described this as a shift from "inner space" to "science fiction space."[3] The black void is now not the domain of the psyche, but of "outer space." This conception of space is territorial and not symbolic. When I look at Choi's paintings, I see the dark space of the army blanket as a territory in dispute, as the site of a war of cultures in which various socially specific poetic systems battle it out. Can we assume, then, that this is what viewers on both sides of the Pacific Ocean might discern: that these paintings are glimpses of an unstable world—a dyspeptic universe?

NOTES

1 Bismuth subsalicylate, the active ingredient in Pepto-Bismol, relieves such symptoms as upset stomach, indigestion, nausea, vomiting, heartburn, and diarrhea. The original variant of Pepto-Bismol was introduced in 1900, and distributed nationally in 1918 under the name Bismosal by the Norwich Eaton Company. A year later the product was rebaptized as Pepto-Bismol, and the formula remained relatively stable for the next eighty years. Following the brand's acquisition by Procter & Gamble in 1982, Pepto-Bismol tablets and caplets were launched. Even the P & G archivist was unable to explain why Pepto-Bismol was made pink.

2 Kelley discusses McCracken's plank pieces and some of the associated qualities of pink in his essay on Paul Thek, "Death and Transfiguration," in this volume.

3 Gerome Kamrowski, in Evan M. Maurer and Jennifer L. Bayles, eds., *Gerome Kamrowski,* exhibition catalogue (University of Michigan Museum of Art, Ann Arbor, August 30 to October 16, 1983), p. 2. For a summary of Kamrowski's career, see Paul Schimmel, *The Interpretative Link: Abstract Surrealism into Abstract Expressionism, Works on Paper 1938–1946,* exhibition catalogue (Newport Harbor Art Museum, Newport Beach, Calif., July 16 to September 14, 1986), p. 100.

MARCEL BROODTHAERS

JCW *Along with a number of other contemporary artists, Kelley was asked to offer a brief response to the work of the Belgian poet, filmmaker, sculptor, and conceptual artist Marcel Broodthaers (1924–76) for the catalogue of the exhibition* **Marcel Broodthaers: Correspondences** *at the Galerie Hauser & Wirth, Zurich, in 1995.*

OK, here's what I think of Marcel Broodthaers. I think.

To be honest, Broodthaers is not an artist I have spent much time considering. I know his work is wide-ranging and complex, but I'm not that familiar with it. As I never found its surface aspects very appealing, I've never been inclined to explore it in detail. By that I mean I don't really like the way it looks.

The association of Broodthaers's works with the recent trend of commodity art has also put me off. His resuscitation seems to ride somewhat on the coattails of that movement which—like much pop art—doesn't appeal to me especially, since I don't find the reduction of the art object to its economic value or position to be very interesting. Broodthaers is sometimes linked with the related, more overtly "political" tendency toward "museological" practices—those that focus

on, or attempt to deconstruct, the conditions of the public presentation of artwork, usually in more privileged and powerful institutional sites like the museum. All of this leaves me cold.

I find it extremely interesting, however, that Broodthaers's pieces look so different from the kind of works to which they are usually compared. His works are unruly and provisional in a way that pop, commodity, and museological works rarely are. Visually, they remind me quite a bit of the neosurrealist junk assemblages associated with the Beat movement—works that are often overtly nostalgic and interiorized. This is where my respect for Broodthaers hits home, because his work is obviously not like that; and it's difficult to figure precisely what it is. I find myself feeling stupid in the presence of his work, because I've been suckered by it. Hokey and obvious it may be, but I fall for its superficial museological ordering. It's a kind of negative seduction. My attempts to stick Broodthaers's art into simple historical categories collapse because his systems are just too weird to tie down, and his intentions too convoluted to ascertain immediately. Then I feel guilty for wanting his work to look better. It looks just right for the confusing job it does, I guess.

Before I even knew they were linked, I felt a kinship between Broodthaers and René Magritte—and also, the early Jim Dine. Both are artists who have made works I respect very much. I like how in their works surface meaning wrestles with whatever other meaning there is. I like how object and language, the material and the mental, intertwine and become confused. This tension is overtly cruel. Magritte is cold, socialized, and mean. Dine is garish, cheap, and obvious. These are compliments. Broodthaers, though, is more devious. His work looks sentimental and heartfelt, all the while proclaiming its insincerity. Yet its true insincerity lies in the possibility that Broodthaers really *is* sentimental and heartfelt. He strikes me as a contrary artist—who wants to have his cake and eat it too. He desires to be sincere and insincere at the same time. I find that admirable.

There is a great tension between the "useful" and the "poetic" in Broodthaers's work. I very much like his plastic signs. They have a straightforward cleanliness that is denied by both what they convey and the inconsistency of their design elements. The painted, vacuum-formed plastic signs he made for his *Musée d'Art Moderne* project (1968–72/75) are a good example. What's with the weird blobby border surrounding the central text in the sign for the *Département des Aigles* (1968) that includes the names David, Ingres, Wiertz, and Courbet?[1] Most of these signs refuse to adhere to any standard design logic. They are quite perverse, but in a very refined way. And, unlike much of his work, they really look good too.

Yet probably my favorite works of Broodthaers are the mussel shell pieces, like *Grande casserole de moules* (1966), where the shells heap up beyond the confines of their cooking pots and the lids sit on top. In one way, I like them simply because they are exotic. Unlike the eggshells, which he also uses, mussel shells are not common in America. The pieces, then, already stand in opposition to the "international style" of much pop, minimalist, and conceptual work. I'm glad about that. The mussel works strike me as overtly regional, yet Broodthaers plays simple games with them. While he wrote poems about mussels revealing the complex symbologies he invested in them, the works can be seen simply as arenas of overabundant materials—places where there's too much stuff. Such pieces are therefore regional and universal, complex and dumbly simple, bland and mysterious, all at once. I find myself hating them, but they continue to intrigue me. What more could you ask of an artwork? I just changed my mind, I prefer the plastic signs.

NOTES

1 Benjamin Buchloh notes that Broodthaers's first "museum fiction" announced under the auspices of the "*Musée d'Art Moderne, Département des Aigles*" was staged "on September 27, 1968 in his former studio at Rue de la Pépinière in Brussels." The series came to an end "in 1972 with the installation of the *Section des Figures (The Eagle from the Oligocene to Today, Düsseldorf)* and the ultimate installation was staged at the Palais Rothschild in Paris under the title *L'Angélus de Daumier* in 1975." Benjamin Buchloh, "The Museum Fictions of Marcel Broodthaers," in AA Bronson and Peggy Gale, eds., *Museums by Artists* (Toronto: Art Metropole, 1983), p. 53. In the catalogue for the Tate Gallery's retrospective, *Marcel Broodthaers* (April 16 to May 26, 1980), the works to which Kelley alludes here are titled "Département des Aigles" and are described as follows: "Two vacuum-formed reliefs in painted plastic made from the same former, one gold lettering on red ground, the other black on gold. Exceptionally, a third relief was made in gold on white" (p. 58).

MYTH SCIENCE

JCW *This essay was commissioned for the catalogue of the exhibition curated by Eva Schmidt and Udo Kittelmann,* Öyvind Fahlström: The Installations *(Ostfildern: Cantz Verlag, 1995), pp. 9–27, which showed at Gesellschaft für Aktuelle Kunst e.V., Bremen, November 25, 1995, to January 14, 1996, and at the Kölnischer Kunstverein, Cologne, March 1 to April 21, 1996. Kelley doesn't limit himself here to discussion of Fahlström's installation work, claiming that his "exhibitions were 'installations' in and of themselves." Instead, he uses the occasion to outline a context for Fahlström's career as a whole, which he sets in relation to issues in pop art and politics, cartooning, and composition.*

Happily, Öyvind Fahlström is now starting to be recognized for what he was: one of the most complex artists of the 1960s. While to my mind he is a complete "original," until recently Fahlström was considered a minor player in the drama of pop art. He was perceived by the champions of pop as, at best, somewhat naïve, and, at worst, a mere throwback to surrealism or agitprop. Why? Well, because he allowed the "political" to enter his work, because he was interested in issues of narrative, and because his work was compositionally "busy." His deviation from pop standards was explained away by the fact that he was European. In America the battle lines were drawn: any hints

of the old abstract expressionism, and its distant father, surrealism, would be excised from the serious artwork. Psychoanalytic references were taboo, and social concerns were something quaintly old-fashioned, antiquated matters that concerned Grandpa in the 1930s. Pop art was youth culture formalism. Despite its surface topicality, pop was "timeless," its images meaningless. Only their compositional *position,* centralized and uninflected, was important. Pop reflected a world where all meaning was surface meaning—a uniform gloss. You could choose to read this as social commentary, if you were so inclined. It was up to you. But while different critics embraced pop in various ways, one thing was certain: compared to the "cool" of artists like Warhol and Lichtenstein, Fahlström was "hot." Some thought Fahlström was telling a retrograde, anti-pop tale, dressing it up in pop's fashionable clothing.[1]

More recently, the supporters of the agitprop sensibility have championed Fahlström.[2] These critics accept the same divisions, they believe in the same insurmountable chasm dividing the "formal" from the "political," but they stand on the "hot" side. They want Fahlström alongside them, espousing social truths in a popular language aimed at the masses. But Fahlström's work is not as simple as that.

In fact, Fahlström is a formalist of sorts. His arrangements of topical and historical materials have no more narrative coherence than the image combinations of James Rosenquist or Robert Rauschenberg. Fahlström *is* interested in having his work function optically. By this I mean that he sets things up in such a way that one is prompted to look through the image as "content" to see it as pure form. His use of the silhouette promotes this effect. Yet, unlike Rauschenberg, for example, Fahlström acknowledges that the viewer always *attempts to "read"* a collection of images and make sense of them, and does this in terms of a common—socialized—visual language. His work is overtly about this impulse to read, which he plays with and subverts in various complex ways. The exchange between legibility and opacity produces, he suggests, "the thrill of tension and resolution, of having both conflict and non-conflict (as opposed to 'free form' where in principle everything is equal)."[3] Thus, while Fahlström constructs image constellations that are impossible to read as simple narrative, he strives to keep them from becoming "noncommittal."[4] He differentiates his practice in this regard from Rauschenberg's, which, he says, "tends to neutralize all statements through a pattern of relationships and thus achieves a state of total weightlessness of . . . elements."[5] At the time, there was a tendency to see this "flattening" as a kind of artistic nihilism, and, in fact, the pop artists were first perceived as neodadaists. Fahlström, by contrast, saw his use of fracture and leveling as "constructive and thus not Dada at all."[6]

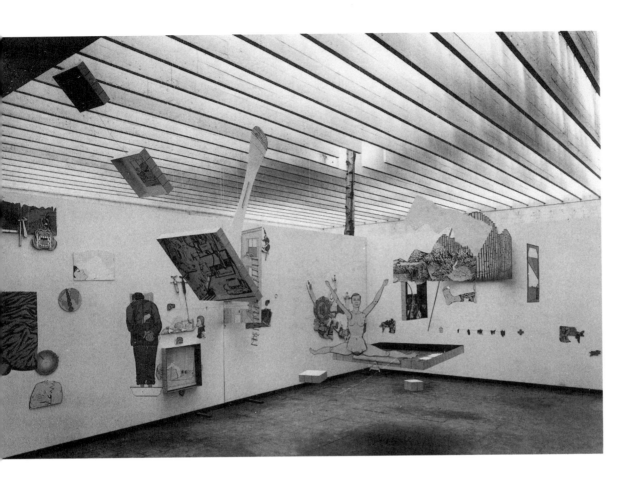

Öyvind Fahlström, *Dr. Schweitzer's Last Mission, Phase One* (1964–66). Installation shot from XXXIII Venice Biennale, 1966. Tempera on eight metal boxes, 10 cut-out boards, and 50 magnetic metal and vinyl cutouts. 177 x 402 x 89 ins. (variable). Photo: Giacomelli. © 2001 VG Bild-Kunst, Bonn.

Fahlström's tactics have more in common with the ambitions of the conceptualists than with those of the pop artists. But while his interest in game strategies as an organizational principle clearly links him to conceptual art, Fahlström's use of popular imagery is inconsistent with most conceptualist practice. Conceptual artists generally kept their distance from material associated with "low culture," focusing instead on "informational" forms like photography and typography. Fahlström, however, had little regard for uniformity of style, feeling these kinds of class-based image distinctions were unimportant. For him, style was largely irrelevant apart from the content and experience it could convey. He felt painting should remain "invisible"; it should be a carrier of meaning and not remain simply self-referential.[7] This indifference to the "fetishistic" aspect of the artwork led him to conclude that artworks should, preferably, be produced as multiples.[8] Today—in the wake of a neoconceptualist generation that accepts as a given the "postmodern" plurality of styles—it is easier to see Fahlström's practice as a kind of deconstruction deploying the popular signs which surround us every day, rather than as an exercise in raising "low" cultural material to the lofty realm of fine art.

This deconstruction is predicated on the construction of an artistic world—in the form of a model. Fahlström's preference is for multipart works, the various elements of which are organized in complex interrelationships that imply system and narration. This tendency inclined his work toward art that had decisive spatial and temporal aspects: work that was *theatrical.* We can see such a turn even in his early abstract paintings, done while he was still living in Sweden. Pontus Hultén describes Fahlström's presentations of *Ade-Ledic-Nander II* between 1955 and 1957 as a kind of performance. Fahlström would exhibit the painting covered by a sheet with holes cut in it so that only sections were exposed.[9] He would then "explain" these areas to the assembled company by reading from a thick, typed manuscript that contained his written analysis and "topographical maps" of the work.[10] He claimed that this presentation in parts prevented the audience from becoming distracted by other elements of the painting during the analytic process. But it was not only the presentation of the painting that was organized in this manner: Fahlström composed it using the same process, covering the part of the canvas he was not working on so as not to be seduced by overall aesthetic considerations or competing details.[11] His method called for the construction of separate cells whose interrelationships were revealed only when the entire work was completed. This compositional technique reflects Fahlström geopolitical views, which called for urban decentralization and communalism.[12] The overall "equality" of composition is to be read as democratic, rather than

nihilistic and chaotic. Each part is as important as every other part of the painting, but each is considered in turn, first as an autonomous unit, then in relation to the system as a whole. The whole thus becomes more than a sum of its parts, more than a mere compilation.

At this time, Fahlström's pictorial "signs" were still abstract, recalling, on the surface at least, the pictographic matrixes of some of the late surrealist artists of the 1940s and '50s who came under the influence of Jungian theory (Adolf Gottlieb's work comes to mind).[13] But if we look more closely, their concerns are almost antithetical. Fahlström doesn't offer an array of timeless or "primitive," archetypal signs, referring to some universal ur-language. His abstract marks are grouped typographically and imbued with specific character traits. These marks interact in the pictorial field in a very specific—and narrative—manner determined by a complex set of gamelike rules. The painting can be read as a kind of model universe, with composition acting as the visual clue allowing us to unravel its "politics." Fahlström invented three character-forms that dominate his painting—the Ades, the Ledics, and the Nanders—which he describes as akin to alien "clans" involved in a struggle for power.[14] Hans Hofmann's "push-pull" precept[15] is reenvisioned in social terms: compositional tension symbolizes dialectical argumentation. The written narrative accompanying *Ade-Ledic-Nander II* has a sci-fi flavor; its title is derived from a short story by the science fiction writer A. E. van Vogt.[16] Science fiction is a genre where the shift of time is a transparent device; everyone knows that the futures it describes are actually versions of the present illustrated in the terms of a parable.

Easily misinterpreted as ahistorical, Fahlström's abstract pictographs were soon replaced by overtly "timely" ones. In *Feast on Mad,* a drawing from 1958–59, various graphic elements taken from comic illustrations in the popular satirical *Mad* magazine[17] are decontextualized and rearranged in a chaotic cluster. In *Sitting* (1962), elements taken from DC adventure and superhero comics are similarly decontextualized (there are recognizable details of Batman's cape). Here, however, the original context is more obvious. The painting is composed in a compartmentalized fashion recalling the sequential frames used in comic book narratives, but presented in such a way that the frames no longer read sequentially. Again, Fahlström's use of the comic book image is not an exercise in high/low displacements (as in Lichtenstein, for example); instead, he plays with temporality and narrative. For Fahlström the comic strip was a narrative form situated halfway between the novel and film,[18] and he was interested in it for this reason, not because it represented kitsch in general. Comic books offered a potentially rich pictorial source reflecting contemporary mytholo-

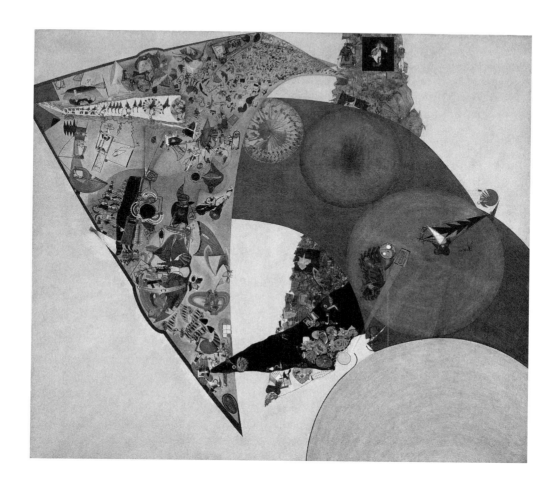

Öyvind Fahlström, *Ade-Ledic-Nander II* (1955–57). Oil on canvas. 75 x 83 ins. Collection Moderna Museet, Stockholm. Photo: Moderna Museet, Statens Konstmuseer, Stockholm. © 2001 VG Bild-Kunst, Bonn.

gies, values, and belief systems in clear image tropes comprehensible to the culture at large. By the end of the 1960s, Fahlström was also using photographic images taken from the popular press, both serious and tabloid. Presented in their normal narrative context, these image tropes remain invisible and thus "natural." Using a technique similar to collage, Fahlström reveals that these tropes are manufactured, often arbitrarily coded, and thus "unnatural." As manmade images, they are politicized; and Fahlström re-presents them as deliberately constructed toward specific social ends. Fahlström's interest in the liquidity of meaning, in image signification defined by context, led him soon after to abandon fixed composition. Shifts of relationship, implied earlier through simultaneous depictions of a sign in various interactions within the visual field, were replaced by a decision to make the various elements in the paintings movable, thus facilitating the possibility of change *over time.*[19] In *Sitting . . . Six Months Later* (1962), the elements of the painting have been magnetized and can be moved about, producing a "variable painting"—a kind of latent kinetic artwork. Fahlström continued to produce variable paintings until his untimely death in 1976.

This exhibition focuses on three of Fahlström's installations: *The Little General (Pinball Machine)* (1967), *Meatball Curtain (For R. Crumb)* (1969), and *Garden—A World Model* (1973). As I have already suggested, from the very beginning Fahlström's work had strong spatial and temporal aspects: his exhibitions were "installations" in and of themselves. The variable artworks were generally shown alongside related "fixed" pieces that revealed its various "phases"—preferred arrangements of the variable paintings determined by the artist—as well as sketches that shed light on their source materials. These were complemented by completely separate artworks that used some of the same images in different configurations. The ideational constructions of the artwork, as well as its various permutations over time, were presented as a whole.

Fahlström strove to create total artworks, hence his fondness for Happenings. Opera was also an important model, not only because it aimed for synthesis, but because, as he wrote, it "demonstrates the 'amorality' of art, its readiness to profit from and transform into art anything at all to stimulate and broaden our self-awareness . . . which in turn can or need not be made to serve a political end."[20] He felt the artist, like the composer or writer, should make fewer, bigger, and more complete works.[21] In fact, one of Fahlström's earliest and most important pieces is titled *Opera,* a massive drawing that he worked on from 1952 to 1957. Composed horizontally, this giant, "additive" work wraps around the room, enveloping the viewer and promoting a sense of narrative progression. Fahlström was very interested in "pre-Columbian Mexican book paintings,

which evolved in long panels, folded concertina fashion."[22] In *Opera,* Fahlström's abstract pictographs develop progressively from panel to panel in a manner analogous to the recurrence of motifs in music or of characters in a comic strip. The scale of the work forces the viewer to engage the picture physically, with the whole body, not just the eyes. More important, its vastness makes it impossible to take the work in as a whole.[23] It can only be experienced as a sum of experiences, as a gestalt.

The "installations" in this exhibition offer further examples of Fahlström's larger-scaled works, representing some of the strategies that characterize various parts of his career. *The Little General (Pinball Machine)* (1967) is the largest of a group of sculptural works in which Fahlström's signature silhouette elements float in rectangular, table-like pools of water. The related works are *Parkland Memorial* (1967), *The Dante-Virgil Skating Race* (1968), and *Blue Pool* and *Green Pool* (both 1968–69). The water in the two latter works is dyed and functions analogously to the monochrome pictorial fields of some of Fahlström's variable paintings, such as *Sylvie* (1965) or *Pentagon Diptych* (1970). The pools can be seen as variable paintings shifted from a vertical to a horizontal orientation, from parallel to the wall to parallel to the floor, a move that stresses their theatrical, puppet-show-like aspect. As with the variable paintings, which allow for the movement of the individual magnetized "figures" within their metal "grounds," the elements here float freely about in their aquatic pictorial fields (except for *The Dante-Virgil Skating Race,* in which the water is literally frozen, fixing the elements in position). Composition is liquid. Unlike the cartoonish or paper doll-like silhouettes of some other works, the silhouettes in *The Little General* are photographic, drawn from a variety of sources, including cheap advertising images, lurid headlines and photos from tabloid newspapers, cheesecake nudie shots, "leftist" imagery (such as a Pepsi bottle turned Molotov cocktail), and popular figures, ranging from the youthful Shirley Temple to Lyndon Johnson and Che Guevara, among others. The subtitle of the work, *Pinball Machine,* presents all of this as an active, festive game. The work is more overtly garish and outlandish—and more random-looking—than the other works in the series. The variety of source materials calls to mind those montage sequences in end-of-the-year news summaries which barrage the viewer with an incomprehensible array of newsworthy events with no apparent context except their status as signs of what is "current." While Fahlström's notes and a fixed model for the work reveal the presence of an underlying associational system, and certain privileged connections, the surface jolt of the piece is one of overt humor, reflecting the absurdist politics of the Yippies (Youth International

Party) and the New Left in general, with which Fahlström was actively involved. Despite the seeming randomness of the work, its evident "political" aura makes it difficult to view in terms of the leveling effect characteristic of more formalized pop art. Fahlström plays with the viewer's tendency to split "political" from "formal" readings, refusing to succumb to the common dictate that these terms must be set in opposition.[24] This is Fahlström's real contribution to the art world of the late 1960s. Unfortunately, it was not much recognized at the time.

The *Meatball Curtain (For R. Crumb)*, a massive work done as part of the Art and Technology Program of the Los Angeles County Museum of Art, was made two years later, in 1969.[25] LACMA's program paired artists with companies which assisted them in the production of an artwork utilizing the special equipment or resources they had at their disposal. Fahlström chose to work with Heath and Company, a maker of commercial signs which manufactured the sort of huge illuminated signs that adorn gas stations and fast food restaurants such as Kentucky Fried Chicken, and specialized in working with plastics and metals. Interestingly, while Fahlström was in Los Angeles on a site visit, he was introduced to *Zap Comics* and ended up making a work utilizing the imagery he found there. Started in San Francisco in 1967, *Zap* was one of the first underground comic books made by—and geared toward—the hippie subculture. Fahlström had done an earlier work using imagery derived from *Mad* magazine, so it's not surprising that he would be drawn to *Zap*. *Zap* cartoonists were the much more radical, countercultural descendants of the artists who worked for the socially satirical *Mad* magazine during its heyday in the 1950s. The *Zap* artists openly defied the Comics Code Authority of America,[26] which monitors comic book content, by wallowing in the very subjects that the code was designed to censor: sex, violence, drugs, and left-wing politics. Robert Crumb is by far the most famous of the *Zap Comics* artists, and most of the imagery in Fahlström's work was taken from his drawings.[27] The title itself, *Meatball Curtain,* was derived from a Crumb story called *Meatball,* in which meatballs fall from the sky, striking people and causing a sort of instant satori. Fahlström describes the *Meatball Curtain* as an "homage to Robert Crumb. . . . a great American artist."[28]

The work is an ensemble of large freestanding metal and plastic cutouts. Once again, they are silhouettes, but this time radically simplified, with little of the detail and graphic outlining found in earlier Fahlström works. Because of this simplicity, one is tempted to see the work as a reaction to the then-current trend in minimal, brightly painted public sculpture of the Alexander Calder or David Smith variety. The *Zap* references, however, are quite specific, and the work is extremely

baroque and playful in form. Fahlström described his interest in the silhouette as a way of putting emphasis on the "character" or "type" of an element.[29] This use of the silhouette promotes the double reading of the element as either a sign or an abstract form. In the *Meatball Curtain,* as in the variable paintings, these isolated silhouettes are used to create a shifting, organic whole. The silhouettes function as parts of a "machine to make paintings—a picture organ."[30] In this work, the emphasis is more on the "abstract," and I don't find I have the same impulse to project a narrative onto the relationships as in the works that contain more detailed elements. The *Meatball Curtain* is one of Fahlström's most light-hearted works, a kind of countercultural sculpture garden.

Garden—A World Model (1973) represents the final phase of Fahlström's work, starting in 1971, when he became interested in using current historical and economic data—commonly accepted "factual" material. The *World Bank* installation (1971) is the first work that Fahlström described as being entirely based on such material.[31] Pictorial images derived from popular sources that were the core of the variable paintings were replaced by images drawn by Fahlström himself. I believe this was a radical decision. Fahlström's use of appropriated material produced the sense that the artist was something of a sociologist, somehow standing outside of the culture whose myths he was "deconstructing." This is a fallacy, of course, and, despite the freedom he afforded the viewer in interpreting them, Fahlström's work is littered with clues about his own ideological positions. But I think Fahlström's decision to use his own pictorial system is a sign of his uneasiness with this anonymity. As evidenced by the continuing war between so-called neoexpressionists and neoconceptualists, from pop art on, the trace of the hand has been a loaded issue. The defining trait of pop is the use of generic illustrations or photographs drawn from, or mimicking the style of, mass media. Pop's "cool" aesthetic is dependent on this use of images that read as being general, referring to society at large, rather than being "expressive," or indicative of a specific personality. By introducing into his work a gestural manner recognizably his own, Fahlström called into question the pictorial convention of "authorlessness" and anonymity—a convention that is essentially class-based, and reflects an ideology that seeks to prolong the useless distinction between so-called low and high art.

What else could explain the fact that in the fine art world Lichtenstein is considered the sole author of images lifted with only minimal changes from other artists? To people familiar with comic book illustrators, the images that Lichtenstein quotes are immediately recognizable as the work of specific cartoonists.[32] But to the general viewer, this kind of image is read as a sign of

"cartoons" in general, which are synonymous with the "low," with the reading habits of children or the illiterate lower classes. To the upper class viewer, a cartoon symbolizes the undifferentiated mass mind of the working classes.

Fahlström's own style is a kind of loose cartooning. He had, in a sense, learned the language of cartooning well enough to speak it rather than quote it. Yet Fahlström's position within the domain of "fine" art prevents his comic-style imagery from being completely transparent. By virtue of their context, it is impossible to see his cartoons as simple, invisible carriers of the information they illustrate. They are too idiosyncratic to be seen within the tradition of agitprop, in which the artist tends to become invisible in order to appear the spokesman of the masses. Nor do they decontextualize and formalize the cartoon illustration, as with Lichtenstein. Instead, through the formal complexity of his composition and information groupings, Fahlström very self-consciously subverts the viewer's various impulses to read popular images. He does not heroize them as symbols of the common man, nor does he treat them simply as vernacular symbols. Instead, he poses them as elements of a visual language whose syntax, like that of concrete poetry, can be altered and rearranged. With a dizzying and conflicted array of "factual" material presented using this language, and by presenting cartoons in an unnatural way, Fahlström works against the implication that a popular lexicon represents a homogeneous audience. The cartoon's "naturalism" lies in its air of anonymity, in its invisibility, which is why cartoons lend themselves so well to use in agitational propaganda. They have an air of truth about them; they appear as given, pre-existing, unconstructed. Fahlström's busy, unstable compositions and information overloads throw this naturalism into question. The only true "political" image is the unnatural one, the one that challenges preordained and unquestioned pictures of reality.[33] This "unnaturalism," however, does not necessarily imply a desire to escape the pictorial; it can be understood as a dissection of the pictorial. The secret language of pictorial conventions must be revealed as a construct, otherwise one remains the unwitting pawn of its shaping influence. This is what Fahlström does with his strange use of mass-media conventions. The dissection of the natural is Fahlström's politic.

The finest example of Fahlström's "factual" period is *World Map* (1972), which presents a topography of current historical "facts" separated from each other by boundaries reminiscent of national borders. You soon realize that these borders are random, produced by a pictorial necessity that is driven, in turn, by the amount of information each zone contains. This play with borders is most apparent in *At Five in the Afternoon (Chile 2: The Coup. Words by Plath and Lorca)* (1974).

Here, the recognizable silhouette of Chile becomes the site of connection between various other random silhouettes, attached to it by long needle-like feelers, which contain images by Fahlström "illustrating" excerpts of the poetry of Sylvia Plath and Federico García Lorca. The enclosing forms are now much more extravagant and baroque than those of *World Map*. The "political" form of Chile is thrown into sharp contrast with the "aesthetic" forms hovering about it.

In 1974, Fahlström wrote, "recently I have been making hundreds of improvisations to arrive at shapes that are interesting in themselves, and totally 'un-natural' to the factual content and the space needed for the facts." These forms, he continues, "have something of the surprising beauty of tropical fish."[34] *Garden—A World Model* uses these kind of extravagant forms in a way similar to their use in *At Five in the Afternoon* but plays up their "aesthetic" qualities by presenting them as flowers growing out of pots. The material contained by these "flowers" is the same kind of information used in *World Map,* historical and economic data. *Garden* can be seen as an intermediate work, lying between *World Map* and *At Five in the Afternoon:* it still uses historical data, but presents it in a much more opulent frame. The piece can be described as an installation in that it is presented within a green room as an environmental tableau. But this is done in a highly simplified way, which is not nearly as complex, formally, as *Meatball Curtain* or Fahlström's installation masterwork *Dr. Schweitzer's Last Mission* (1964–66), which I consider his most important variable painting. The stripped-down quality of *Garden—A World Model* makes it look somewhat like a product display. It recalls Fahlström's *World Bank* installation, which was similarly arranged as a simple monolithic display, presented by itself in a matched color-coded room. *Garden* has a pathetic quality—by that, I mean that the isolation of the work in a room by itself may be read as a display of false grandeur. The beauty of the installation, with its complex jungle-like shadow effects, purposely grates against its disturbing historical and economic content, producing a confusion of emotional effects.

Soon after this—in *At Five in the Afternoon* and the beautiful variable painting *Night Music 2: Cancer Epidemic Scenario (Words by Trakl, Lorca and Plath)* (1975), in which both the field and the magnetized informational elements are highly baroque forms—historical "facts" are replaced by "facts" taken from poems. Commenting on his use of such material in *At Five in the Afternoon,* Fahlström writes, "The loss of Chile cannot be expressed merely by depicting a succession of events."[35] In these final works before his death from cancer in 1976, Fahlström proclaims the "reality" of art. Historical facts are as mythic as literary constructs; and art, on the psychic level, is

Öyvind Fahlström, *World Map* (1972). Acrylic and India ink on vinyl mounted on wood. 36 x 72 ins. Private collection, New York. Photo: Tom Powell. © 2001 VG Bild-Kunst, Bonn.

just as "real" as this worldly material. Functioning in a symbolic world, the artist nevertheless affects our perception of the "real" world. The artist's problem is to devise games interesting enough to bridge the gap. Fahlström continues to stand the test of time because he did just that.

The Realm of Myth

A myth among other things
Is basically in the category of an idea
The vibration-radiation of an idea
Activates itself manifested synchronization.

A lie among other things
Is basically in the category of a myth.

The myth is of images,
Because the myth and that which is of the myth
Is the activator of unlimited imagination
------------ Parallel to or more ------------
Synchronized to that which is not.

Everything is of a particular science
And myth is no exception.
Witness: 'Science-fiction'
And the manifestation of its self
To a living what is called reality
Or so-called reality.

As a science Myth has many dimensions
And many degrees.
Tomorrow is said to be a dimension of myth

Or even the very realm of myth itself

When it is said that
'Tomorrow never comes',
Thus when we speak of the future,
We speak of a lie,
Because the future is tomorrow
And tomorrow never comes.[36]

Sun Ra, 1972[37]

Postscript

I met Öyvind Fahlström in late 1975 (I think), in New York City. I was then a student at the University of Michigan in Ann Arbor and, on occasion, I would go to New York to check out the real art world. I was already a huge fan of Fahlström's work and, luckily, he happened to be in an exhibition at the time. I can't remember for sure, but I think it was a group show of graphics. Anyway, even though it wasn't a solo exhibition, Fahlström was in attendance. I introduced myself and asked if he would be interested in doing a lecture at the university. Fahlström was a shy person, and I'm sure he had no interest whatsoever in doing a lecture at a boring midwestern university. Unfortunately for him, I had one of those needling, never-give-up personalities and kept bothering him until he finally agreed. He came to speak at U of M in April 1976, and since I was totally responsible for his visit, pretty much all of the organization was left up to me. I had absolutely no experience doing such things, and was quite naive about university protocol. Getting the administration to do anything for Fahlström was equivalent to pulling teeth. The whole situation was horrible, and, in my estimation, Fahlström was treated very poorly. I ended up regretting asking him to come. I had to pick Fahlström up at the airport myself, and drive him to the college in my junker car that, literally, had no floor on its passenger side. Fahlström brought large-format glass transparencies of his works, and the audio-visual department was not equipped to show them. Eventually, he projected them by laying them flat on an overhead projector, so that much of the detail was lost. Nevertheless, the lecture proceeded smoothly. Afterwards, since the university had made no plans

for the evening, I asked a few of the faculty members if they would like to go to dinner with Fahlström and me. After eating at a local restaurant, I was shocked when none of the faculty members offered to cover the check and charge it to the school, something I just assumed would be done. This led to a heated argument, which must have greatly embarrassed Fahlström. Finally, after one of the teachers consented to put the dinner on his credit card, I took Fahlström to a local bar to meet and have drinks with some of the students who had attended his talk. Afterwards, while driving Fahlström back to his hotel, we were stopped by the police, probably because of my sleazy looks. I remember Fahlström being quite angry because of this, since the police had stopped me for no reason and it was obviously just harassment. This endeared him to me greatly. Then, when we were almost back to where he was staying, he realized he had left a book at the bar—a copy of Sylvia Plath's poetry. Fahlström would write notes and draw little sketches in the margins of this book as he read it, and these were later elaborated into finished artworks. He was extremely upset at the prospect of losing this book, which he had spent so much time working on, and which meant a great deal to him. Amazingly, when we returned to the bar, the book was still there—truly a miracle! The next day, I picked Fahlström up and took him back to the airport. He didn't have too much to say. This trip could only have bolstered what I assume, on the basis of his work, was Fahlström's conspiratorial view of the world. I was ashamed by how things had turned out and never spoke to Fahlström again. He died seven months later of cancer.

I decided to end this essay with a poem by Sun Ra because I have long commingled Fahlström's and Sun Ra's works in my mind. I discovered them around the same time and see many similarities between them. Both believe in synthesis, in complexity over simplicity; both have a disregard for signature style; and both proclaim the importance of art as a force for changing consciousness and the world. Both believe that you should not talk down to your audience, yet both use popular modes of address that are radically transformed—perverted, you might say—to get their points across. To borrow a Sun Ra term, they are both "myth scientists" of the highest caliber.

NOTES

1 See e.g. Barbara Rose, "Dada Then and Now," in Steven Henry Madoff, ed., *Pop Art: A Critical History* (Berkeley: University of California Press, 1997), p. 58 (originally published in *Art International* [January 1963], pp. 23–28).

2 See e.g. Barry Swartz, *The New Humanism: Art in a Time of Change* (New York: Praeger, 1974), p. 124: "Some will argue that Fahlström's art is an oversimplification, that political questions require a more complex analysis. Sure."

3 Öyvind Fahlström, "Take Care of the World" (1966), in Thomas M. Messer, *Öyvind Fahlström* (New York: Solomon R. Guggenheim Foundation, 1982), p. 64.

4 "Obviously, most artworks (neo-Dada, Pop-art, conceptual art) use data that are 'noncommittal,' 'unimportant' per se. Will facts about economic exploitation or torture techniques destroy the balance and make the works 'propaganda'?" Öyvind Fahlström, "Propaganda" (1973), in *Öyvind Fahlström: The Installations,* ed. Sharon Avery-Fahlström in cooperation with Eva Schmidt and Udo Kittelmann (Ostfildern: Cantz Verlag, 1995), p. 78.

5 Öyvind Fahlström, "Jim Dine" (1963), in John Russel and Suzi Gablik, *Pop Art Redefined* (New York: Praeger, 1969), p. 67.

6 Öyvind Fahlström, "Hipy Papy Bthuthdth Thuthda Bthuthdy," from "Manifesto of Concrete Poetry" (1953), in Messer, *Öyvind Fahlström,* p. 29.

7 "The painting as a handmade *object* would then decrease in significance compared with a painting that exists for the experience, the content, that it can convey. Become invisible painting." Öyvind Fahlström, "The Invisible Painting" (1960), in *Öyvind Fahlström: The Installations,* p. 31.

8 Fahlström, "Take Care of the World," p. 64.

9 Pontus Hultén, "Öyvind Fahlström, Citizen of the World" (1979), in Messer, *Öyvind Fahlström,* p. 106.

10 Öyvind Fahlström, "Notes on 'Ade-Ledic-Nander II'" (1955–57) and "Some Later Developments" (1965), in Messer, *Öyvind Fahlström,* p. 32; see also Lasse Söderberg, "Öyvind Fahlström," in Carmen Alborch, *Fahlström* (Valencia: IVAM, Centre Julio González, 1992), p. 129 (note 19).

11 Hultén, "Öyvind Fahlström, Citizen of the World," p. 106.

12 Öyvind Fahlström, "S.O.M.B.A. (Some of My Basic Assumptions): Variable Painting 1972–73," in Messer, *Öyvind Fahlström,* p. 99.

13 Adolf Gottlieb (1903–74) co-founded a group called The Ten with Mark Rothko in 1935. He co-signed, again with Rothko, a notable letter to the *New York Times* in 1943 which declared their commitment to "tragic and timeless" subject matter and "spiritual kinship with primitive and archaic art." In *Surrealism in Exile and the Beginning of the New York* School (Cambridge, Mass.: MIT Press, 1995), Martica Sawin notes that "during 1942 Gottlieb developed the style for which he became known, usually referred to as pictographic" (p. 297). Influenced by the surrealists, Gottlieb acknowledged his interest in Freud and Jung, but tended to disavow his relation to so-called primitive art.

14 Fahlström, "Notes on '*Ade-Ledic-Nander* II'" and "Some Later Developments," p. 32.

15 Hans Hofmann (1909–66) was a German abstract painter who opened a painting school in New York in 1933. The famous teacher of many of the New York School painters, his theory of "push and pull" composition is outlined in "The Search for the Real in the Visual Arts," in Hans Hofmann, *Search for the Real and Other Essays,* ed. Sara T. Weeks and Bartlett H. Hayes, Jr. (Cambridge, Mass.: MIT Press, 1986), pp. 40–48.

16 Fahlström, "Notes on '*Ade-Ledic-Nander* II,'" p. 32.

17 *Mad m*agazine was founded by William M. Gaines in 1952.

18 Suzi Gablik, "Öyvind Fahlström" (1966), in Russel and Gablik, *Pop Art Redefined,* p. 72.

19 "The factor of time in paintings becomes material through the many, in principle infinite, phases in which the elements appear. As earlier, in my 'world' pictures, such as '*Ade-Ledic-Nander*' and 'Sitting . . . ' a form would be painted on ten different places on the canvas, now it may be arranged in ten different ways during a period of time." Öyvind Fahlström, "Manipulating the World" (1964), in Messer, *Öyvind Fahlström,* p. 45.

20 Öyvind Fahlström, "After Happenings," in Messer, *Öyvind Fahlström,* p. 48.

21 Fahlström, "The Invisible Painting" (1960), p. 31.

22 Öyvind Fahlström, "Opera" (1958), in Alborch, *Fahlström,* p. 137.

23 Ibid.

24 "It appears to me that critics see my work largely in terms of its success or failure as propaganda art. Apparently it is difficult for them to accept that—even though my sympathies are clear—my work is about certain facts, events and ideas, rather than for or against them. If I were only, or mainly, interested in educating the viewers, I would create simpler structures, and use other media than hand-made art." Öyvind Fahlström, "Notations" (1974), in *Fahlström* (Milan: Multhipla Edizioni, 1976), p. 59.

25 Maurice Tuchman, "A Report on the Art and Technology Program of the Los Angeles County Museum of Art (1967–1971)" (Los Angeles: Los Angeles County Museum of Art, 1971). The section dedicated to Fahlström is on pp.102–13.

26 The Comics Code Authority was created by comic book publishers in 1954 as a gesture of self-regulation designed to appease the chorus of moral scare-mongers and their political backers who were protesting against representations of crime, nudity, and violence in the comics. The "standards" adopted by the authority are reprinted in e.g. Les Daniels, *Comix: A History of Comic Books in America* (New York: Bonanza, 1971).

27 Cartoonist Robert Crumb (b. 1943 in Philadelphia) worked for the humor magazines *Help* and *Mad,* and the alternative newspaper the *East Village Other,* in the early and mid-1960s. Moving to San Francisco in 1966, he was one of the founders of the underground comic book *Zap* in 1967. In 1970, an X-rated film version of *Fritz the Cat* (which Crumb had first drawn as a single-issue comic back in the late 1950s) was released by film animator Ralph Bakshi. In 1978 Crumb created *Weirdo* magazine with Aline Kominsky. A decade later Crumb left the U.S. to settle in France. His work was included in the New York Museum of Modern Art's 1990 exhibition *High & Low* (see note 32, below).

28 Öyvind Fahlström, in Tuchman, "A Report," p. 109.

29 Öyvind Fahlström, "Manipulating the World," p. 45.

30 Ibid.

31 Öyvind Fahlström, "World Bank" (1973), in *Öyvind Fahlström: The Installations,* p. 75.

32 See the comparison of Roy Lichtenstein's paintings with their source materials, in Kirk Varnedoe and Adam Gopnik, *High & Low: Modern Art and Popular Culture* (New York: Museum of Modern Art, 1991), pp. 196–209.

33 "For me, it has been important to demonstrate in my works that 'heavy' art (not cartoons, etc.) can be critical and socially concerned. Of course, most heavy art is not a tool for political change." Fahlström, "S.O.M.B.A. (Some of My Basic Assumptions)," p. 99.

34 Fahlström, "Notations," p. 63.

35 Ibid.

36 Sun Ra, "The Realm of Myth," in *The Immeasurable Equation* (Chicago: Infinity Inc./Saturn Research, 1972), p. 21

37 Pianist, band leader, and jazz improviser Sun Ra was born Herman "Sonny" Blount in Birmingham, Alabama, in 1914, and died there in 1993 after spending many years living and playing in Chicago, New York, and Philadelphia. Sun Ra developed a complex mythopoeic philosophy of black liberation that combined references to Egypt as the ancestral homeland of black culture and utopian parables of interplanetary space travel. See John F. Szwed, *Space Is the Place: The Life and Times of Sun Ra* (New York: Pantheon, 1997).

SHALL WE KILL DADDY?

JCW *Along with other former students of Douglas Huebler, including John Miller and Mitchell Syrop,*
Kelley was asked to contribute to the catalogue of the two-person exhibition Origin and Desti-
nation: Alighiero e Boetti, Douglas Huebler, *ed. Marianne van Leeuw and Anne Pontégnie, at*
La Société des Expositions du Palais des Beaux-Arts du Bruxelles in 1997 (pp. 155–71). The essay
was also published in C31 *magazine, part of the* Striking Distance *website, December 1996 to Jan-*
uary 1997 (http://strikingdistance.com). What follows is a lightly modified version of these texts.

When we are forty, other younger and stronger men will probably throw us in the wastebasket
like useless manuscripts—we want it to happen!

 They will come against us, our successors, will come from far away, from every quar-
ter, dancing to the winged cadence of their first songs, flexing the hooked claws of predators,
sniffing doglike at the academy doors the strong odor of our decaying minds, which already will
have been promised to the literary catacombs.

 But we won't be there. . . . At last they'll find us—one winter's night—in open coun-
try, beneath a sad roof drummed by a monotonous rain. They'll see us crouched beside our

trembling airplanes in the act of warming our hands at the poor little blaze that our books of today will give out when they take fire from the flight of our images.

> *They'll storm around us, panting with scorn and anguish, and all of them, exasperated by our proud daring, will hurtle to kill us, driven by hatred: the more implacable it is, the more their hearts will be drunk with love and admiration for us.*

Filippo Tommaso Marinetti, "The Founding and Manifesto of Futurism," 1909[1]

It is not my intention to point out a negative aspect of the work, but only to show that Huebler—who is in his mid-forties and much older than most of the artists discussed here—has not as much in common with the aims in the purer versions of "Conceptual Art" as it would superficially seem.

Joseph Kosuth, "Art after Philosophy," 1969[2]

First of all, I am an ex-student of Douglas Huebler from my days at the California Institute of the Arts in the mid-1970s, a period many romanticize as its conceptualist heyday. In fact Doug was my "mentor," the faculty member charged with keeping an eye on me. Actually, I chose him because I couldn't get along with the mentor I had originally been assigned. Doug came into the school as chair of the Department of Art at exactly the same time as I arrived as a student. We have another thing in common—we went to the same undergraduate art school, at the University of Michigan, Ann Arbor. Despite the fact that Doug graduated twenty-one years before I did, we still had some of the same teachers and courses. Hard to believe, isn't it? Oh, we have one other thing in common . . . Doug Huebler and I share the same birthday: October 27. He was born exactly thirty years before me.

 When asked to write a short essay on the work of Douglas Huebler, I immediately said yes. That was quite a while ago, and now I'm sitting here scratching my head. I'm finding it difficult to begin. I want to say at once that I like Huebler's work very much. I would even say that I'm a fan. But talking or writing about it, figuring in language why his practice interests me so much, is hard. Why is that? I never gave it much thought before. Some artists instantly provoke from me a stream of commentary, almost involuntarily—like drool—but not Doug. His work seems to ask me to ponder it, to think it over. But my responses are generally in opposition to this apparent directive.

I have an unconscious physical response—I laugh. I am confused, which is surprising, in that, on the surface, his work often looks so dumbly straightforward. There is an image, typically quite mundane and recognizable, accompanied by text which one might expect to elaborate on, or explain, the image. But it doesn't do that. Instead, in Huebler's terms, the text "collides" or "dances" with the image. You expect the expected first. This expectation is induced through familiar visual terms. Then, by using a device which in our culture is the most common mode of explication—the written explanation—the expectation is destabilized. What looks so familiar becomes ungraspable. The result is not so much "uncanny"—that is, the familiar become unfamiliar—as it is annoying. We crave familiarity and instead we are made dizzy. Like schoolchildren we seek to please the erudite master, the one who orders the visual chaos of the world, who renders it in clear language. We seek to please him through our understanding of his message, through shared communion with him. But this is a cruel teacher whose lessons elude understanding. You are left only with yourself, and the nervous laughter of doubt.

When I was asked what the theme of my essay would be, I said something to the effect that it would be about "ageism." I didn't know exactly what prompted me to say this. I just blurted it out. I realize that such a theme might not be appropriate for an essay in an artist's monograph, since it seems to prioritize the social reception of the work over and above the artist's own strategies and intentions. Yet Doug's age is something that has been of great consequence in the way his work has been received over the years—just look at Kosuth's comment, above. In 1969, when conceptualism was in its infancy, Doug's age was already an issue. It was still an issue, though in a different sense, in the mid-1970s when I was his student. And even now, when Doug is being reintroduced into art history as a conceptualist "master" and, one would think, his age might no longer be of much importance, it continues to be so.

In his opening essay in the monograph accompanying Huebler's exhibition at the FRAC Limousin (1993), for example, Frédéric Paul raises the issue once again. He furnishes a list of sixteen artists, all associated with recent art movements, who are listed chronologically by their birth date. Huebler is located third from the top with a birth date of 1924; Kosuth comes in last with 1945. Following this list, Paul offers several interpretations of it, organized around the hypothesis of Huebler's "late development": "either one concludes that Douglas Huebler was the founding father and prime mover of conceptual art (it has to be admitted that precious few have reached

this conclusion) or alternately one can opt for the view of Huebler as a sort of ageing dandy, versatile and shrewd enough to jump on the bandwagon."[3] The latter reading of Huebler as an art world Humbert Humbert succumbing to the Lolita-like charms of conceptualism in the late 1960s strikes me as patently ridiculous considering the movement's miniscule critical and economic clout at that time. What, one wonders, was Huebler supposed to gain from "jumping on the conceptualist bandwagon"? If the answer is "youthful vigor by association," Doug might have been better off putting a flower in his hair and going to San Francisco with the rest of the flower children for the "summer of love."

What is the purpose of Paul's list of artists' birth dates? What does it imply? Unfortunately, the answer seems to be that we still expect artists to conform to some clearly constructed evolutionary timeline that somehow guarantees their art historical development. Kosuth's estimation that Huebler was too old to be a pure conceptual artist has become so entrenched in the history of conceptualism as it now stands that his premise demands to be addressed in any discussion of Huebler's work. Here I am, doing it again. But if Huebler was too old to be a conceptual artist, then what was he? A poseur perhaps? But since posing doesn't seem exactly antithetical to the operations of conceptualism, his problem must be that he was the wrong kind of poseur. An even sadder conclusion would be that he was simply not a *young* enough poseur to meet the expectations of the late 1960s, a moment when youth itself was portrayed as avant-garde and the equation of counterculture with youth culture was the kitsch philosophy of the moment. According to this mindset, if conceptualism was to be understood as vanguard, it could not be seen to keep the company of "old men."

Not surprisingly, Huebler's most-often discussed works of late are his early works which, contrary to the problematic nature of his definition as a conceptualist, prove, in fact, that he really was one. They do so in a double sense—by virtue of their dates, and through their outward appearance, which conforms quite readily to our expectations of what a "conceptual" artwork should look like. Maps, diagrams, unprofessional photography, and simple, understated typography are the dominant signifiers of the conceptual mode which is currently in the process of institutional definition (witness two recent major survey shows of conceptual art: *L'Art conceptuel: une perspective,* at the Musée d'Art Moderne de la Ville de Paris, 1990; and *Reconsidering the Object of Art: 1965–1975,* at the Museum of Contemporary Art in Los Angeles, 1995).[4] By focusing on his early

works, we can more easily assimilate Huebler into this fresh history of conceptualism which, like all histories, is less complicated and diverse than the period and practices it purports to define.

I don't want to discuss Huebler's early photographic works, even though I thoroughly respect them. Personally, I am more interested in Huebler's work when it begins to take into account his own historical placement. This turn appears most clearly in his large-scale project collectively titled *Crocodile Tears*—begun in 1981, but which Huebler sees as an outgrowth of his *Variable Piece #70 (In Process) Global* of 1971—loosely described as a proposal to "photographically document the existence of everyone alive."[5] Doug continues his work on *Crocodile Tears* to this day.

As the story goes, a conversation about conceptual art with Hollywood B-movie director/producer Roger Corman[6] resulted in Huebler's writing a screenplay—the aforementioned *Crocodile Tears*. When asked, Doug wasn't very clear about the choice of title, but as the viewer experiences the plethora of complaints emanating from the cast of unsympathetic characters portrayed in the project, the choice is not surprising. The initial script details the daring exploits of performance artist Jason James in a ridiculous and convoluted story that paints James as a comic book superhero artist, who, aided by his sidekick and lover, feminist artist Mollie Trainor, performs death-defying stunts in order to fund his utopian arts organization, the "Vincent Foundation" (named after his favorite artist, Vincent van Gogh).[7] The script is filled with allusions to art-world preoccupations of the time: spectacle, body art, tech and computer art, multinational corporate conspiracy theory, anti-art commodity rhetoric, and PC politics. In a side plot, James is hunted by an ex-convict who was jailed as the result of an earlier James conceptual artwork—an allusion to Huebler's own *Duration Piece #15* (1969), in which the artist himself offers a reward for information leading to the arrest and conviction of bank robber Edmund McIntyre.[8] This piece is recontextualized, in turn, by *Variable Piece #70* (1971)—the work in which Huebler states his intention to document photographically the existence of everyone alive—and merged into the *Crocodile Tears* project as *Variable Piece #70 (In Process) Global, 1981, Crocodile Tears: Inserts "Woody Wright."*

In this work, McIntrye is replaced with current "wanted-by-the-FBI" criminal William Leslie Arnold, who is recast in the *Crocodile Tears* narrative as Woody Wright—the killer out to get hero Jason James. This particular work also inaugurates Huebler's return to painting, at least in a quotational manner, in that it contains a painting of Arnold, supposedly done by Jason James, in which he is depicted, "as he might look today"—aged to make up for the fact that his photo on

the wanted poster is twenty years old. This portrait of Arnold/Wright is painted in the manner of Vincent van Gogh who, as you might remember, is James's favorite artist.

At this point Huebler's already complex work becomes even more layered and allusive. As the *Crocodile Tears* project progresses, he adds to it parallel or tangential elements that seem quite extraneous to the plot at hand. Older works and working methodologies, art-historical allusions presented in paintings done in the manner of famous artists, and side-narratives about characters only marginally connected (if at all) to the Jason James story (illustrated in a cartoonish manner), all compete for attention. While Huebler's early work was quite reserved visually (he limited himself to diagrams, simple typewritten texts, and photographic snapshots), at this point his work becomes almost psychedelic in its overload of elements.

In much of Huebler's early work there had been a tension between surface blandness and infinite meaning. Consider, for example, *Duration Piece #2, Paris* (1970), which presents the viewer with six snapshots said to illustrate the "timeless serenity" of a statue seen in the distance behind some cement trucks. The accompanying text informs us of the mechanistic intervals at which the statue was photographed, but it also tells us that the photos have been shuffled so that they are out of chronological sequence. No longer reportage, we are instead presented with time scambled—which produces, I suppose, the statue's "timeless serenity." In other examples too numerous to mention, Huebler similarly activates banally presented fields of visual information in textual form. In *Crocodile Tears,* visual presentation is elevated into hitherto unprecedented equality with the text. You might say that the image itself is for the first time treated as a text instead of as an invisible convention.

Let's consider for a moment a work by Mel Bochner, *Language Is Not Transparent* (1970). I've always found this piece particularly annoying, though at the same time oddly compelling. In some ways, I feel, it's one of conceptualism's most self-conscious works. The piece consists of a sloppy, dripping band of black paint applied to a wall and large enough to contain the phrase "Language is not Transparent," which is written on it in chalk. At first, the work seems to elicit a tautologically induced "So what?" from the viewer. But after a moment's reflection, the work's very inability to define, assisted by its limited presentational mode, opens up a whole vista of questions. *Language Is Not Transparent* seems to be full of very particular allusions: its drippy execution refers to abstract expressionism, the Oedipal father of conceptual/minimal art; and its use of offhand lettering rendered in chalk on a black surface suggests some kind of childish educational scenario.

These things cannot be looked at simply through the abstract message of the phrase. They inform and "color" the phrase, problematizing its abstraction. Yet what this piece by Bochner tells us cannot be done is what much early conceptualist art asks us to do. Huebler himself wrote in 1969: "I use the camera as a 'dumb' copying device that only serves to document whatever phenomena appears before it through the conditions set by a system. No 'esthetic' choices are possible."[9] In essence, Doug claims that his photographs are transparent—something he thought possible because the photos are purportedly "nonaesthetic," which supposedly allows the viewer to look through them directly into the system they exemplify. I could never accept this proposition.

It is primarily the problem of transparency introduced here that I believe separates the first generation of conceptual artists from the so-called second generation (within which my work is often located). Much of the pleasure I got from early conceptual artworks arose from seeing them as a critique—or parody—of dominant modes of the presentation of "knowledge." I think this was accentuated by the fact that, in the late 1960s, conceptual artworks were in a milieu where they coexisted with psychedelic, counterculture graphics. Psychedelic graphics offered a mode of oppositional visual address quite distinct from dominant cultural modes, whereas conceptual art was a pathetic version of them. Conceptual art's primary visual source looks to be the academic textbook, where a poorly printed photograph or diagram, accompanied by a caption, is standard fare. But the fact that this mode of address is culturally omnipresent does not make it invisible, for, as I have already pointed out, there are informational modes distinct from it that, by contrast, always render it visible again: it is only invisible in context. There are two reasons why, at this time, the art world would wish to render the visual tropes of conceptualism invisible. The first was political: artists sought to make works that, in their seemingly invisible state ("dematerialized" is Lucy Lippard's term),[10] could symbolically escape commodity status. The second was philosophical: to downplay the fetishized material nature of artworks was to "play up" the mind, or intelligence, of their makers (or "conceivers"). This is the Duchampian model. Of course, the visual tropes of conceptualism *were not* invisible, which is obvious now that conceptualism has been codified as an academic and historically recognizable art movement.

In response to this crisis of the "look" of conceptualism, the neoconceptualists of the late 1970s and early 1980s began exploring presentational modes previously taboo in conceptual art—utilizing imagery taken from modernist art history and popular culture. I know from personal ex-

perience at Cal Arts in the mid-1970s how much popular culture was reviled. The general consensus of the first-generation conceptualist faculty was that use of such material merely reiterated the values of the dominant culture, and *critical* usage of it was deemed simply impossible. The widely shared belief that pop art was an apolitical movement had seemingly closed the issue back in 1960s. However, some of the most widely discussed writings by people of my generation tackled the politics of image usage, especially the deployment of mass media imagery: "Images That Understand Us: A Conversation between David Salle and James Welling" (1980); Tom Lawson's "Last Exit: Painting" (1981); and Richard Prince's *Why I Go to the Movies Alone* (1983)[11] are good examples of these kind of texts. In one way or another, all three attempt to reconcile the use of mass media imagery with the political aims of conceptualism. Lawson tries to reintroduce imagistic painting as a viable artistic pursuit, while the other two writings (Prince's in the form of a narrative novel) evoke a kind of phenomenology of popular image reception—both discuss, for example, the allure of magazine photography.

These popular images, the kind of "images that understand us," are dead—are opaque. Salle and Welling put it like this:

So what are the big themes? Much talk about opacity as a positive value, ambiguity, and the complex notion that there are some images or some uses of images which, rather than offering themselves up for a boffo decoding by the viewer, instead understand us. That is to say that there is a class of images, call it an aesthetic class, that allows us to reveal to ourselves the essential complicity of the twin desires of rebellion and fatalism. To say that a work of art is dense or opaque is not to say that it is not implicative, subversive or poignant.[12]

Lawson proposes that, due to the very fact that it is an outworn mode, painting is the "last exit" for the radical artist: "He [the artist] makes paintings, but they are dead, inert representations of the impossibility of passion in a culture that has institutionalized self-expression. . . . The paintings look real but they are fake."[13] This experience is a familiar one in relation to conceptual art—Huebler's early work presents itself in such terms, as I have already suggested. The very deadness of its academic facade diverts the viewer elsewhere.

Shortly after Lawson's essay was published in *Artforum,* Huebler lashed out at the ideas it expressed in the same journal. His counteressay, "Sabotage or Trophy? Advance or Retreat?" adopts a Marcusean position in relation to the embrace by "New Painting" of popular style: "Little wonder that art-world marketing strategies are so successful: they simply emulate an all-pervasive ideological impulse which seeks gratification through constant change. Little wonder that the products of art are regarded as consumable; little wonder that the historicizing of Conceptual Art lined it up in the fashion parade of art as yet another example of avant-garde style!"[14]

Huebler brands as "reactionary" and pluralist the use in New Painting of already consumed and lifeless images from the past and present.[15] Surprisingly, Huebler cites as alternatives to the New Painters socially engaged artists such as Suzanne Lacy, Hans Haacke, and Helen and Newton Harrison, preferring them because they focus on matters that lie outside of art. Surprising, because this is not, of course, the path that Huebler himself takes. In his own work Huebler also reintroduces painting, mimicking the styles of famous art historical figures; he also begins producing works utilizing such popular forms as the Hollywood narrative and the newspaper comic strip. And none of these works are overtly political in the manner of Haacke, for instance. They raise the question: How, exactly, are their strategies different from neoconceptualist work?

Needless to say, Huebler's attacks on neoconceptualism did not exactly endear him to the younger generation. On the other hand, his work at this point had more in common with theirs than it did with that of most of his contemporaries. Huebler was an interesting figure in the 1980s art world in that many young artists had a kind of attraction/repulsion response to him. His work certainly had an impact on many of the artists associated with neoconceptualism—both the New Painters (and photographers) and the commodity and appropriation artists. But I want to point out one important difference between Huebler's practice and neoconceptualism. In most neoconceptualist work, the artist is rarely present (this is true of their social positions as artists as well, for by the mid-1980s hardly any of the neoconceptualists wrote critically and many of them became increasingly tight-lipped, in the Warholian manner, about their artistic motives). In Huebler's work, by contrast, his own position in relation to the art world becomes more and more overt, even though it is presented through fictional characters. Despite the fact that Cindy Sherman continually photographs herself, you never learn anything about Cindy Sherman, nor do you expect to. The work—especially her famed *Film Stills* series—constantly refers back to social archetypes. In Huebler's *Crocodile Tears,* a great deal can be gleaned about his relationship to the art world, the

art market, and art history. Again, his work *is* fictive, not overtly biographical, but it does allow access to social realities instead of social archetypes. While I'm aware this is a distinction that is seldom clear in art, I guess it would be more proper to say that Huebler's work *intimates* experience instead of fantasy. The popular images he uses are not completely dead; they still resonate somewhat with life. His work rides a slippery line between the two.

In one version of the *Crocodile Tears* project, done as a weekly comic strip for a Los Angeles newspaper,[16] Huebler presents the tale of a character named Howard, a first-generation expressionist painter. As I recall, the rise of 1980s neoexpressionism prompts Howard to think his career will make a comeback. No way. A reminder of expressionism's less-than-new history, Howard is simply an embarrassment, a threat to neoexpressionism's pose as fresh goods—as current style.

I remember hearing young artists describe Huebler's *Crocodile Tears* project as the complaints of an aging and bitter man. They were frankly embarrassed that the pathetic art-world scenarios it depicted were being paraded in public. Huebler's work did not engage the popular dream spectacle to the proper degree. It wasn't removed enough—it wasn't "cool." He seemed too present in his fictions. These younger viewers disdained the work precisely because it introduced unsavory topics that young, up-and-coming artists didn't want to think about. Again, the specter of Huebler's age looms large. I, for one, embraced his tactics. Why shouldn't these things be the subjects of his work—they are the realities of his life, and have become the realities of mine now that I have been in the art world for a while. These embarrassing and loaded themes *should* be the material of art production. And if, as with Cindy Sherman's work, we are supposed to look through the thoroughly recognizable trash of film and television melodrama and find meanings that are not reducible to these appearances, why can't we do the same with Huebler's scramble of dreary art-world scenarios? Perhaps the main reason is one I have already mentioned: they are embarrassing—at least to artists. They venture too close to home. In this sense you can even say that Huebler has a remote connection to Abject Art.

But I don't want to dwell too much on the sociopolitical aspects of Doug's work. To do so would only downplay the work's formal ingenuity. The social commentary in Huebler's project, of course, means next to nothing unless it is considered in relation to the complex structures through which it is presented. Doug's work is extremely playful formally, and much of my enjoyment of it—and exasperation with it—arises from that. The work's self-criticality develops from Doug's insane

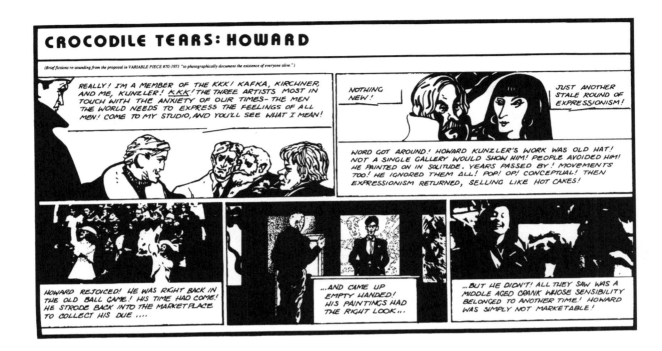

Douglas Huebler, *Crocodile Tears (Howard)* (1984). Segment of conceptual comic strip that appeared in weekly installments in the *L.A. Weekly* between June 29 and August 30, 1984. Ink and photograph on paper. 11 x 13¼ ins. Courtesy Huebler Estate.

interplays of structure and content: he continually sets off in one direction only to divert or mutate into something else, often unexpected or indecipherable. I referred above to the seeming contradiction between Doug's attack on the pluralism of New Painting and his own involvement in what could be understood as pluralist practices—*Crocodile Tears,* in particular, is a giant mishmash of styles and references. In one sense, then, Doug's compositional methodologies are akin to David Salle's strategies of leveling. But this is not how I experience them. Despite its complexities, his work still strikes me as dialectical—even though the various positions he plots are sometimes so numerous that it becomes impossible to position yourself in relation to them. Yet I do not experience this as planned futility. Rather, I take it as a challenge to involve myself in complexity. It's up to the viewer to respond to the challenge—or not to. Doug's work is not designed to fail. It is possible to navigate through Huebler's multilayered constructions. It's just that his is not an "easy" art.

The subject of pluralism is wittily evoked in *Crocodile Tears* through the inclusion of material relating to the "Peaceable Kingdom." Throughout the project, the narrative is interrupted by various nonillustrative elements, including photos from the continuing *Variable Piece #70* (which, in its stated intention to document everyone alive, is already an impossibly democratic endeavor). Another intrusive element consists of paintings mimicking the works of other artists, executed in the manner of Bruegel, Piet Mondrian, Claude Monet, Henri Matisse, etc. Occasionally, these paintings have included within them the phrase "The Peaceable Kingdom," which refers to a vision of the Old Testament prophet Isaiah: "The wolf also shall dwell with the lamb, and the leopard shall lie down with the kid; and the calf and the young lion and the fatling together; and a little child shall lead them./ And the cow and the bear shall feed; their young ones shall lie down together: and the lion shall eat straw like the ox."[17] What better parable of harmless (nondialectical) coexistence could there be? Although Huebler was not evoking him specifically, it's hard not to think of the nineteenth-century American painter and Quaker preacher Edward Hicks,[18] who is said to have made over 100 paintings illustrating the vision of the peaceable kingdom. Because members of the Quaker religion separated themselves from general society to reside in their own communities based on pacifist beliefs, the theme of the peaceable kingdom becomes, in Hicks's case, more than a mystical parable. It is a call to social action, the expression of a utopian desire for the construction of a society based on brotherly love.

This scattering of works, rendered in myriad styles, labeled "The Peaceable Kingdom"

could be read as an illustration of "postmodern" pluralism. It could also be understood as a snide comment on the failure of the modernist utopian program which sought a kind of aesthetic version of brotherly love in its various attempts at international style, or a common language of abstract form. I don't think it would be so wrong to read it that way. Huebler's work, however, is never solely ironic. It continues to hold within it a spark of modernist utopianism. He has told me as much. Though it reveals no clear social program, and staunchly refuses to speak clearly, his work is not fatalistic. His very choice to work with narrative, to set up a system that progresses forward, even as it constantly evokes its own past and process of construction, testifies to his belief that art is forward-looking.

And now I will attempt the impossible, by stating that the "generation gap" (a term that makes your skin crawl just saying it) no longer exists. We now live in a paradoxical community of dialectical, brotherly love free from distinctions based solely on chronology. Hooray!

That's not to say that we are equals, however.

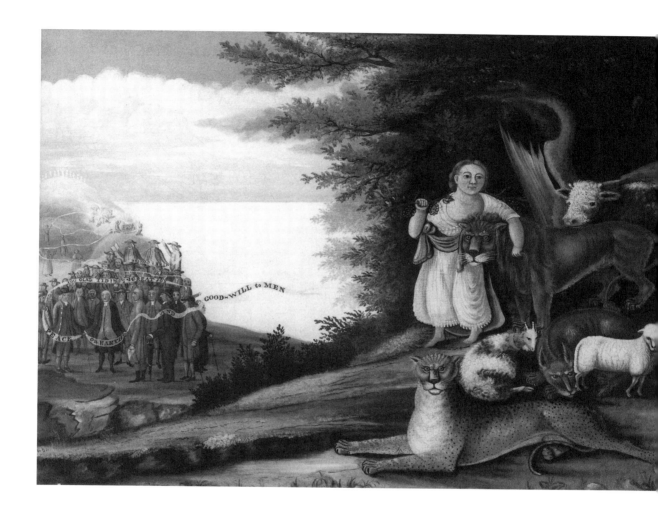

Edward Hicks, *The Peaceable Kingdom* (1825–30). Oil on canvas. 17 1/2 x 23 1/2 in. Yale University Art Gallery, Bequest of Robert W. Carle, B.A. 1897. Courtesy Yale University Art Gallery.

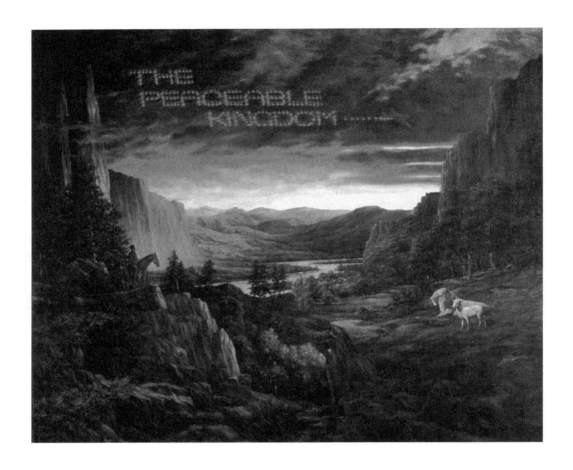

Douglas Huebler, *Crocodile Tears II: Lloyd (Peaceable Kingdom I),* detail (1985). Oil on canvas, framed text, framed black and white photograph, and text. Variable dimensions. Courtesy Huebler Estate. Collection Museum of Contemporary Art, San Diego (Contemporary Collectors' Fund).

NOTES

1 Filippo Tommaso Marinetti, "The Founding and Manifesto of Futurism" (1909), in *Marinetti: Selected Writings,* ed. R. W. Flint (New York: Farrar, Straus and Giroux, 1972), p. 43.

2 Joseph Kosuth, "Art after Philosophy," in Kosuth, *Art after Philosophy and After: Collected Writings, 1966–1990,* ed. Gabriele Guercio (Cambridge, Mass.: MIT Press, 1993), p. 26. This essay was first published in *Studio International* 178, no. 915 (October 1969).

3 Frédéric Paul, "D H *still* is a real artist," in *Douglas Huebler: "Variable", etc.* (Limoges: FRAC Limousin, 1993), p. 28.

4 *L'Art conceptuel: une perspective* (Musée d'Art Moderne de la Ville de Paris, November 22, 1989, to February 18, 1990); *Reconsidering the Object of Art: 1965–1975* (Museum of Contemporary Art, Los Angeles, October 15, 1995, to February 4, 1996).

5 The piece is reproduced in Paul, "D H," p. 133.

6 In 1970, Roger Corman founded New World Pictures, a Los Angeles-based production/distribution company which produces low-budget movies in such genres as horror, "blaxsploitation," and the "nurse film."

7 A synopsis of the original script and several storyboards appear in the catalogue for the exhibition *Douglas Huebler* (La Jolla Museum of Contemporary Art, May 27 to August 7, 1988).

8 "In this work Huebler offered $1,100 for the return of Edmund Kite McIntyre, a bank robber wanted by the FBI. Huebler mandated that any collector who bought the piece would incur the responsibility for paying off the reward should McIntyre be brought to justice. Rather than submerging the varying agendas and social roles of the participants, *Duration Piece #15—Global* contrasts and complicates them, ironically binding the artist and connoisseur to a social obligation while implicating the FBI and McIntyre in an aesthetic endeavor." Jon Ippolito on *eyebeam;* see <http://www.eyebeam.org>.

9 Douglas Huebler, exhibition catalogue statement for *Prospect '69,* October 1969; cited in Jack Burnham, "Alice's Head: Reflections on Conceptual Art," *Artforum* (February 1970), p. 41.

10 Lucy R. Lippard, *Six Years: The Dematerialization of the Art Object from 1966 to 1973* (New York: Dutton, 1973).

11 David Salle and James Welling, "Images That Understand Us," *Journal,* Los Angeles Institute of Contemporary Art, June/July 1981; Thomas Lawson, "Last Exit: Painting," in Brian Wallis, ed., *Art after Modernism: Rethinking Representation* (Boston: David R. Godine, 1984); Richard Prince, *Why I Go to the Movies Alone* (New York: Tanam, 1983).

12 Salle and Welling, "Images," p. 4.

13 Lawson, "Last Exit: Painting," p. 160.

14 Douglas Huebler, "Sabotage or Trophy? Advance or Retreat?" *Artforum* (May 1982), p. 73.

15 Ibid., p. 76.

16 Excerpts from the strip, commissioned by the Los Angeles County Museum of Art as part of their "In Context" program of monographic exhibitions and originally published in the *L.A. Weekly,* appear in the catalogue for Huebler's show at La Jolla Museum of Contemporary Art (see note 7), pp. 14–18.

17 Isaiah 11: 6–7 (Authorized [King James] Version of the Bible).

18 For further information on Edward Hicks (1780–1849), see Alice Ford, *Edward Hicks: Painter of the Peaceable Kingdom* (Philadelphia: University of Pennsylvania Press, 1998).

DAVID ASKEVOLD: THE CALIFORNIA YEARS

MK *David Askevold asked me to write a brief account of his years in California, especially the period from the late 1970s to the early 1980s. The resulting essay, published in the catalogue for the exhibition* David Askevold: Cultural Geographies and Other Works, *at the Confederation Centre Art Gallery and Museum, Charlottetown, Prince Edward Island, Canada, in 1998, does not, of course, address the entire range and complexity of Askevold's artistic practice, even during these years—which would require a whole book. His work is so elusive and multilayered that it defies easy description, and even though I've been fascinated by what he's achieved—pieces I saw twenty years or more ago continue to intrigue me—I am still mystified by it. The task I attempt here, however, is relatively simple and essentially biographical. I offer a general outline of the artistic milieu we shared—at least as I understand it.*

I met David Askevold in 1977 while I was a graduate student at the California Institute of the Arts, Valencia (Cal Arts).[1] Before I got to Cal Arts, I was unfamiliar with his work—hardly surprising since the school where I had done my undergraduate degree was oblivious to the world of conceptual art, and Askevold is a conceptual artist, though a somewhat unusual one by conventional

definitions of that term. I had attended one of those frumpy state university programs that never ventured beyond the influence of the New York School of painting. Askevold, by contrast, had taught from 1968 to 1974 at one of the most vanguard art schools of the period: the Nova Scotia School of Art and Design in Halifax, Canada,[2] where he was a teacher famous for applying the strategies of postminimalist art practice to the classroom. David first came out to California to teach at the University of California, Irvine, in 1976. He taught the following academic year at Cal Arts.

When I arrived at Cal Arts, I was suddenly faced with a group of artists and a set of art terminologies that were completely foreign to me. The faculty was composed primarily of concep- tual artists, and photography, accompanied by text, was clearly a dominant methodology— "photo/text" was its abbreviated designation. A number of my teachers made works in this manner at one time or another: John Baldessari, Laurie Anderson, Douglas Huebler, Robert Cum- ming, and Askevold himself. While this group was quite diverse, and each artist used photo/text strategies in a different way, I perceived all of them them as connected aesthetically, in one way, at least: they all seemed to be attempting to free themselves from the reductivism associated with the so-called first generation of conceptual artists. I'm referring here to the well-known group of artists that collected around Seth Siegelaub in New York: Lawrence Weiner, Joseph Kosuth, Robert Barry, and the early Douglas Huebler.[3] Baldessari's humor, Anderson's folksy storytelling, Cumming's flat- footed absurdity, and Huebler's increasing referential density were at odds with the tautological simplicity of much first-wave conceptualism.

Another point of contention between first-generation conceptualists and the Cal Arts group is the question of narrative. In one way or another, all the artists I just mentioned addressed narrative issues in their work. Sometimes their narrative concerns were overt—as in Anderson's streams of anecdotes, or Huebler's *Crocodile Tears* project (rooted as it is in a film-script proposal);[4] sometimes they were implicit, as in Baldessari's *Blasted Allegories* series (1974),[5] with its seemingly random collection of tinted photographs of television programs paired with words and arranged horizontally like scenes in a storyboard.

From among this group, it was Askevold who appealed to me most directly. His work struck me as the strangest, the most dense, and the scariest of the lot. His commitment to narra- tivity was the most elastic—present enough to allow me access, but sufficiently oblique to leave me disoriented. One of the first of his artworks I encountered, the photo/text piece *The Ambit: Nine*

Clauses and Their Allocations (1976), consists of nine four-part color photo panels "illustrating" a confounding text; the closest I can come to describing it is to suggest that it's done in a kind of psychotic legalese. The text is descriptive—it states rules and sets conditions—but you don't know what of or what for. Consisting of murky depictions of light and shadow, material textures, and glistening watery reflections, the photos are equally opaque. The continuity of language and image usage provides a sort of formal closure, but one's sense of the piece attaches, finally, more to a mood than to narrative meaning. The combined effect of the image/text pairing is akin to reading an overly complex contract while enveloped in the twilight fog that descends on you after a heavy dose of cough syrup. Oddly enough, I find this extremely pleasurable.

Conceptual art could be loosely defined as a movement that attempted to point out, and experiment with, the presentation of "knowledge" by means of pictorial tropes. This often took the form of parodic recreations of the typical page layouts of academic textbooks: bland documentary photographs accompanied by redundant footnotes; absurd charts, graphs, maps, and diagrams. David's work hardly ever addresses this arena of knowledge. Instead, he is drawn to the world of more arcane knowledge: the hard-to-pinpoint logic of rambling, un-self-conscious bar conversation, or the free-floating mind caught in some daydream or other zone-out mode. He favors the poetics of pseudo-science, pop psychology, or the occult. Yet the work does not strike me as surrealist. Its rendition in "streams of consciousness" is too obviously a structured fabrication. It's unnatural . . . but also somehow too "analytical" to come off as dandyistic posturing. At times, I think of David's work as offering a kind of structuralist take on Kenneth Anger's psychosexual film rituals[6]—clearly an unlikely, even contradictory, project. Can delirium ever be analyzed—while being experienced? Wouldn't such an effort disrupt the seductive, mysterious qualities of delirium? Well, David seems to have his cake and eat it too. He is a scientist of disorientation.

I was given a three-part Askevold crash course in 1977—seeing works in his studio, at an exhibition (shared with Michael Asher and Richard Long) at LAICA,[7] and in a compilation of artists' projects and writings called *Individuals: Post-Movement Art in America*,[8] which has a selection of works David made in the early to mid-1970s. The writings, in particular, were a revelation. I was taken aback by their odd mixture of gamelike strategies, fractured, Burroughs-ish[9] word and genre pairings, and weird, ritualistic overtones. Not since reading Lautréamont[10] had I been so moved by "poetry"—I don't what else to call it. David's perverse misuse of logic structures, his unusual

applications of pulp fiction tropes, and his unembarrassed, romantic imagistic revelings were un-like anything I had come across before. All the positive aspects of mystical rapture were there—the ritual, the opulence, the inebriation, the rich, elusive symbology—yet mysticism's negative aspect, its faith in some transcendent beyond, was utterly absent. This was *art*, not religion, and its plea-sures were material and constructed. As I perceived it, the message was "surrender to spectacle need not be mindless."

Our mutual interest in the poetics and structure of occult practices and imagery led to a collaborative work called *The Poltergeist*. We each researched the literature on this particular "phe-nomenon," and produced two separate bodies of work—a series of large-scale photographs ex-hibited together at the Foundation for Art Resources in 1979. FAR, another Los Angeles alternative space, which also funded lectures and artists' projects, was co-directed at that time by David's then wife, Christina Ritchie. It was one of the first places in Los Angeles to present works—such as Jack Goldstein's films and the performances of Matt Mullican[11]—by the younger generation of neo-conceptualists. In addition to the photographic series, there was also an evening presentation of David's new videotape, *Bliss D.F.*[2] (1977–79), a light-hearted work (for David) in which a text de-scribing how to shrink a human head is demonstrated using avocados as stand-ins, while excerpts from a sex therapy audiocassette drone on simultaneously. I presented a performance work titled *The Monitor and the Merrimac* (1979).

Several of the photographs from the series make reference to early twentieth-century spiritualist photography, a tradition both David and I were especially interested in, I believe, because of the light it shed on the photographic assumptions of conceptual art. I found the transparent quality of the photographs used in much conceptualist art quite problematic. As in traditional doc-umentary photography, the viewer was supposed to look straight through the photographs to encounter the "information" they contained. Spiritualist photography, it seemed to me, problematized this experience of photography because, at least at the time they were produced, these photographs were taken for depictions of actual supernatural occurrences. But the increased familiarity of the common viewer with photographic technologies renders these fabrications laugh-able and explodes their status as "documentation." This change—the shift from naturalistic read-ing to the recognition of the photograph as a staged event—challenged the believability of any photograph as a transparent record of a "real" event.

My work with David was not his first collaboration. At the 1977 LAICA exhibition, David made an installation in the form of a "video bar," where viewers could relax and watch his video-tape *John Todd and His Songs* (1977). (Before describing this tape, I must digress to explain to the present-day reader what a video bar is. In the pre-MTV period, the only place one could see art videos—and their bastard cousins, the emerging underground of self-produced rock videos—was at alternative spaces or certain hipster discos where video DJs would project them. For a short time, attempts were made to start up video bars, bohemian versions of the sports bar, where one could have a drink and watch videos presented on television monitors behind the bar. The fad never caught on, probably because of the rise of music video shows on regular broadcast TV.) David's videotape documented the extemporaneous songs and performances of a student of his in a class he had taught at the University of California at Irvine. The tape also documented John Todd's in-teraction with fellow students in a crit class. This piece, and another tape from the same year, *Very Soon You Will* (1977), were somewhat controversial at the time because of the issues they raised about authorship and the moral obligations of artists when they use other people in their work. Apparently, John Todd was supposed to edit the video footage to produce his own version of the documentary, but as far as I know this never happened. Judging by the student we see in the tape, it seems unlikely that this was ever a real possibility. Adopting the manner of a therapist or acid-trip guide, the off-screen Askevold in *Very Soon You Will* leads a woman through a mental exploration of her own death. It was David's role as the instigator of these works that upset people. He set up situations that could, and did, venture into unsettling territory, while he himself was distant, almost not present at all, as if the situations he set up were natural occurrences.

Critiques of power relationships were in the air at this time. Conspiracy theories abounded: the media buried secret subliminal messages in advertising, Satanist rock stars inserted backwards slogans into their records, cults were growing by leaps and bounds, feminist readings of the hierarchies of university life made both students and teachers hyperaware of the dangers of fraternization. In this milieu, it was asking for trouble to work with students at all. In fact, in the very same show at LAICA that included Askevold's video bar, Michael Asher presented a work for which he hired a number of people, primarily students I believe, simply to hang around the gallery during opening hours. For this they were paid something akin to minimum wage. In the catalogue for the show, several "employees" wrote statements describing their experience of Asher's artwork

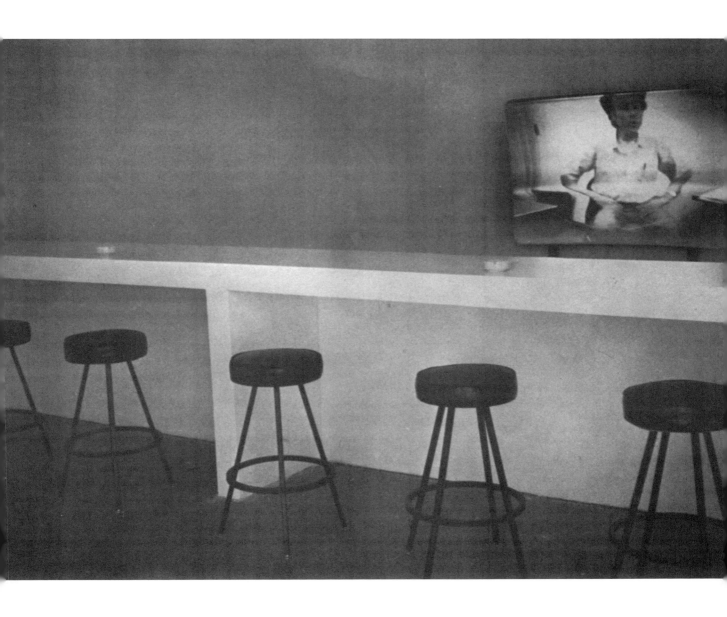

David Askevold, *Video Bar Installation* (1977). Work included Askevold's video *John Todd and His Songs* (1977). Installation shot from Los Angeles Institute of Contemporary Art. Photo: Robert Smith. Courtesy David Askevold.

and it is obvious that they felt like pawns. This was no Happening, no fun, and no collaboration; it was a mirror of the world of wage slavery. The artist could be seen as a kind of cult leader, a "mind-fucking" specialist. Around this time, Jenny Holzer was making street posters mimicking the syntax of inflammatory rants; Survival Research Laboratories were starting up their machine theater, infused with conspiracy theory; and the new punk movement was reassessing the ultimate feel-bad hippie, Charles Manson, king of the mind-fuckers, as a kind of negative role model.[12] Paranoia was running deep. David's work obviously mirrors these states of affairs. But not overtly. The works are beautiful, they seem to invite viewers to let their minds wander, to interpret as they desire . . . and poison themselves of their own free will.

I recall David's classes at Cal Arts as some of my favorites. However, I can't really say that I can remember them specifically at all. The assignments he gave were so open-ended that I never knew exactly what was expected of me, or even what the aim of a particular exercise was. This confusion was part of the point of the class, I suppose: to define our activity as it went along, or, rather, to learn to develop an approach that would elude definition. The crits circled on and on. Strategies were proposed, then found to be too simple or obvious. You always had to move on to the next level of complexity. Too confusing? Then back to square one. When we were appropriately dislocated by round after round of mental gymnastics, that's when our conventionalized—slavish—addiction to the laws of visuality set up by the Super Ego, started to dissipate. At this point there occurred the *death of the author.*

The general fear of being controlled by other people, which I mentioned earlier, is part of the reason, I think, for the rise of the appropriation art movement. You become the thing that you fear or desire out of choice, rather than against your will. At around the same time that Sherrie Levine and Richard Prince began their practice of rephotographing photographs, so did David. *Ten States in the West* (1978–79) is one of his most beautiful photographic series. It consists of ten color photographs that progress in one horizontal line, giving the impression of a wide landscape panorama evocative of the grand sweep of the Western plains and their desert vistas. The work is composed from a number of image sources, including actual landscape photographs, sparkling close-ups of indeterminate nature, elaborate fabric patterns, and sections of glossy, color magazine pages. In a manner that's not collage-like at all, each of the elements morph together very naturally into one spectacular sunset. It has all of the drama and effect of nineteenth-century

landscape painting in the grand style—like Frederic Edwin Church[13] at his most opulent. Unlike the younger artists, for whom restriction to the original source material seems almost a political imperative, David allows himself free reign to mix image sources of an almost psychedelic variety—a range that Prince, for example, can only nod to in his variations of photographic exposure times and focus. Like Askevold, Prince is obviously drawn to the beauty of glossy magazine illustration, yet his desires seem rooted, primarily, in the borrowed imagery itself. With Askevold it is the intensely colored, mirror-like surface of the page itself that appears to be the focus of attraction— how it picks up and distorts in reflection what is in proximity to it, producing double-exposure effects.

This conclusion is in keeping with Askevold's use of distortion and reflection throughout his career—in, for example, the watery distortions of the "Muse Extracts" photographs (1974), and his play with mirrors in the photos illustrating the *Draft for a Syncretism (Notes from Lisbon)* (1974).[14] Such visual extravagance was not the norm in the art of the late 1970s and early '80s. Compared to that of the younger, neoconceptualist photographers then arriving on the art scene, David's work looked positively manic. Perhaps this is why David stopped making photographic pieces around this time, to concentrate instead on video works.

While in California, David, Christina, and their son Ben lived in a small house in Venice, just a few blocks from the beachfront Venice Boardwalk, with its assortment of gang members, weight lifters, teenage surfer runaways, hippies (old and young), hordes of tourists, and the street performers they attract. Rents in Venice at that time were quite inexpensive and the area was part barrio, part bohemian enclave. Many artists of the 1960s and early 1970s generation lived there, before the economic upswing of the '80s raised their rents. John Baldessari's studio, just down the way, was the site of many gatherings and parties where artists of various generations mixed. I spent a lot of time at David's place, just hanging out. The photo shoots for *The Poltergeist* were done in his small backyard garage-cum-studio. We also listened to a lot of music, which was another interest we shared. I was fascinated by the sound elements and musical references in David's work: the homemade instruments from *Visits* (1975–77); *Kepler's Music of the Spheres Played by Six Snakes* (1971–74); the rhythmic nature of his short film *Knife Throw* (1969); the simplicity of the videotape *Fill* (1970), which documents the sound of aluminum foil being wrapped around a microphone until the frame is filled; his recordings of the pure tones of tuning forks; his dronelike

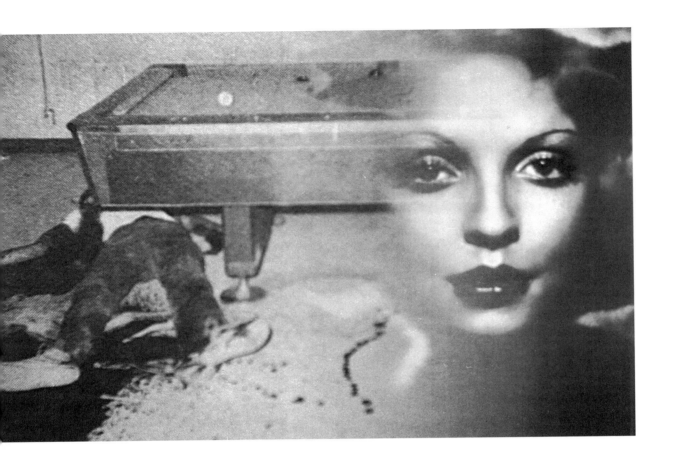

David Askevold, *Ten States in the West,* detail (1978–79). Ten color photographs, type C prints on board. 13½ in. high with variable widths from 39 to 78⅔ ins. Courtesy David Askevold. Collection of Canada Council Art Bank and private collections.

collaborations with various musicians, as in the soundtrack to *Jumped Out* (1984–85); his recordings of John Todd's strange songs; and the musicality of his writing itself. It was in response to all this that The Poetics, a band I was then involved with, used a section of his text "Searing Gum" as song lyrics. Later, David's interest in music led him to make a first-wave rock video with Hüsker Dü (1985); the bucolic video short *1/4 Moon* (1986), in which a violinist serenades animals in a barnyard; the ambient video *Two Rotating Candle Chandeliers* (1990); and *Honky Tonkin'* (1986), which chronicles a novice learning to sing country style—a nod to David's long-standing love of country music.

David soon left Los Angeles, spending some time in Minneapolis, going on to Toronto, and then eventually back to Halifax. After he left LA, he worked primarily in video, producing some of his most complex pieces, including the fractured soap opera *How Long Have You Known Barbara* (1986–87)—his closest attempt at standard narrative form—and the moving *Six Fifty* (1987–89)—a "portrait" of two men that mixes real and fictive biographical material. Recently, however, David has returned to photography, at least in part, creating a new installation that combines aerial photographs of coastal harbors with video footage of "life on the surface." I'm hoping this will prompt a reassessment of his photographic work from the 1970s.

NOTES

1 Funded by Walt and Roy Disney, the California Institute of the Arts was founded in 1961 through the merger of the Los Angeles Conservatory of Music and the Chouinard Art Institute. Cal Arts moved to its present site in Valencia, California, in 1971, and offers degrees in art, music, theater, film/video, and dance. In 1995, a writing program in critical studies was added.

2 Established in 1887 as the Victoria School of Art and Design, the Nova Scotia School of Art and Design in Halifax, Canada, took its present name in 1969, and moved to the current campus in downtown Halifax in 1978.

3 The Xerox Book show organized by Seth Siegelaub and John W. Wendler has been considered one of the first collective manifestations of the conceptual art movement; see Siegelaub and Wendler, *Carl Andre, Robert Barry, Douglas Huebler, Joseph Kosuth, Sol LeWitt, Robert Morris, Lawrence Weiner* (December 1968), book of Xerox copies.

4 Kelley discusses the *Crocodile Tears* project in his essay on Huebler, "Shall We Kill Daddy?" (1996), in this volume.

5 On John Baldessari's *Blasted Allegories,* see Hal Foster, "John Baldessari's Blasted Allegories," *Artforum* (October 1979).

6 Kenneth Anger (b. 1930) is a noted avante-garde filmmaker, who made his first film, the eleven-minute *Who Has Been Rocking My Dream Boat?,* in 1941; *Fireworks,* his since-distributed film, in 1947; and the influential *Scorpio Rising* in 1963. His chronicle of Tinsel Town scandal, *Hollywood Babylon,* was first published in France in 1959.

7 LAICA (Los Angeles Institute of Contemporary Art) was an alternative space founded in 1973. Curated by Tom Jimmerson and Helen N. Lewis, the exhibition *Michael Asher. David Askevold. Richard Long* took place between January 15 and February 10, 1977.

8 Alan Sondheim, ed., *Individuals: Post-Movement Art in America* (New York: Dutton, 1977).

9 William Burroughs (1914–97), the oldest member of the Beat generation, wrote a series of vivid and violent books about his drug addictions and homosexual adventures, including *Junkie* (1953). *Naked Lunch* (1959) and following works inaugurated his experimental "cut-up" and "fold-in" techniques.

10 The Comte de Lautréamont (Isidore Ducasse) (1846–70), author of *Les Chants de Maldoror* which combined black humor and extreme metaphors, was a favorite of the surrealists. See *Maldoror and the Complete Works,* trans. Alexis Lykiard (San Francisco: Exact Change, 1994).

11 Jack Goldstein (b. 1945) has worked in film, photography, and painting; Matt Mullican (b. 1951) in performance, installation, and most recently with computer-generated graphics.

12 Jenny Holzer (b. 1950) began using posters pasted in the streets in her *Truisms* series (1977–79). For her *Inflammatory Essays* (1979–82), *Living Series* (1980–82), and *Survival Series* (1983–85), she used posters, stickers, LED displays, printed T-shirts, the Times Square Spectacolor Board, and later incised stone benches and other media for the public display of her slogans and messages. On Survival Research Laboratories, see Kelley's essay "Mekaník Destruktíw Kommandöh: Survival Research Laboratories and Popular Spectacle" (1989), in this volume; on Charles Manson, see "Death and Transfiguration," in this volume, note 6.

13 On Frederic Edwin Church (1826–1900), see "Go West," in this volume, note 4.

14 Sondheim, *Individuals,* pp. 97–102.

GO WEST

JCW *First published in the catalogue for the exhibition* **John Miller: Economies Parallèles/Parallel Economies,** *at Magasin, Centre National d'Art Contemporain, Grenoble, June 6 to September 5, 1999, pp. 38–41.*

Brown. Just as Yves Klein's patented blue is so associated with his artistic practice that it is now his "signature,"[1] so it is at this cultural moment with John Miller and the color brown. So much so, I would say, that it is difficult for another artist to use his particular shade of the earth tone and not have it seen as a quotation. But the priority accorded this one aspect of Miller's work has radically affected the art world's reception of the rest of his oeuvre. Those of us who have followed John Miller's career over the past fifteen or so years know that he is one of those artists who has worked in a multitude of manners. He has painted scenes of everyday life that bring to mind the works of the social realist artists of the American 1930s; and he has made other paintings, in the same very direct manner, of such stereotypical or "stock" images as butterflies, fairies, and devils—images that look almost as if they were clipped directly from children's storybooks. He has made simple pencil drawings of "real estate," uninflected renderings of the interiors and exteriors of a wide variety

John Miller, *Untitled* (1990). Styrofoam, objects, plaster, papier-mâché, and acrylic paint on Masonite panel. 60 x 48 x 14 ins. Courtesy Metro Pictures.

of abodes. Then there are photographs, taken during the middle of the day when the sun is positioned directly overhead, casting its unflattering light on a seemingly endless variety of human activities and locales. He has worked with found objects, covered in gold leaf, grouped together in assemblages . . . and sometimes slathered with, or buried in, a deep brown impasto. John Miller has done all this and more, but the mental image that always recurs is—brown.

Consensus holds that Kleinian blue is the ascendant color of the heavens, and so it follows that John Miller brown is the lowly color of the "base." At best, his brown is dirt, but more often it is shit. I have never heard anyone describe John's usage of brown paint as evocative of the earth without negative connotations, despite the fact that he has made landscape-like sculptures where the color choice seems only natural. In fact, he has used brown pigment in myriad ways, natural and unnatural, but it is the abject association of the color that has stuck with him. Even when no brown is present, abjection tints the rest of his work by default. His photographs of quotidian street scenes take on a melancholy or existential air. Groupings of brightly colored objects become "happy" only ironically. All meaning is reduced to the level playing field of the shitty where every action can only be the negative reaction to something more elevated. His practice is thus construed as nihilistic.

One aspect of John's work that runs counter to this generally negative reading is his occasional evocation of the American landscape tradition. Such references are most readily apparent in his paintings of the landscape of the American Southwest. These works, obviously copied from photographs, recall such influences as the garish photography of *Arizona Highways* magazine,[2] scenic calendar prints, and postcards. Certainly the paintings can be seen as ironic, as kitschy debasements of the grandiose American landscape paintings of the nineteenth century. Yet I would claim that John's paintings retain some measure of the ambiguous aesthetic of romantic landscape painting itself. Their ambiguity resides, however, in how they mean critically rather than how they are experienced phenomenologically. John's paintings are, perhaps, only sublime in that they propose desublimation.[3] They imply criticality through an evocation of natural beauty that is too overt, as well as in their insinuation of a revisionist view of American history, specifically that of the colonization of the West. However, the paintings do not follow through on these "critical" promises in any obvious manner. They may, in fact, be nothing more than skillfully executed paintings of scenic

wonders and regional traditions. It is this opacity of intention, this critical ambiguity that produces a vertiginous effect.

This is a different kind of sublime experience than that induced by the paintings of Frederic Edwin Church. Looking at his magnificent *Cotopaxi* (1862), it is difficult to tell up from down, sky from land, as the painting teeters on the edge of representation.[4] The viewer is lost in a limitless vista, and nature, postulated as that which cannot be framed, threatens our own sense of boundaries and self-identity. Some of John's artworks do evoke this kind of sublime affect, especially such landscape sculptures as *Restless Stillness* (1991) or *We Promoted Ourselves Only Slightly* (1992). With their strange shifts of interior scale relationships, the ambiguous spatiality of these model-sized landscapes is not dissimilar to Church's uncertain locales. But an even stronger disorienting effect arises from the confusion they provoke in relation to both their positive or negative value and their position in (cataclysmic) time. Are they landscapes or simply wads of brown muck? Are they representations of that which is preformed (the primordial goo/the originating chaos), or are they postapocalyptic landscapes (representing the end of time)? But while Miller's landscape-sculptures admit certain comparisons to Church's sublimity, they do not invite a similar metaphysical interpretation. The depiction of sublime nature in nineteenth-century romantic painting clearly has religious overtones: in its ungraspable boundlessness, nature is an image of God.

With every geological discovery America grew older. Geological time, transcending exact chronology, was infinite and thus potentially mythical. Through geology, chronological time was easily dissolved in a poetic antiquity that fortified the "new" man's passion for age. From this point of view, the "nature" of the New World was superior to the "culture" of the Old.[5]

Barbara Novak underlines here how artists and scientists in nineteenth-century America collaborated in commingling nationalist tendencies and mystical fervor. The naturalists and painters who scouted the great unknown expanses of the West paved the way for the realization of the doctrine of Manifest Destiny—the belief that colonization of the entire North American continent was a "natural," even preordained, right in the development of the United States.[6] The deification of the unspoiled West marked the beginning of an attempt to produce a new, uniquely "American" aesthetic, completely severed from European history. The monumental mountains, redwoods, and

Frederic Church, *Cotopaxi* (1862). Oil on canvas. The Detroit Institute of Art: Founders Society Purchase, Robert H. Tannahill Foundation Fund, Gibbs-Williams Fund, Dexter M. Ferry, Jr., Fund, Merrill Fund, Beatrice W. Rogers Fund, and Richard A. Manoogian Fund. Courtesy The Detroit Institute of Art.

rock formations of the West would be God's stand-ins for the lesser, manmade ruins featured in European landscape painting. Our history would not be described in terms of a mundane past, through the images of ruins, but through timeless natural objects and ahistorical principles. The landscape of the West itself would be our art.

Yellow, red, gray-green, purple-black chasms fell
 swiftly below each other.
On the other side,
Strong-built, arose
Towers, whose durable terraces
 were hammered from red sandstone,
Purple granite, and gold
Beyond
A golden wall,
Aloof, inscrutable.
It was hidden
Behind layers of white silence.
No voice might reach it;
It was not of this earth.[7]

This attempt to escape from the weight of European history returns with even greater vigor at the end of the period of the first American avant-garde. The flowering of modernism in New York City in the 1910s was very much a response to—or at least a mirror of—the European model. Its high point is generally considered to be 1913, the year of the famous Armory Show, the first major exhibition of modernist art held in the United States.[8] But by 1917, Mabel Dodge, one of the major figures associated with the New York modernist movement, had moved to Taos, New Mexico. Her relocation was instigated by a vision: while lying in bed one night, the floating image of a male Native American face appeared to her. Upon arriving in Taos, she met the very man she had seen in her vision, a Tiwa Indian named Antonio Luhan. "Luhan satisfied her quest for spiritual integration, and she felt grounded in his tribal community. The hostess of the new age now looked back on

New York as 'a world that was on a decline ' [. . .] and on her earlier self as 'a zombie wandering empty upon the earth.'"[9] Taos became an artists' Mecca, drawing to it such former metropolitan intellectuals as D. H. Lawrence, John Collier, Carl Gustav Jung, John Marin, and Georgia O'Keeffe, among others.

John Collier, a New York community activist and poet (who had been instrumental in bringing Isadora Duncan to New York in 1914, with the intention of having her teach working girls how to dance), became Federal Commissioner for Indian Affairs in 1933. Martin Green writes: "The idea gradually came to him that the ethos and genius of the West might be the earth's doom as well as its hope. The great decade after 1908, which he had known in New York, why had it failed? The answer is that white culture is fatally flawed, and the sensitive individual can renew his or her life only by rerooting himself or herself elsewhere—in the Native American culture of the Southwest."[10]

This flight from Eurocentric history, the search for an "other," indigenous or native American, history, recurs once more toward the end of World War II, when both European artists, fleeing the war-torn continent and their American counterparts headed westward again in search of renewal.

Showcasing works by some of Europe's most renowned modernist masters, the *Artists in Exile* exhibition was held at the Pierre Matisse Gallery, New York, in 1942. Matta, Yves Tanguy, Marc Chagall, Fernand Léger, Piet Mondrian, André Masson, and Max Ernst, among others, each exhibited one work, completed after their arrival in the United States. Ernst's contribution was a large horizontal landscape painting, *Europe after the Rain* (1940–42). Begun in Europe before Ernst's escape, the painting was finished in the States. Despite its surrealist accents, the work is one of Ernst's most naturalistic efforts, its rich details accomplished through his use of the decalcomania process in which random textural effects are produced by pressing paint between two surfaces. *Europe after the Rain* depicts a desolate landscape of mountainous lumps and jutting buttes, like the bottom of a vast emptied ocean or post-Deluge floodplain. Continuing westward from New York, Ernst ended up living in Sedona, Arizona, in 1946, surrounded by a vista seemingly presaged by *Europe after the Rain*.

In addition to its effect on Ernst, the landscape of the Southwest is credited with influencing the paintings of surrealist artists such as Kurt Seligmann, Tanguy, and Dorothea Tanning.

The artworks and mythologies of indigenous Native American culture were important to the surrealist poets André Breton and Benjamin Péret, and to the painters of the Dyn group—Wolfgang Paalen, Lee Mullican, and Gordon Onslow Ford—who for a time lived and worked in Mexico.[11] Ford stated that "the countryside, the atmosphere of the Tarascan Indians, their vision of the universe, have me in their spell. It is so different from Paris and from African art and I feel more than ever convinced that something culturally very important, far removed from Surrealism, is going to happen on this continent."[12]

In the early 1940s, Ernst made sand paintings, executed flat upon the ground in the manner of the Navaho Indians.[13] So did Jackson Pollock, who in 1941 accompanied his Jungian therapist to the large exhibition *Indian Art of the United States* at the Museum of Modern Art in New York.[14] The very fact that New York's Museum of Modern Art would stage such a show, in which two Navaho medicine men produced sand paintings on site, seemed to signal the accomplishment of the American dream that had begun in the nineteenth century. An indigenous aesthetic had finally displaced the overbearing influence of European culture on American art, and the Indian-inspired paintings of Pollock have come to mark this triumph. They put an end to American surrealism, and announced the ascension of the New York School of painting as the premier form of painting, not only in America, but also worldwide.

But there is an irony, for, relative to Native American aesthetics, Pollock is no more "indigenously" American than Ernst. Moreover, if the Jungian interpretations that are often applied to the "pictographic" works of this period (Pollock's paintings are frequently discussed in this manner) are taken seriously, of what importance is an artist's nationality anyway? Surely the "primitive" signs in such works, linked as they are to a universal collective unconscious, should transcend petty nationalistic concerns—shouldn't they?

But what do John Miller's paintings have to do with the Jungian pretensions of abstract surrealism and abstract expressionism? Well, nothing, except by virtue of their proposition that the American Southwest still holds some interest as a source of inspiration for American artists. They obviously have no investment in Jungian ahistoricity, for their lineage is quite clear. Following in the footsteps of pop art and photorealism, their debt is to the mass media and not to nature. The viewer feels secure in one fact—that, more than likely, Miller's paintings are almost direct copies of photographs. If they evoke nature, it is the call-to-nature of the postcard or the travel brochure. If

they remind us of the exoticism of surrealism, it is the comical surrealism of a Road Runner cartoon. They depict clichés.

It is true that the paintings are lovely. Built up with thin washes of pigment so that the white canvas ground shines through, they yield a sense of interior illumination quite in accord with their sun-drenched subjects. These days, though, it is difficult to utilize such quite particular color schemes and not produce "interior decoration," albeit in a manner that is illustrative of the Southwest's *exterior*. A certain set of bleached earth tones and sunset pastels have come to be known as the Santa Fe style. When Barbara Novak describes the "dry, pink-ochre tonalities and horizontal extensions"[15] of Samuel Coleman's nineteenth-century desertscapes, she could just as easily be describing a Santa Fe-style row of tract housing. This is not lost on John Miller. At *Display,* an exhibition of paintings in Copenhagen in 1997, he exhibited a series of his Southwest landscape paintings hung on walls painted a warm sand color.[16] The unnaturalism of the juxtaposition of Santa Fe style and Danish architecture was striking.

At this moment, it is simply not possible to paint the traditional subject matters associated with Southwest genre painting and not have their romanticized nature, and the racism that lies at the root of much of that romanticization, become the subject of the work. After the surrealist exploitation of the American Southwest in the 1940s came the hippie pseudo-Indian appropriations of the 1960s. These have continued in the new age mysticism associated with the area, and even in the more recent—and more extreme—"modern primitive" movement with its liftings of various Indian initiation rituals and tattoo styles.[17] Perhaps calling this "exploitation" is too harsh, since I believe much of this interest in Indian culture and its environments has been pursued in good faith. Yet, with few exceptions, none of these movements has produced Indian-inspired art that is much more than escapist kitsch. In contrast to the first half of this century, no one would seriously propose today that any of the internationally known artists who happen to make their home in the Southwest at this moment—Bruce Nauman, Susan Rothenberg, John McCracken, the late Donald Judd, among others—somehow express the "soul" of that locale in their work. Indeed, such a suggestion would only sound like a regionalist gesture itself.

We reach, then, the problematic "sublime" of John Miller's Southwest genre paintings: every transcendental quality they evoke is open to question. Again, this is not to say that they are nihilistic, for the "questioning" they provoke does not strike me as some simple inversion. Despite

the manifest problems of contemporary discussions of "beauty" in art (neoformalism, residual elitism, too much—or too little—relativism, and so on),[18] somehow Miller's paintings can be said to be beautiful. The question is whether their beauty lies primarily in their visual or their discursive qualities.

There in the red world of jagged souvenirs signed by the great glacier, pioneers named their scenic views to bring them down to size. Cathedral Rock was a ruddy mass imitating for those childlike settlers a cathedral. Courthouse Rock, noble giant reduced in name to a reminder of fiefs and files. Just west of Sedona was Cleopatra's Nipple. It isn't known of course who named it so, or why anyone as remote as Cleopatra should occupy the imagination of the American cowboy—for it must have been a cowboy—but it was often thus pointed out to us, just as naturally as the other poverty-stricken titles. Coming back years later and encountering an entirely different population: retirees hoping to live ten minutes longer than they would elsewhere, failed doctors with cloudy pasts, wistful but determined unpublished writers, painters with camera eyes and a penchant for scenery, old adepts at new religions or, in general, people who didn't get along with their relatives back home; coming back then, we found that Cleopatra's Nipple no longer existed; its name had been cleaned up by less fevered imaginations, that it was now known as Chimney Rock and had never, in anyone's memory, been called anything else.[19]

Here, Dorothea Tanning describes the locale where she lived in the mid-1940s with her partner, Max Ernst. She reveals the shift in mindset, from those who came to that place specifically because they had "fevered imaginations" to those who had a stake in portraying it as a place of healing and calm. Like Tanning herself, the cowboy who named Cleopatra's Nipple found wonder in this strange place of a kind that could only be erotic. The landscape, as well as the indigenous peoples living there, their art and their religion, were all eroticized in ways that can only befall the truly "other." Once that was accomplished, when the other had been completely absorbed into the dominant culture, it could no longer remain erotic. That's where the Southwest is at now as a subject matter (artistically speaking)—and that's where John Miller is at too. The ecstasy has waned.

Two of John's Southwest paintings are named after 1960s psychedelic songs—both, interestingly, by black groups: *Psychedelic Shack* (1995) is named after the song by the Temptations,

and *Time Has Come Today* (1995), after the song by the Chambers Brothers. The first painting depicts a rough fieldstone building, the other a ruined Spanish-style adobe mission and cemetery. The title of a third painting—depicting an abandoned pueblo settlement—says it all: *The Fashionable Excess Wears Thin.* Collapsed under the strain of political discourse, the romantic ruin, as a sign, is itself in ruin. We have woken up from our trip and found ourselves drenched in blood. We had a good time; now we are sorry. Being sorry is how we have fun now. Or maybe we are past that; maybe we have fun now by pretending to be sorry—or sorry isn't even an issue.

> *Together we will fly so high, together tell our friends goodbye.*
> *Together we will start life new, together this is what we'll do.*

> *Go west. . . .* [20]

John Miller, *Time Has Come Today* (1995). Acrylic on canvas. 27¾ x 19¾ ins. Courtesy Metro Pictures.

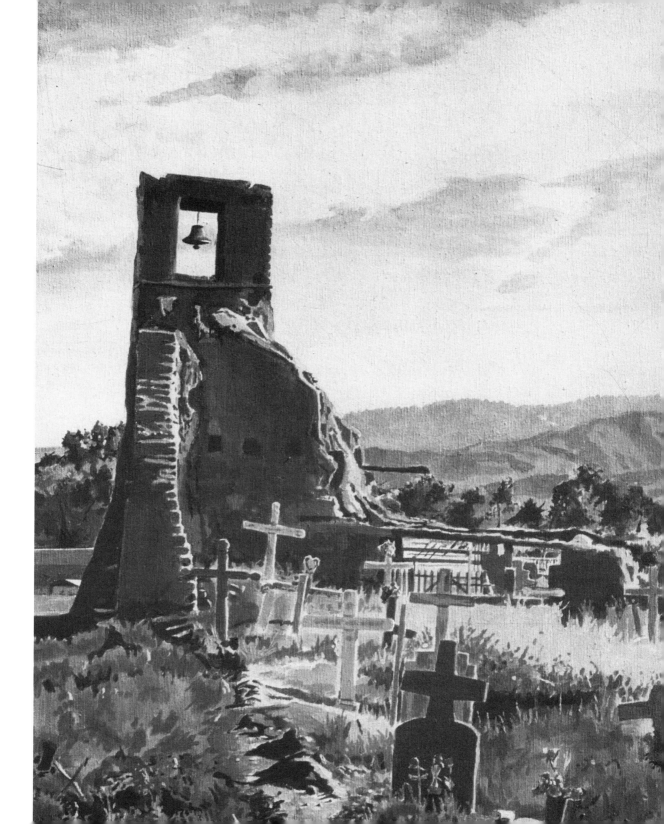

NOTES

1 On May 19, 1960, Yves Klein patented the pure ultramarine blue he had developed under the designation "International Klein Blue" or "IKB." He also cultivated his identification with the color by referring to himself as "Yves Klein le monochrome."

2 *Arizona Highways* is a promotional tourist magazine that has been espousing the beauty of the Grand Canyon region since it was founded in 1925.

3 Ideas of the sublime, derived from Longinus, Edmund Burke, and Immanuel Kant, among others, and variously reinvented in the American context—from nineteenth-century landscape painting to postwar popular culture—have interested Kelley from the beginning of his career. See, in particular, *The Sublime* (part of the "Explorations" performance series at the Museum of Contemporary Art, Los Angeles, 1984); *Plato's Cave, Rothko's Chapel, Lincoln's Profile* (a performance with Sonic Youth at Artists Space, New York, 1986); and Kelley's conversation with Thomas McEvilley, "From the Sublime to the Uncanny" (1993), reprinted in this volume.

4 Frederic Edwin Church (1826–1900) was a pupil of Thomas Cole and a member of the Hudson River School. His preference, however, was for more exotic locales, in South America, Europe, and the Middle East. Imaging a then-active volcano in Ecuador, *Cotopaxi* was exhibited with other South American works in a dramatic gaslit chamber set with indigenous plants, outside of which fee-paying visitors would line up.

5 Barbara Novak, *Nature and Culture: American Landscape and Painting 1825–1875* (New York: Oxford University Press, 1980), pp. 58–59.

6 The term "Manifest Destiny" was first articulated by John L. O'Sullivan in 1845, when he asserted "the right of our manifest destiny to over spread and to possess the whole of the continent which Providence has given us for the development of the great experiment of liberty and federaltive development of self government entrusted to us." Cited in Alan Brinkley, *American History: A Survey,* vol. I (New York: McGraw-Hill, 1995), p. 352.

7 John Gould Fletcher (1886–1950), excerpt from "The Grand Canyon of the Colorado," in *Selected Poems* (New York: Farrar and Reinhart, 1938); cited in *Arizona Highways* 30, no. 3, (March 1954), p. 25.

8 The International Exhibition of Modern Art, known after its location in New York City as the Armory Show, opened on February 17, 1913. Its approximately 1,600 works, including Marcel Duchamp's *Nude Descending a Staircase, No. 2* (1912), were seen by around 70,000 people during the month run. Smaller versions of the exhibition traveled to Chicago and Boston.

9 Steven Watson, *Strange Bedfellows: The First American Avant-Garde* (New York: Abbeville, 1991), p. 341. Socialite and patron of the avant-garde, Mabel Dodge (1879–1962) met and married Taos Pueblo Indian Antonio Luhan in 1918. Their house was the social center of a diverse group of artists, radicals, anthropologists, and lost souls, who came to hear Mabel's infectious enthusiasm for Native American culture. Invited in 1922, John Collier went on to become one of the most activist Federal Commissioners for Indian Affairs. See also

Lois Palken Rudnick, *Utopian Vistas: The Mabel Dodge Luhan House and the American Counterculture* (Albuquerque: University of New Mexico Press, 1998).

10 Martin Green, *New York 1913: The Armory Show and the Patterson Strike Pageant* (New York: Collier/Macmillan, 1988), p. 259.

11 Invited by Diego Rivera and Frida Kahlo, Wolfgang Paalen (1907–59) emigrated to Mexico in 1939, where he published the magazine *Dyn.* With British surrealist Gordon Onslow Ford (b. 1912) and California artist Lee Mullican (1919–98), he co-founded the Dynaton group in San Francisco nearly a decade later. See also *Wolfgang Paalen's DYN: The Complete Reprint,* ed. Christian Kloyber (Vienna and New York: Springer, 2000).

12 Onslow Ford, letter to Paalen, cited in Martica Sawin, *Surrealism in Exile and the Beginning of the New York School* (Cambridge, Mass.: MIT Press, 1995), p. 282.

13 Ibid., p. 173.

14 See Frederic H. Douglas and René d'Harnoncourt, *Indian Art of the United States,* exhibition catalogue (New York: Museum of Modern Art, 1941; reprint edition, Ayer, 1975). The Indian Arts and Crafts Board of the U.S. Department of the Interior sponsored the exhibition. For Pollock's visit to the show with Dr. Henderson, see Dickran Tashjian, *A Boatload of Madmen: Surrealism and the American Avant-Garde, 1920–1950* (New York: Thames and Hudson, 1995), p. 320.

15 Novak, *Nature and Culture,* p. 147.

16 *Display,* organized by the British Council (Charlottenberg Exhibition Hall, Copenhagen, September 3 to October 19, 1997).

17 See e.g. *RE/search* no. 12, *Modern Primitives: An Investigation of Contemporary Adornment & Ritual,* ed. V. Vale and Andrea Juno (1989).

18 For two different positions in the "beauty" debate, see Dave Hickey, *The Invisible Dragon: Four Essays on Beauty* (Los Angeles: Art Issues Press, 1993); and Jeremy Gilbert-Rolfe, *Beauty and the Contemporary Sublime* (New York: Allworth Press, 2000).

19 Dorothea Tanning, *Birthday* (Santa Monica: Lapis Press, 1986), pp. 83–84.

20 The Village People, "Go West," written by Jacques Morali, Henri Belolo, and Victor Willis, from the album *Go West,* Casablanca/Polygram USA, 1979.

ARTIST/CRITIC ?

MK *This essay was written as the introduction to the second collection of writings by the artist/critic*
John Miller.[1] I decided not to attempt to sum up John's approach to writing, or to take on the
totality of his critical output, its chronological development, range of styles and venues, etc.
Rather, I address John's position as a visual artist who resolved to make critical writing as
important an element in his production as his artistic output.

――――――――――

The first question, then: Is there a difference between an artist/critic and an art critic? I would have
to say yes, there is. Jasper Johns made a lead relief in 1969 called *The Critic Smiles,* depicting a tooth-
brush, the bristles of which have been replaced with a row of gold teeth.[2] What does this mean? I
don't know, but my assumption has always been that it is a negative statement—an attack on the
art critic. Its very status as an ambiguous artwork—offering no clear-cut didactic statement—
carries this implication. The antagonistic relationship between the artist and art critic is such a com-
mon cliché that it is the stuff of Hollywood comedies. The crux of the joke is that the artist and critic
are dependent on each other but have fundamentally different social positions and worldviews. As
the story goes, the artist is uneducated but has a kind of innate gift for visual expression, which the

educated and socialized critic must decode for the general population. The pathetic symbiotic relationship of this odd couple is endlessly amusing. Of course, while this clichéd scenario is ridiculously simplistic, it does contain an element of truth. For the most part, there has been a division of labor in the art world between those who produce art and those who comment on it. And, as all of us know, those who possess language have an advantage over those who do not. By virtue of his or her muteness, the artist is infantilized in this equation. There also seems to be a prejudice against those artists who do attempt to speak for themselves. Holding dual occupations is looked down upon. One cannot be a master in two fields, so the artist/critic is portrayed as a dabbler—and if one does happen to be a good writer, then the presumption is that he or she must be a bad artist.[3]

Of course, there is a long tradition of writings by artists. It could almost be considered a literary genre. But these writings are suspect because their authors are both objects and subjects of the critical discourse, and *must* therefore be prejudiced. Artists' writings may be useful insofar as they reveal technical information regarding artistic output, various aesthetic predilections, or even artists' critical intent (in relation to their milieu); but because they are not the products of a trained art historian or critic, they do not carry real cultural authority. Because critics work outside of the system, it is supposed that they have the kind of distance necessary for unbiased critical insight. But this is obviously a fallacy; critics are no more outside of the system than artists. Their analyses of contemporary art are colored by their allegiance to previous art historical models, or other biases that they share, culturally, with the artist. This complicity, coupled with the intellectual inequality often inferred between artist and critic, led artists to make outright attacks on the field of art history and criticism—not by "writing back," but through their visual art itself. Much conceptual art of the 1960s could be seen as a parody of critical language and its forms. But even though much of this work is language-based, its location is still primarily within the realm of visual art. Though obviously indebted to art theory, the wall statements of Lawrence Weiner, for example, could not themselves be construed as a version of it.[4]

Both Miller and I are products of this artists' backlash. We both studied at the California Institute of the Arts in the late 1970s, a period when the art faculty was composed primarily of conceptualists and language was often given priority over image. In the art program at Cal Arts, called a "post-studio" program, an evolutionary presumption was clearly at work: art-making had

advanced beyond the work of the hand to that of the mind. Thus, studios were unnecessary for the contemporary art student (it was often joked, though, that a studio *was* necessary, but only one big enough to hold a typewriter). Oddly, the irony associated with conceptualist language only seemed to add legitimacy to the notion that art criticism was a more serious endeavor than fine art production.

The response to this condition was twofold. On one hand, there was a reaction against the visual reductivism of conceptual art, which explains the emergence of the *Pictures* generation of neoconceptual artists.[5] In this movement there is an increased focus on the visual aspects of art production, a return to pop and mass culture imagery, and a reexamination of such "outmoded" artistic forms as painting, though now with a "critical" edge.[6] John and I have both been associated with this tendency. Secondly, the removed and pseudo-philosophical tone of much conceptual art led to a renewed interest in "real" social and political commentary—and the beginnings of the so-called politically correct and identity politics movements. Given this cultural atmosphere, it is easy to understand why artists would try to reconcile visual ambiguity and experiment with more overt historical and critical practices—in an attempt to invent a practice where these were not seen as polar modalities.

More simply, the main motivation for an artist such as Miller to start writing criticism is that the critical establishment was not addressing his cultural concerns. Dan Graham was an especially important model at this time. His essays discussed topics as diverse as Presidential Sunday painting, popular television comedy, suburban architecture, subcultural politics, and rock and roll, claiming them as topics worthy of critical consideration within the bracket of artistic discourse.[7] This was very unusual at the time. His approach provoked the question: Was it right that art should be viewed as distinct from other kinds of contemporary cultural production (as was the case in standard art historical approaches), or should they all be subject to a similar kind of analysis based on broader cultural concerns? Graham's writings were sociopolitical in nature and mirrored the concerns of younger artists, like Miller, whose interest in art may have stemmed more from a countercultural base than an interest in art history or theory per se. John's essay "Burying the Underground" is a revisionist attempt to reinsert a huge swathe of "lost" or ignored material back into American art history.[8] While the 1960s New Left, and its attendant approaches to visual cultures, was obviously extremely influential on a whole generation of artists, this history is not

considered properly "cultural" and has been excluded from contemporary art history. Compared to most of John's other essays, this text is unusually simple in tone and broad in its concerns. It is basically a primer on the dominant movements of that era. The reason for the more user-friendly approach is clear—most art-world readers would be unfamiliar with the bulk of its references and need a crash course in the alternative history it foregrounds.

I know that I am horrified by the oppressive, institutionalized version of art history dominant now—the one that begins with the New York School of painters and progresses along the standard path of art stars and isms to the present state of museum culture. When I look at current academic revisionist art histories addressing periods familiar to me, I am dismayed by the choice of figures deemed worthy to represent them. Most of the artists that influenced *me* are absent from these accounts. Historical writing becomes a duty for the artist at this point.

The omnipresent influence of Georges Bataille in recent critical writing (by Hal Foster, Rosalind Krauss, and Linda Nochlin, for example) is a case in point.[9] When I was in college, Bataille was not even mentioned as a figure in the pantheon of surrealist writers. These days his is virtually the dominant voice. Of course, I am in favor of revision of the history of French surrealism. The version of this history handed down to me as a student in the late 1960s and early '70s was flawed and limited. But the scramble for critical ownership of these "lost" figures is amazing. Much of the current critical interest in the "abject" is a by-product of investigations instigated primarily by artists—witness the rise of the so-called "pathetic" art movement in the 1980s, which was really just a gallery-oriented packaging of artistic approaches already active for years.[10] Many of the critical generalities issuing from this current revision of contemporary art with reference to the abject can be traced directly back to Miller's practice. Consider the round table discussion "A Conversation on the *Informe* and the Abject," published in the journal *October* in 1994,[11] itself a somewhat belated response to the so-called abject art movement. In this exchange between several of *October*'s best-known critics, Rosalind Krauss suggests—as if it were a standard reading *at the time*—that Richard Serra's film *Hand Catching Lead* (1968) could be related to abjection and anality. In fact, this example is borrowed from a review by Miller, "Body as Site" (1990),[12] in which he performs a critical experiment, related to his own aesthetic practice at the time, analyzing a screening of classic minimalist films by attending to their scatological implications. What disturbs me about Krauss's position is that she doesn't acknowledge Miller, even though this reading of Serra's film is so odd—and

so anchored in Miller's practice—that it would be next to impossible for her not to know it was specifically his. Her refusal to give the artist a voice seems willful. It's a perfect example of what I posited earlier as the infantilization of the artist by the critical establishment. Now, more than thirty years after the conceptual art movement began to address this schism, after years of struggle by artists to defeat the dichotomy that separates artist and critic, the same split raises its ugly head again. We are right back where we started.

This is why I am so glad that John Miller's writings are finally being published. At last, his distinctive voice is being given some kind of stamp of approval—something that's important now as criticality in the art world has seemingly dropped out of fashion. Critics, it appears, have won the battle; the mute artist now rules. This present condition is considered in two of John's essays: "The Weather Is Here, Wish You Were Beautiful" (1990), a discussion of beauty and contemporary aesthetics produced at a moment when beauty was still a somewhat novel concern, and "The Therapeutic Institution: Presentness Is Grace" (1998), written nearly a decade later when the "new beauty" had fully emerged as an art trend.[13] This version of the "beautiful" emerges in a post-post-post pop-art world where the "rush" of beauty is equated with the recognition of the familiar. No sublime crisis here—just comfort. The art world and entertainment industries have finally merged. For this to occur, the artwork must have no critical pretensions, it must maintain its natural place in the world. It rewards you for compliance.

Though it was still a powerful undercurrent in the art world of the late 1990s, I had not intended to get so caught up in the often clichéd conflict between artist and critic. I want to conclude by stressing the importance of the artist/critic position and of refusing to buy into the stereotypes that govern it. I believe it is important to maintain that art still has a critical function in our society, no matter now much this notion is tested. The problem for the artist/critic now is to escape the present limitations of critical discourse. For the form of criticism itself is an aesthetic consideration. This volume of Miller's writings also contains images of his visual production. The relationship between his various practices has been forced as an issue. I believe this approach complicates the presentation of these writings, and makes us, the viewers of this material, more aware of the complexity of John Miller's practice as a whole. This complexity is part of John's criticality.

NOTES

1 Kelley's introduction is for John Miller, *When Down Is Up,* trans. Thomas Atzert (Frankfurt: Revolver Verlag, 2002). Miller's first anthology was *The Price Club: Selected Writings (1977–1998),* ed. Lionel Bovier (Geneva/Dijon: JRP Editions/Les presses du réel, 2000).

2 Jasper Johns's *The Critic Smiles* (1959) was made a year after Johns's first experiments with sculpmetal sculpture. Kelley is referring to a multiple lead relief made for Gemini in 1969. Discussing the context of the earlier work, Richard Francis notes that "Johns was included in Dorothy Miller's *Sixteen Americans* at the Museum of Modern Art in 1959. . . . Johns's statement for the catalogue established the arena in which critics were to discuss him for the next few years. He outlines his heroes (Cézanne, Duchamp, Leonardo) and adumbrates his technical interest in repetition, busyness, and the exploitation of 'accidents.' Indeed, the works that follow can be seen as responses in part to critical approval; a work such as *The Critic Smiles*—the toothbrush with teeth as bristles on a slab of sculpmetal—does not disguise his ironic disregard for the critics. This is extended with greater and biting cynicism in *The Critic Sees* in 1961. We should not write these off as *jeux d'esprit.* . . . [They] ask questions about the functions of criticism . . . with a wit—Wittgenstein's 'asides'— but their intention is nonetheless serious." Richard Francis, *Johns* (New York: Abbeville Press, 1984), p. 41.

3 See for example Jack Flam, preface to *The Collected Writings of Robert Motherwell,* ed. Stephanie Terenzio (Berkeley: University of California Press, 1999), pp. v–vi: "But the role of the writer and theorist was one about which he [Motherwell] had ambivalent feelings. He was profoundly aware of how dangerous it could be for an artist—especially an American artist—to be perceived as an intellectual. He felt, not without justification, that it could adversely affect the way he was regarded as an artist, for at that time an artist was expected to be 'a feeling imbecile,' wild, unpredictable and passionately inarticulate."

4 Lawrence Weiner began using language as the predominant form of his work in 1968. "A solo exhibition in December 1968 organized by Seth Siegelaub definitively marked Weiner's departure from previously accepted methods of making and exhibiting art. The exhibition, comprising of twenty-four works, took place only on the pages of a palm-sized gray book entitled Statements. . . . For the most part, Weiner's works have remained exclusively in their linguistic state without being constructed. They often take the form of phrases spelled out on the wall using commercially available, black adhesive letters or stenciled, drawn, or painted letters." Anne Rorimer, *New Art in the 60s and 70s Redefining Reality* (London: Thames and Hudson, 2001), pp. 78, 81.

5 The influential exhibition *Pictures* was curated by Douglas Crimp at Artists Space in New York in 1977. A number of key exhibitions, including *A Forest of Signs: Art in the Crisis of Representation,* curated by Ann Goldstein and Mary Jane Jacob at the Museum of Contemporary Art, Los Angeles, from May 7 to August 13, 1989, have examined the legacy of these artists.

6 The most cited essay on the critical redemption of painting at this time was Thomas Lawson's "Last Exit: Painting," in Brian Wallis, ed., *Art after Modernism: Rethinking Representation* (Boston: David R. Godine, 1984).

7 Dan Graham's writings are collected in several volumes, whose contents overlap: *Rock My Religion: Writings and Art Projects 1965–1990,* ed. Brian Wallis (Cambridge, Mass.: MIT Press, 1993); *Two-Way Mirror Power: Selected Writings by Dan Graham on His Art,* ed. Alexander Alberro (Cambridge, Mass.: MIT Press, 1999); and *Video/Architecture/Television: Writings on Video and Video Works 1970–1978,* ed. Benjamin H. D. Buchloh (Halifax/New York: The Press of the Nova Scotia College of Art and Design/New York University Press, 1979). Kelley is referring to such writings as "Eisenhower and the Hippies" (1967), "Homes for America" (1966–67), "Dean Martin/Entertainment as Theater" (1969), and "Punk as Propaganda" (1979), all in *Rock My Religion.*

8 John Miller, "Burying the Underground," was first published in Marius Babias, ed., *In Zentrum* (Dresden: Verlag der Kunst, 1995), and is reprinted in Miller, *When Down Is Up.*

9 See e.g. Rosalind Krauss, "*Informe* without Conclusion," *October,* no. 78 (Fall 1996), pp. 89–105; Hal Foster, "Obscene, Abject, Traumatic," *October,* no. 78 (Fall 1996), pp. 107–24; Yve-Alain Bois and Rosalind E. Krauss, eds., *Formless: A User's Guide* (New York: Zone Books, 1997); "Down and Dirty: Lauren Sedofsky Talks with Rosalind Krauss and Yve-Alain Bois," *Artforum* (Summer 1996), pp. 91–95, 126, 131, 136; Craig Houser, Leslie C. Jones, Simon Taylor, and Jack Ben-Levi, *Abject Art: Repulsion and Desire in American Art* (ISP Papers, no. 3, Whitney Museum of Art, October 1993); and Linda Nochlin, *The Body in Pieces: The Fragment as a Metaphor of Modernity* (New York: Thames and Hudson, 1995), p. 49.

10 One of the first exhibitions organized around the "pathetic" was *Just Pathetic,* curated by Ralph Rugoff at the Rosamund Felsen Gallery, Los Angeles, August 4 to August 31, 1990.

11 Contributors to "The Politics of the Signifier II: A Conversation on the *Informe* and the Abject" included Hal Foster, Benjamin Buchloh, Rosalind Krauss, Yve-Alain Bois, Denis Hollier, and Helen Molesworth; see *October,* no. 67 (Winter 1994), pp. 3–21.

12 John Miller, "The Body as Site," was first published in *Flash Art* (Milan) 24, no. 161 (November-December 1991), pp. 98–99, and is reprinted in Miller, *The Price Club,* pp. 87–89.

13 John Miller, "The Weather Is Here, Wish You Were Beautiful," was first published in *Artforum* 28, no. 9 (May 1990), pp. 152–59; "The Therapeutic Institution: Presentness Is Grace" was first published in the exhibition catalogue *Secession: The Century of Artistic Freedom* (Vienna/Munich: Wiener Secession/Prestel Verlag, 1998), pp. 17–21, and is reprinted in Miller, *The Price Club,* pp. 165–83. For two different positions on "beauty" see "Go West," in this volume, note 18.

INDEX

Page numbers in boldface indicate illustrations.